The History of Gardens in Painting

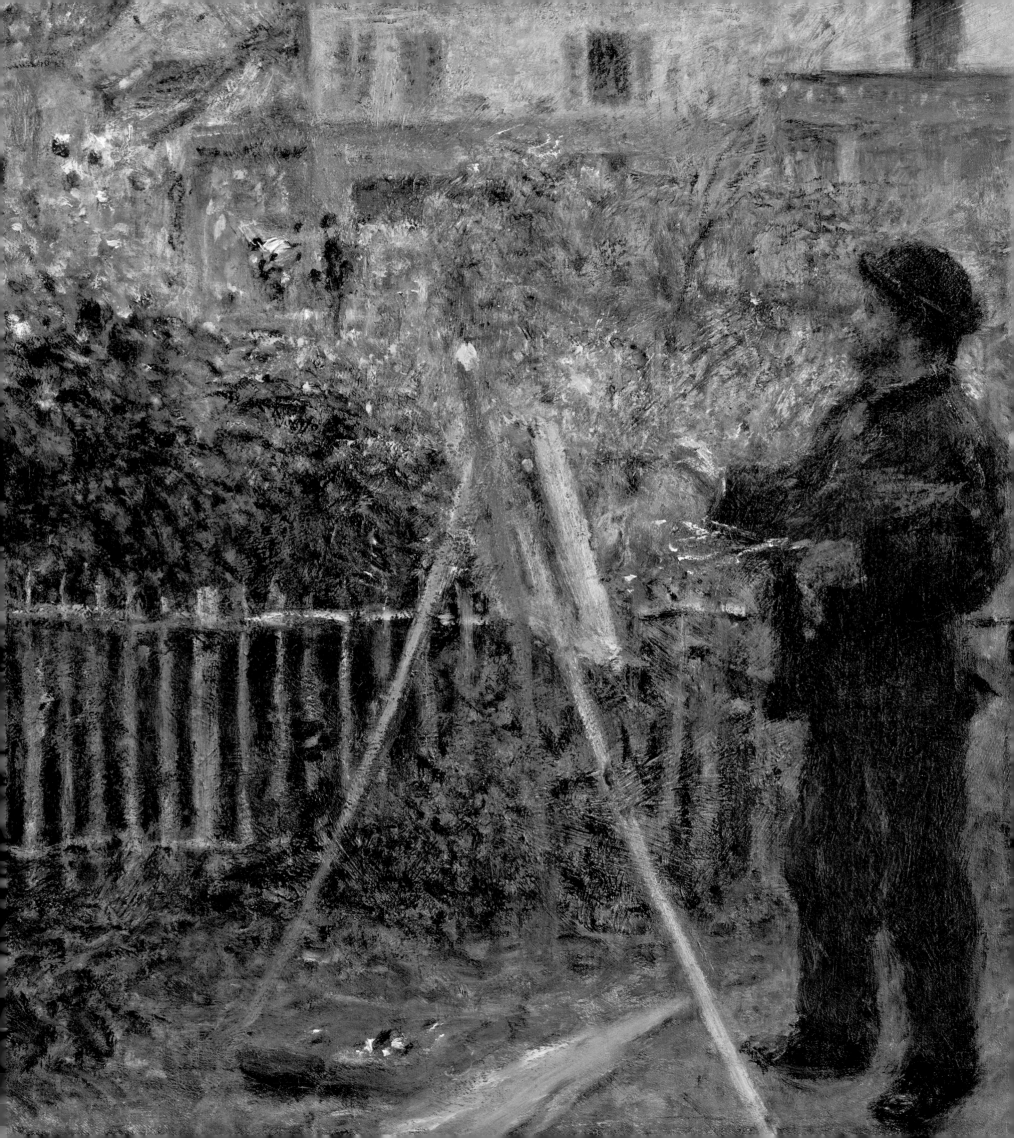

Nils Büttner

THE HISTORY OF
Gardens in Painting

TRANSLATED BY RUSSELL STOCKMAN

Abbeville Press Publishers

New York London

For the original edition
Editor: Margret Haase
Reproductions: Silverio Zanotto/Brisotto, Tezze di Piave (Treviso)
Printing and Binding: Printer Trento S.r.l. Trento-Gardolo

For the English-language edition
Editor: Susan Costello
Copyeditor: Miranda Ottewell
Production Manager: Louise Kurtz
Production Editor: Austin Allen
Composition: Angela Taormina
Typography and jacket design: Misha Beletsky

The text of this book was set in Arno Pro.
Printed and bound in Italy.

© Copyright for the illustrations, see p. 240

First edition: 9 8 7 6 5 4 3 2 1

Library of Congress Cataloging-in-Publication Data
Büttner, Nils

[Gemalte Garden. English]
The history of gardens in painting / Nils Büttner. — 1st ed.
 p. cm.
Includes bibliographical references and index.
ISBN 978-0-7892-0993-1 (hardcover : alk. paper)
1. Gardens in art—History. I. Title.

ND1460.G37B8813 2008
758'.5—dc22
 2008021644

For bulk and premium sales and for text adoption procedures, write to Customer Service Manager, Abbeville Press, 137 Varick Street, New York, NY 10013, or call 1-800-ARTBOOK.

Visit Abbeville Press online at www.abbeville.com.

Front jacket and page 2:
Auguste Renoir, *Monet Painting in his Garden*, details from plate 81

Back jacket:
Pieter Brueghel the Younger, *Spring* (detail from plate 35)

Page 5:
Anonymous, *Garden of Paradise* (detail from plate 12)

Page 6:
Lucas Cranach the Elder, *The Golden Age* (detail from plate 27)

Page 7:
Hans Thoma, *Golden Age* (detail from plate 73)

Pages 8–9:
Bernardo Bellotto, *Schönbrunn Palace* (detail from plate 53)

Pages 10–11:
Claude Monet, *Iris Bed in Monet's Garden* (detail from plate 90)

Pages 12–13:
Gustav Klimt, *Garden with Sunflowers* (detail from plate 102)

Page 14:
Vincent van Gogh, *The Garden of the Maison de Santé* (detail from plate 100)

Page 16:
Max Slevogt, *Grape Arbor at Neukastel* (detail from plate 108)

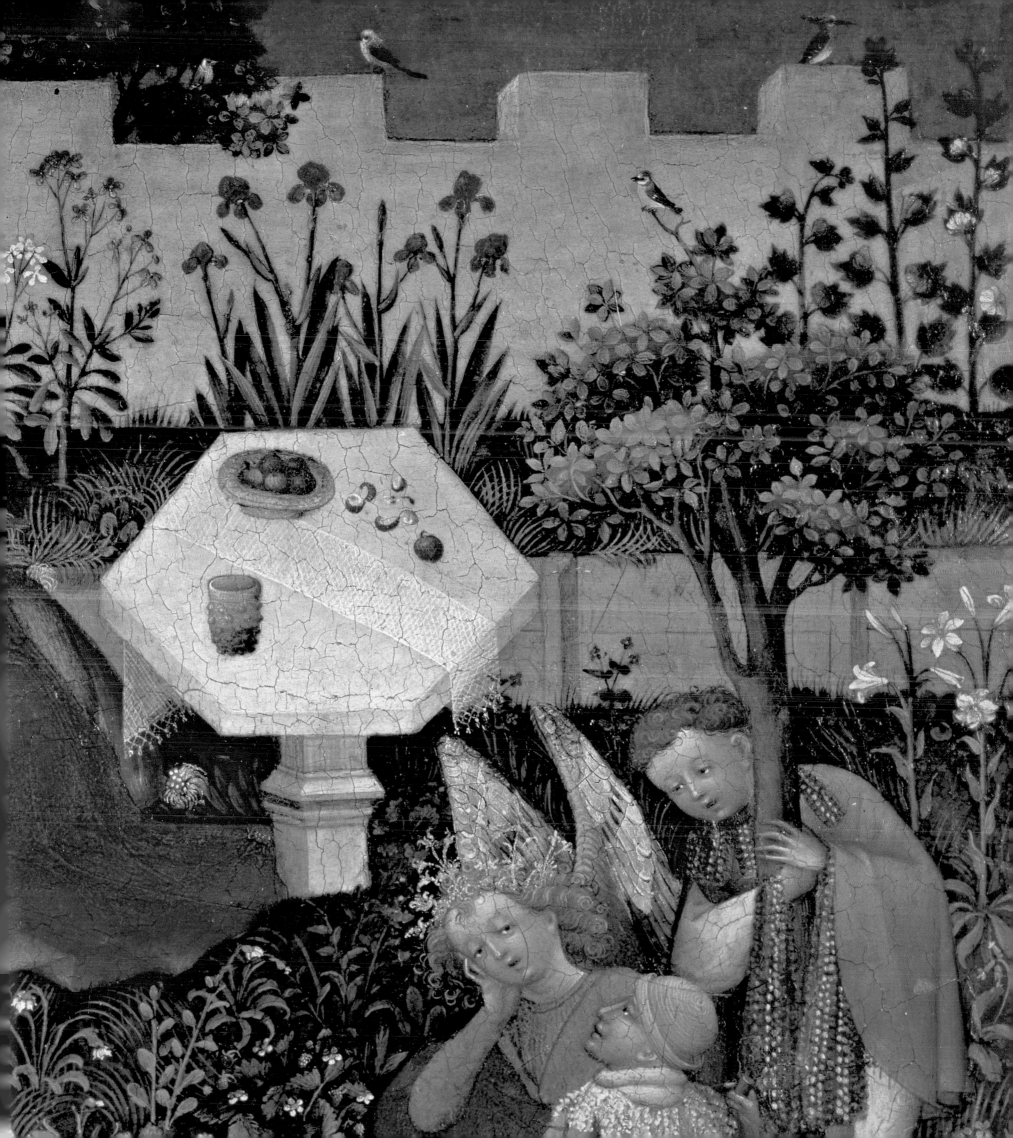

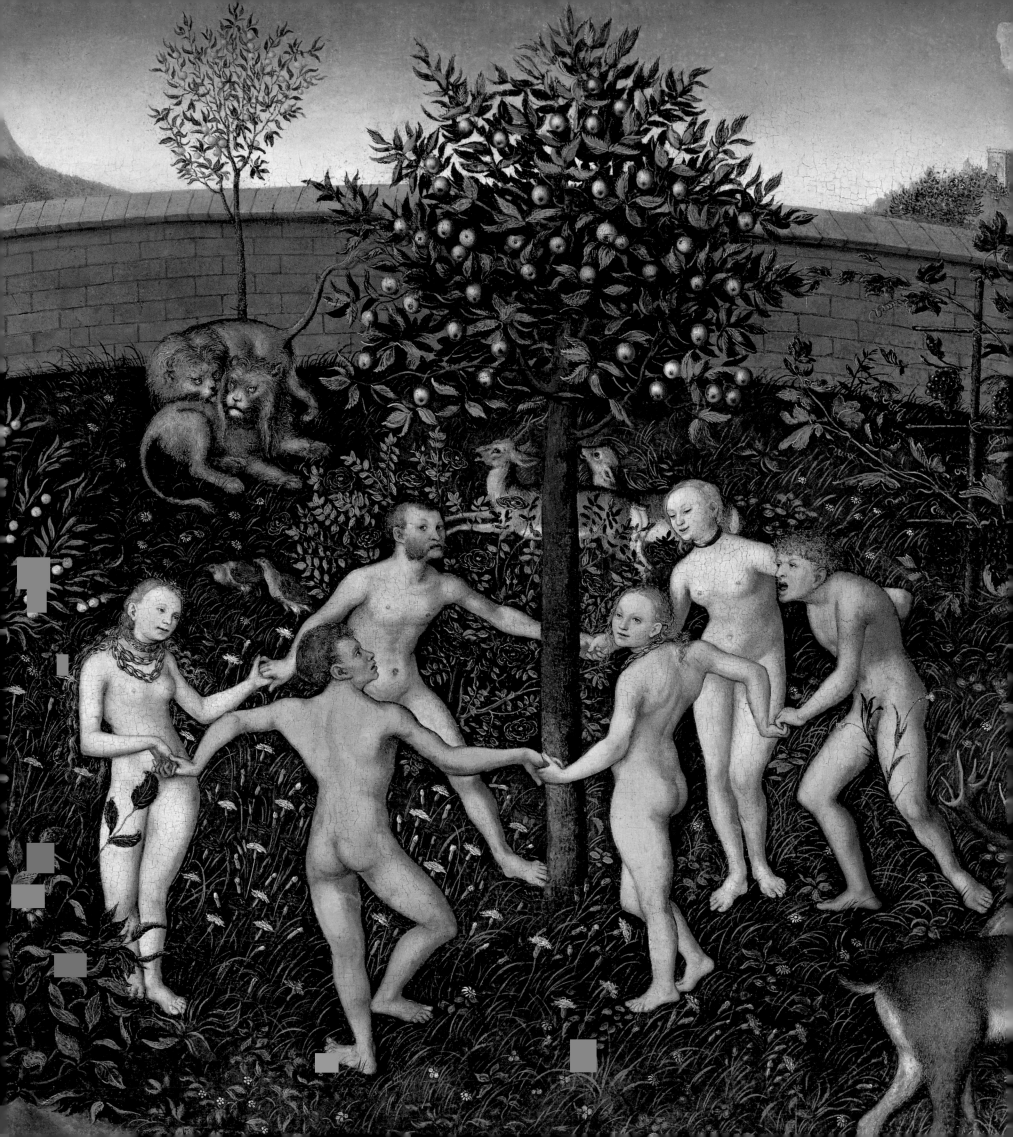

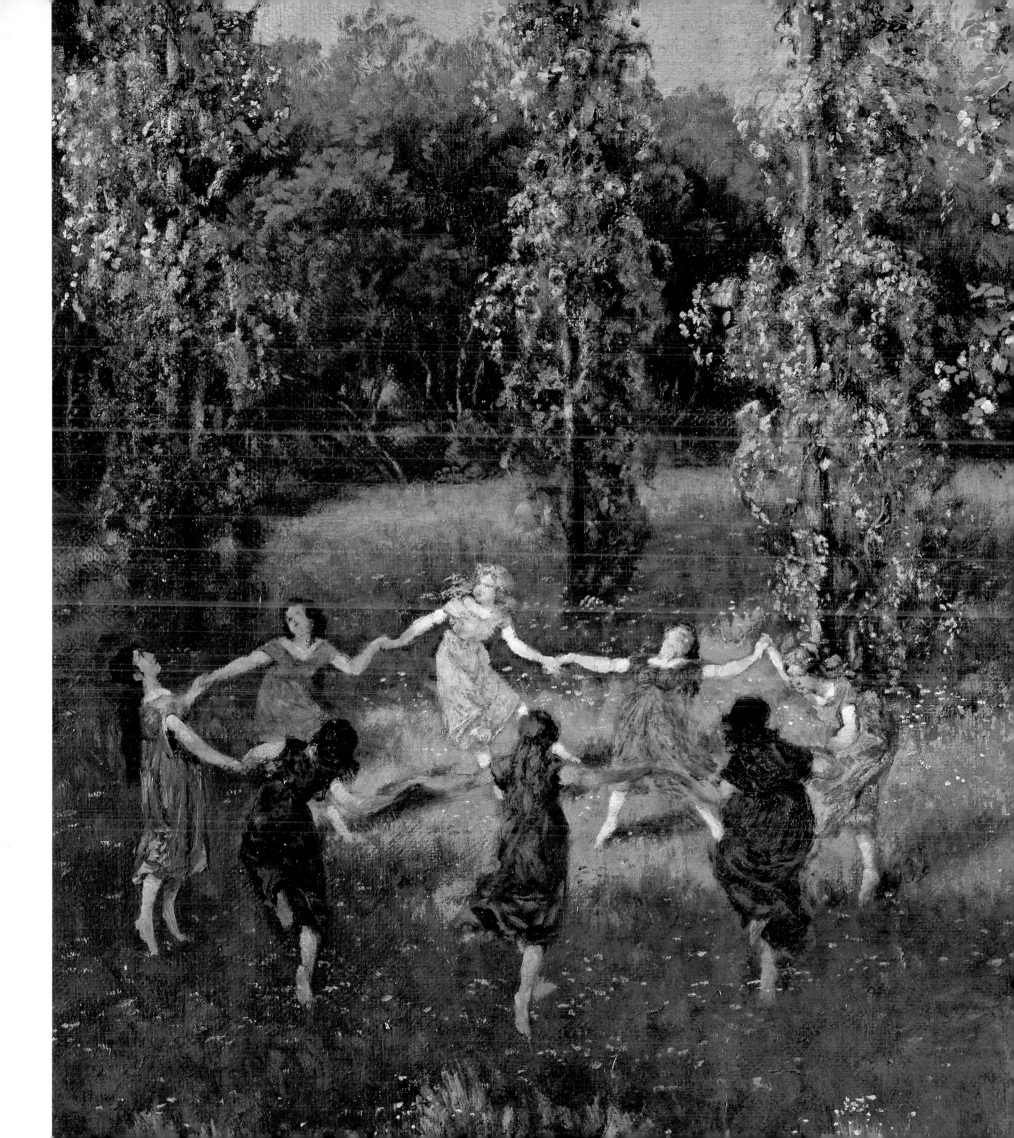

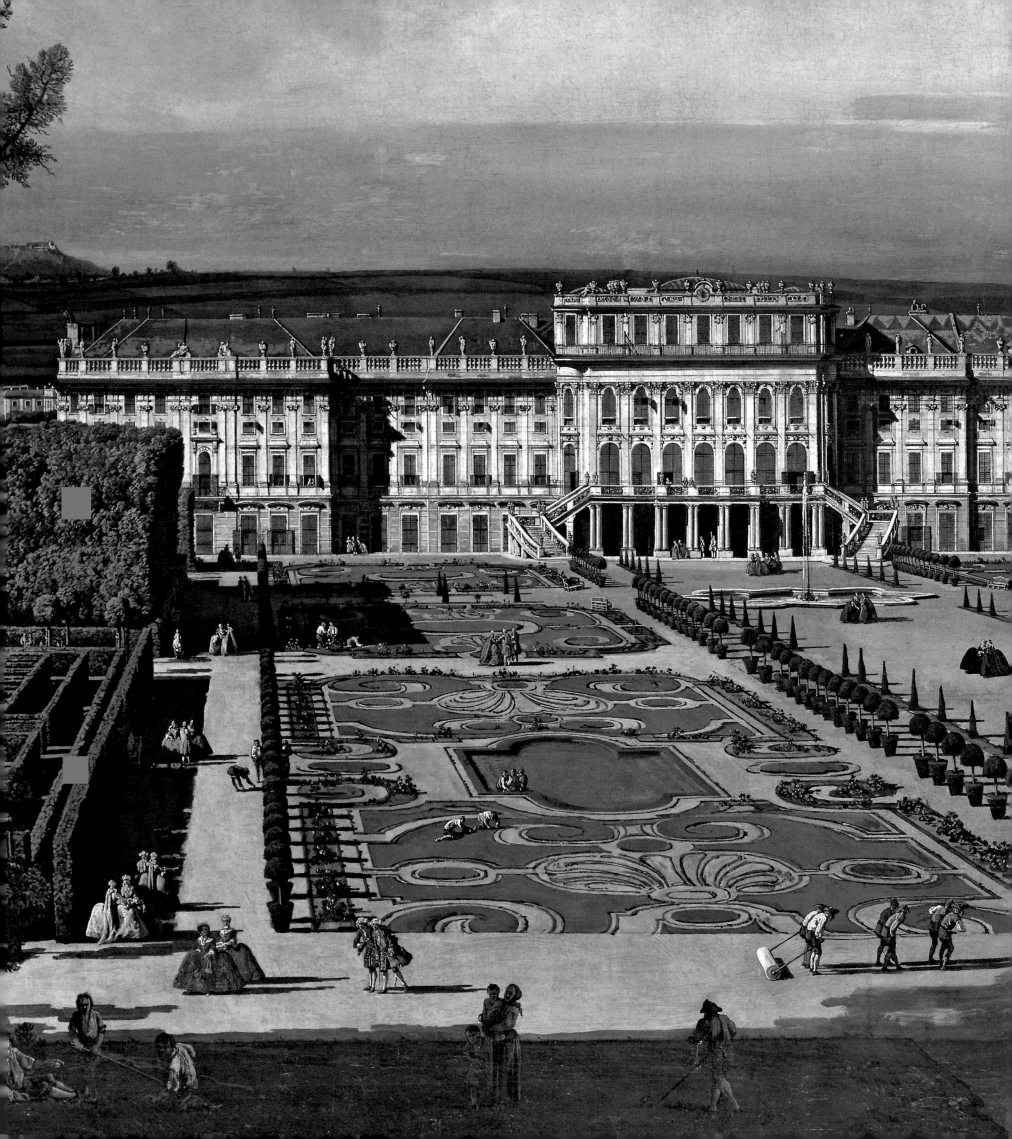

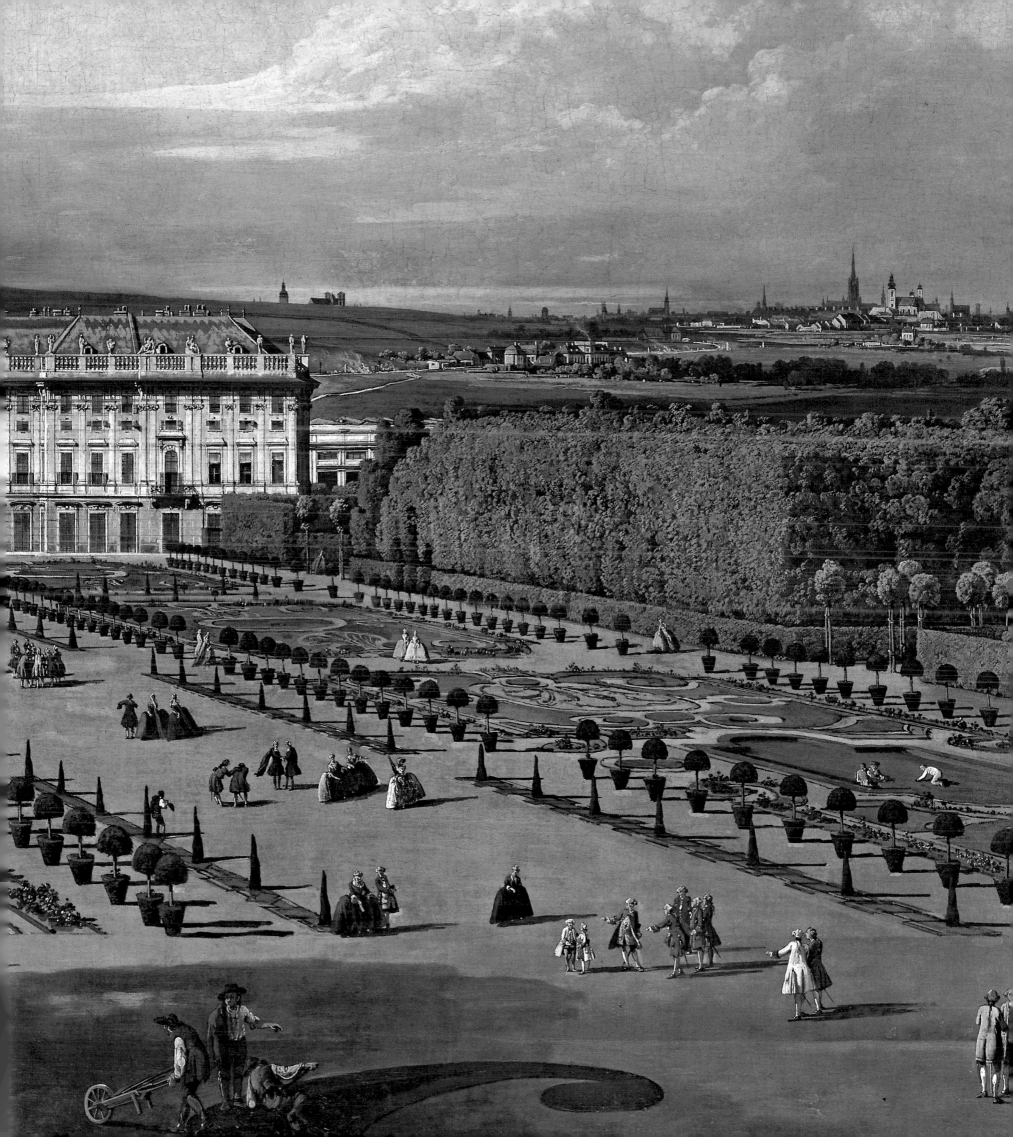

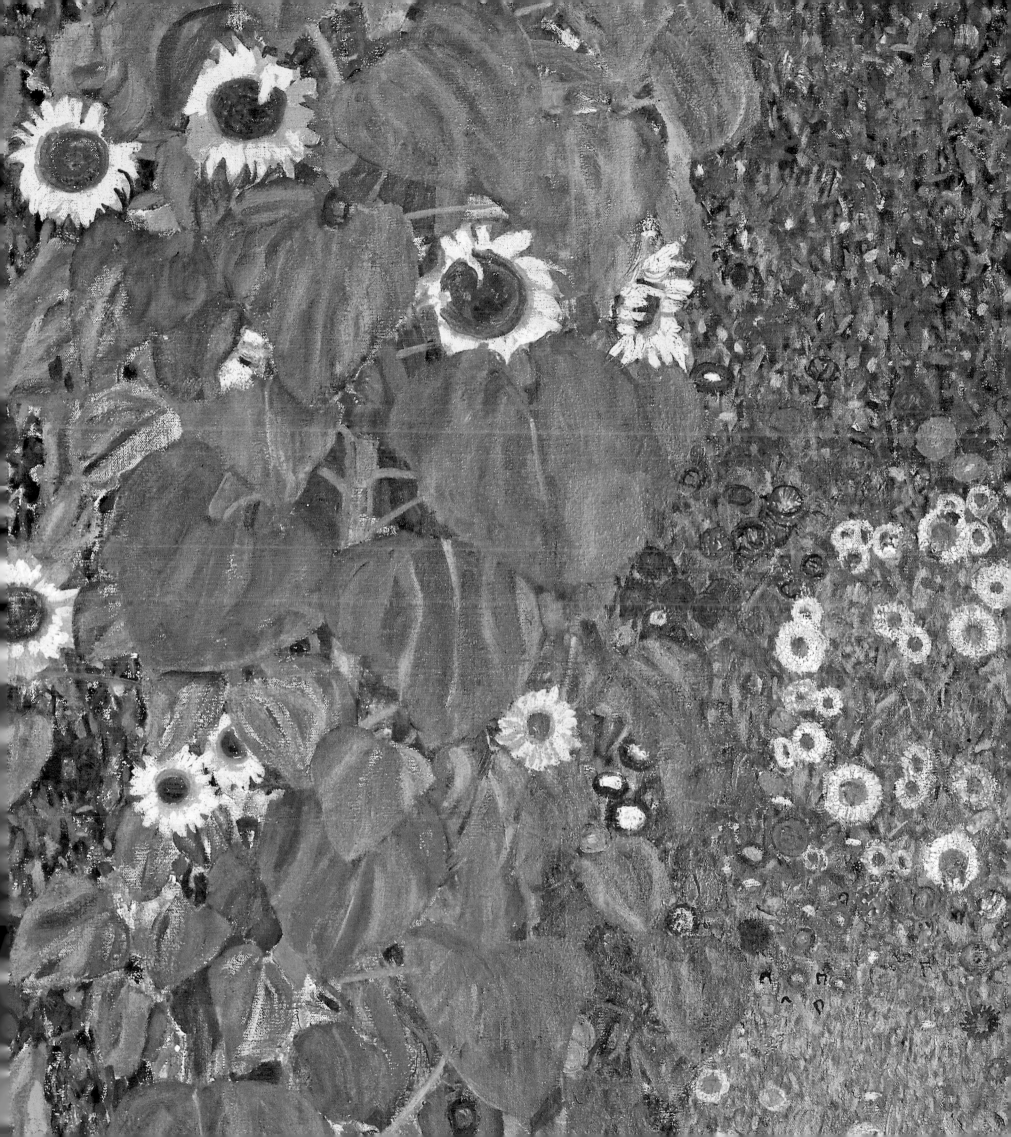

Contents

Introduction: Painted Gardens

According to the Bible, the history of mankind began in a garden that God specifically created for the first man and woman. The Vulgate, the Latin Bible translation attributed to Saint Jerome and the standard text throughout the Middle Ages, employs the term *paradisus* to describe this place removed from all earthly cares: "And the Lord God had planted a paradise of pleasure from the beginning: wherein he placed man whom he had formed" (Genesis 2:8). The word *paradise* derives from a Persian word for the fenced garden or animal enclosure attached to a ruler's palace. It was taken over as a loan word into Hebrew and Greek, and in Latin as well *paradisus* became the common name for an enclosed garden precinct. The forecourt of a medieval church, the ritual function of which is a matter for speculation, was also referred to as a *paradisus*. Such open vestibules, in which a memory of the lost paradise lived on, presumably served the faithful as gathering places where they might prepare their souls for the celebration of the mass. Etymologically, the word *garden* also conveys the sense of a protecting enclosure, a place set apart, and in all the modern languages refers to a walled or fenced precinct. Building upon this concept, the present book presents a collection of pictures of landscaped spaces set apart from untamed nature and showing signs of human intervention in the form of cultivation—in short, gardens. It attempts to trace several lines in the tradition of the motif in European panel painting.

Cultivation of crops and the creation of gardens were among the first achievements of human culture, and garden design was already highly developed in the great cultures of antiquity. As works of art, gardens were both fragile and evanescent, thanks to the eternal natural cycle of growth and decay. Painted representations of ancient gardens provide a better idea of their one-time splendor than the various descriptions by classical writers. Pictures of gardens also document developments in art history, both in garden design and in painting. At the same time, they reflect the specific social and historical circumstances in which gardens have been conceived, laid out, and planted. They also document more or less directly the motives of painters and designers of gardens, as well as those of their patrons and clients. All these aspects have had to be considered. Needless to say, the focus of the book is not gardens themselves and the different concepts of the garden—there is already a wealth of literature on these subjects—but rather the representation of gardens in paintings. But why do people paint gardens?

By examining the context and function of such pictures, it is possible to develop a clear sense of the complex and varied history of the painted garden. To reduce the otherwise impenetrable complexity of history to manageable

segments and thereby make some sense of the past, a chronological approach seemed inevitable as a general framework for this study—though not necessarily a rigid scaffolding, for the passages from one century to the next by no means represent actual interruptions in the flow of historical events. Geography has also been treated as something of a continuum; the absolute divisions between countries and schools so typical of nineteenth-century writing on art history have been deliberately avoided. Since the book's main purpose is to present the characteristic features of garden paintings, it was impossible to include mention of herbariums, botanical illustrations, or still life portrayals of individual plants. By the same token, there was no room for the many design suggestions, plans, or detailed views of gardens circulated in great numbers in the form of prints. However, to do justice to the various facets of the history of motifs and perceptions of the painted garden in panel painting, occasional reference to mosaics, wall paintings and tapestries, book illustrations, and graphics seemed appropriate.

The text begins with a look at ancient Rome, one readily suggested by the artistic lineages acknowledged by artists and art historians alike. Such a starting point seemed justified in this history of the garden motif through the ages to the present day, as it facilitates the identification of subsequent artistic borrowings and relationships between works and between the artists themselves. Already in classical times paintings of gardens were valued both as works of art and as comforting pictures to look at. Moreover, they could serve as visual metaphors for religious concepts and iconographically significant settings. Thirdly, they could effectively capture the fleeting appearance of an actual garden, documenting the prestige of its owner or communicating horticultural knowledge. Beginning in the nineteenth century, painters, many of them avid gardeners themselves, often used gardens as motifs as they experimented with new pictorial possibilities and painting techniques. Along with fantastic visions of an idealized, paradisial nature in a tradition that remains unbroken since antiquity, there are, of course, views of famous historic gardens. But even illustrations of actual gardens intended as topographical records are often echoes of human hopes and longings or projections of symbolic meanings, not simply depictions of pleasure gardens, fruit and vegetable plots, or medicinal gardens. Even today gardens are depicted as unique places haunted by myth and utopian ideals; they can also be understood as illustrations of man's estrangement from nature, or simply as an ultimate refuge, offering blissful privacy free from care. Countless such suggestions and interpretations are provided in the text that follows, but it is above all the reproductions of examples from two millennia that provide a visual history of the continuities associated with the garden motif in painting and the changes it has undergone.

Opposite
Emil Nolde
FLOWER GARDEN
Detail from plate 117 on page 203

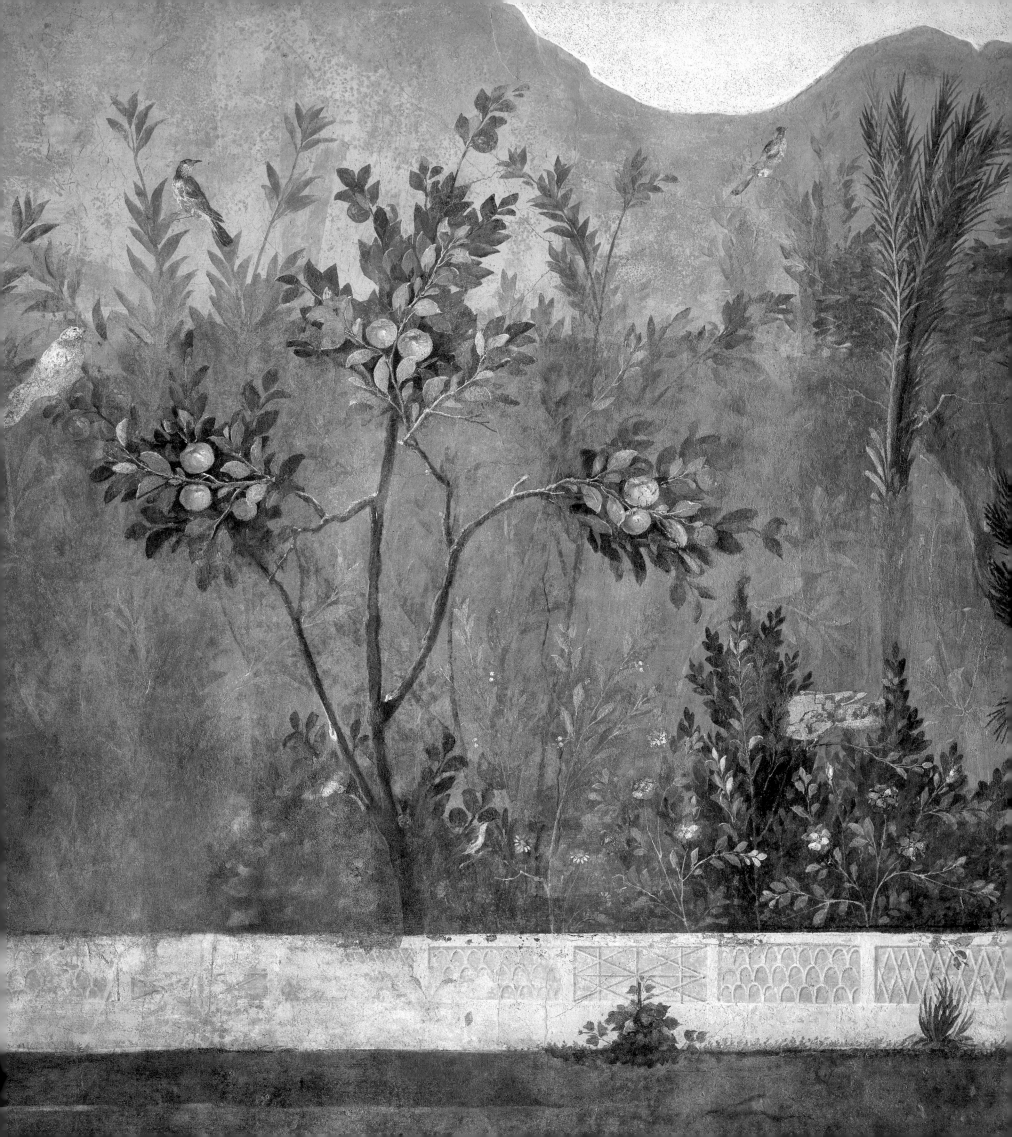

The Realm of Venus

No country on earth is lovelier than Italy. At least that was what Marcus Terentius Varro felt, and in his treatise on agriculture in dialogue form he celebrated the manifold glories of his homeland. After increasingly elaborate praises, he finally had one of his interlocuters wonder if one might not call Italy, with its many trees, a veritable orchard. All Italy a garden? How greatly this literary conceit differed from the ancient reality is attested by other Roman writers. Martial, for example, who lived on the fourth floor of a Roman tenement, complained that in the metropolis it was impossible to find the silence required for intellectual pursuits or for sleeping unless one was wealthy. The only defense against the incessant clamor was what Martial referred to as *rus in urbe*, or a patch of countryside in the city (7.57). Yet the vast majority could hardly afford a garden large enough to provide the desired calm. As Juvenal put it (3.235), "One has to be rich in order to sleep in Rome," and for that reason he maintained that it was better to live in the country. Horace managed to do just that once his patron Maecenas had deeded over to him a small estate near the city. "This is what I prayed for," he wrote in one of his satires (2.6), "a little bit of land with a garden, a reliable source of water near the house, and even a stand of trees. The gods have done me one better. It is delightful. I ask for nothing more." What Horace and others were celebrating was the ideal of the Roman villa, which over time had come to epitomize *otium*, that exquisite calm, far from the hectic bustle of city life, universally considered necessary for any kind of intellectual activity. The garden had here become the ideal setting for philosophical discourse.

The most important documents relating to Roman villa culture are two letters of the younger Pliny, who owned several country estates at the same time. One of his villas lay south of Ostia (2.17), another in the delightful landscape of the upper Tiber Valley. Regarding the situation of the latter, he wrote: "You would not believe you were looking at an actual landscape, rather an idealized picture of one" (5.6.13). These remarkable letters not only attest to a highly developed appreciation for the beauties of nature but also provide a vivid image of the layout and appearance of a classical villa. In addition to the architecture, he describes a number of the features of the garden, with its lawns, its shade trees, and its flower beds bordered by evergreens.

By Pliny's day the garden was part of a long tradition. Many centuries before, in Egypt, in Mesopotamia, and even in ancient Greece, gardens had been indispensable features of rulers' palaces. Babylon's Hanging Gardens of Semiramis were celebrated in literature as one of the Seven Wonders of the World. And Homer, whose verse epics mark the beginning of European

Opposite
Detail from plate 1 on page 23

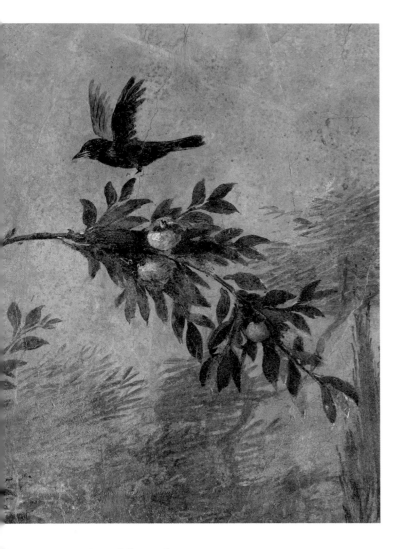

Detail from plate 1

literature, commemorated the gardens of the heroic age. In the *Odyssey* he describes in great detail the garden of Alcinous, as well as the fruit orchard next to Odysseus's palace, where the home-coming hero finds his aged father tending the trees (24.220f.). In ancient Greece any gardens or groves of trees that were not maintained as a means of livelihood were consecrated to the Muses or used as burial places. There was a spiritual dimension to the Greek garden in general, for every earthly garden could be thought of as a reflection of Elysium. What that otherworldly paradise was imagined to be like is apparent from the *Axiochos*, a dialogue ascribed to a pseudo-Plato. In it Socrates describes Elysium to his interlocutor as a "habitation of the godly," where an exquisitely ordered nature bathed in glorious sunlight serves as the setting for the most varied convivial amusements (371d).

The Romans held similar notions, and enhanced their residences with ornate garden layouts. In their combination of architecture and a tamed nature they followed the Greeks; their emphasis on the aesthetic appearance of their villas and gardens, however, was something new. Garden art, or *ars topiaria*, which found its ultimate expression in the design of purely decorative pleasure gardens, was a Roman invention. The special importance of gardens in ancient Roman culture is documented by numerous writers; detailed descriptions are found, for example, in Cato, Varro, and Columnella. To judge from their testimony, the garden appears to have been central to the Romans' sense of themselves. Ultimately, gardens were consecrated to the love goddess Venus, and since she was the mother of the mythical hero Aeneas, she was considered a direct progenitor of the Roman Empire. Thus Rome's gardens came to be potent symbols of its national identity.

This was true not only of actual gardens, of course, but also of pictures of gardens, which are richly documented, especially in ancient Rome. Garden motifs had already been seen in the palaces of Minoan rulers, but they became particularly popular in the decoration of Roman residential architecture. The sight lines of Roman villas were oriented toward the gardens and the surrounding landscape, and it was not only in the villas of the younger Pliny that this general aesthetic concept was extended to painted room decorations as well. One room, for example, was "all in green and shaded by a nearby plane tree, the bases of the walls paneled in marble. The painting above, representing trees with birds perched on their branches, was as lovely as the marble" (5.6.22f.). Examples of such pictures have survived, most of them in the cities buried by Vesuvius but also in Rome and other excavated sites. Visual testimony to ancient garden culture, they show how gardens that have long since ceased to exist were designed and furnished. Painted gardens on the walls of Roman villas were part of an overall decorative program, about whose original meaning little is known owing to a dearth of sources. There may well have been spiritual

overtones to such paintings, possibly as allusions to Elysium. Painted gardens are also common motifs in tombs, especially in the Greek sphere. The Romans adopted earlier traditions in wall painting, mainly from Greece, integrating innovations of their own. Naturally the pictures on the walls of Roman villas had a purely decorative function as well. It is not uncommon to find painted gardens in small dining rooms in city houses, and it has been conjectured that in their imaginary expansion of such confined spaces they represented the gardens of the wealthy. But this can hardly have been the chief motive behind the decoration of a dining room in a villa at Primaporta, not far from Rome, built for the wife of Emperor Augustus. The windowless underground room in the Villa of Livia (plate 1) was transformed into a grotto, with a ceiling imitating rough-hewn rock and paintings of surrounding gardens on the walls. The illusionistic painting, with more than thirty varieties of plants and an equal number of recognizable bird species, recalls that of a birdhouse described by Varro (3.5.18); it was used as a dining room, and in it guests were miraculously transported into a segment of nature teeming with life. With their Elysian overtones, such paintings communicated a sense of well-being and delight, at the same time underscoring the prestige of their owners.

Depictions of gardens are found even in the smallest rooms in Roman city dwellings. Initially they were illusionistic, but over time a decorative repertoire of endlessly repeated motifs was developed that could be integrated into paintings of mock architecture, as in the black-ground decor of the Casa del Frutteto

1
Garden Landscape
c. 20 BC
Wall painting from the so-called House of Livia
Museo Nazionale Romano, Rome

By means of paintings simulating views from a grotto out into verdant nature, the walls of the dining room were made to disappear. They present a vision of a garden of paradise, with birds from various climes and with spring, summer, and fall flowers simultaneously in full bloom.

Details on pages 20 and 22

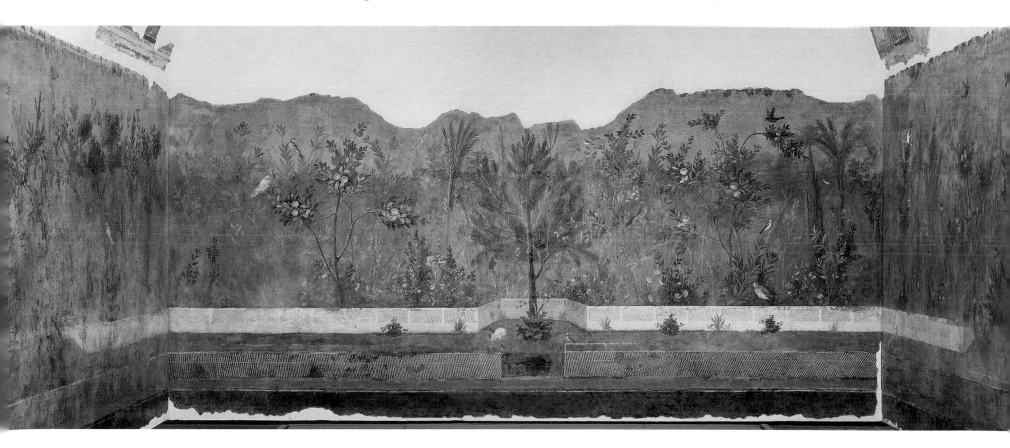

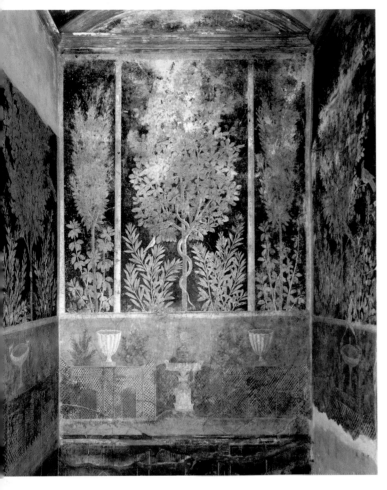

2 (above)
Painted Garden
c. AD 40–50
Wall painting
Casa del Frutteto, Pompeii, Italy, I.9.5

Just like real gardens, such pictures provided aesthetic delight. At the same time they were visual expressions of an ideal lifestyle and a status symbol reserved for the homes of the wealthy.

3 (opposite)
View of a Villa
c. AD 35–40
Wall painting
Casa di Marcus Lucretius Fronto, Pompeii, Italy, V.4.11

Along with narrative paintings and portraits, this villa landscape was part of an imaginary gallery of paintings hanging on the walls. Such detailed depictions of a single region were known as chorographs, the earliest of which were very possibly produced for documentary purposes.

(plate 2). The entire composition, with its richly varied design, exudes a sense of delight—the flower beds and fences in the base register, the fountains, and the water basin, or *labrum*, are generic allusions to gardens. Above them the motif of the serpent winding around the tree refers to the mythological dragon Ladon—ultimately killed by Hercules—that guarded the tree with golden apples, once given to Hera as a wedding gift, in the garden of the Hesperides.

The ancient painters divided wall surfaces into separate architectural units, then filled them with ornaments, decorative scenes, still lifes, landscapes, or garden scenes. Yet they always conceived of the overall architectural design, with its shifting sight lines and views out into surrounding nature, as a single unit. In these decorations illusionistic renderings of nature were replaced by combinations of unconnected motifs, much to the dismay of Vitruvius, who prided himself on having been the first writer to discuss the entire field of architecture. In his *De architectura* he railed against the aberrant taste of his contemporaries, complaining that "they prefer painting monstrosities on the plaster instead of realistic representations of specific things" (7.5.3). It was his contention that pictures of gardens and landscapes, faithfully executed in imitation of nature, were particularly appropriate in the decoration of living and dining rooms.

Yet even the type of decoration so sharply criticized by Vitruvius incorporated naturalistic elements, like the depiction of a villa, conceived as a picture within a picture, in the house of Marcus Lucretius Fronto (plate 3). Landscapes of this type—perhaps depictions of shrines rather than villas—show in great detail how architecture and the design of the surrounding gardens were integrated. Such pictures were pleasant to look at and at the same time documented the social standing of those who commissioned them: senators who had attained political power in Rome or *equites* grown wealthy in the administration of provinces. Those who could afford it found relaxation in their verdant gardens in town and maintained villas and extensive estates in the countryside. Like the actual places, pictures of gardens and villas provided aesthetic pleasure and spiritual refreshment. As earthly glimpses of Elysium and symbols of cultivated leisure, painted gardens were a visual expression of the ideal lifestyle of the Roman Empire's social elite. Pliny the Elder's descriptions of such paintings in his *Naturalis historia* (35.116f.) and Vitruvius's recommendation of them as particularly appropriate wall decor would influence the design of aristocratic living spaces for many centuries to come, long before the systematic excavation undertaken in the eighteenth century brought to light actual examples.

A fixed canon of symbolic motifs for the pictorial representation of gardens had already become established in antiquity, and that classical tradition continued unbroken in early Christian art and literature. Orators, poets, and historians sketched the settings of fictional or actual events using the rhetorical device known as topothesia. Artists borrowed the principle from rhetoric, "placing"

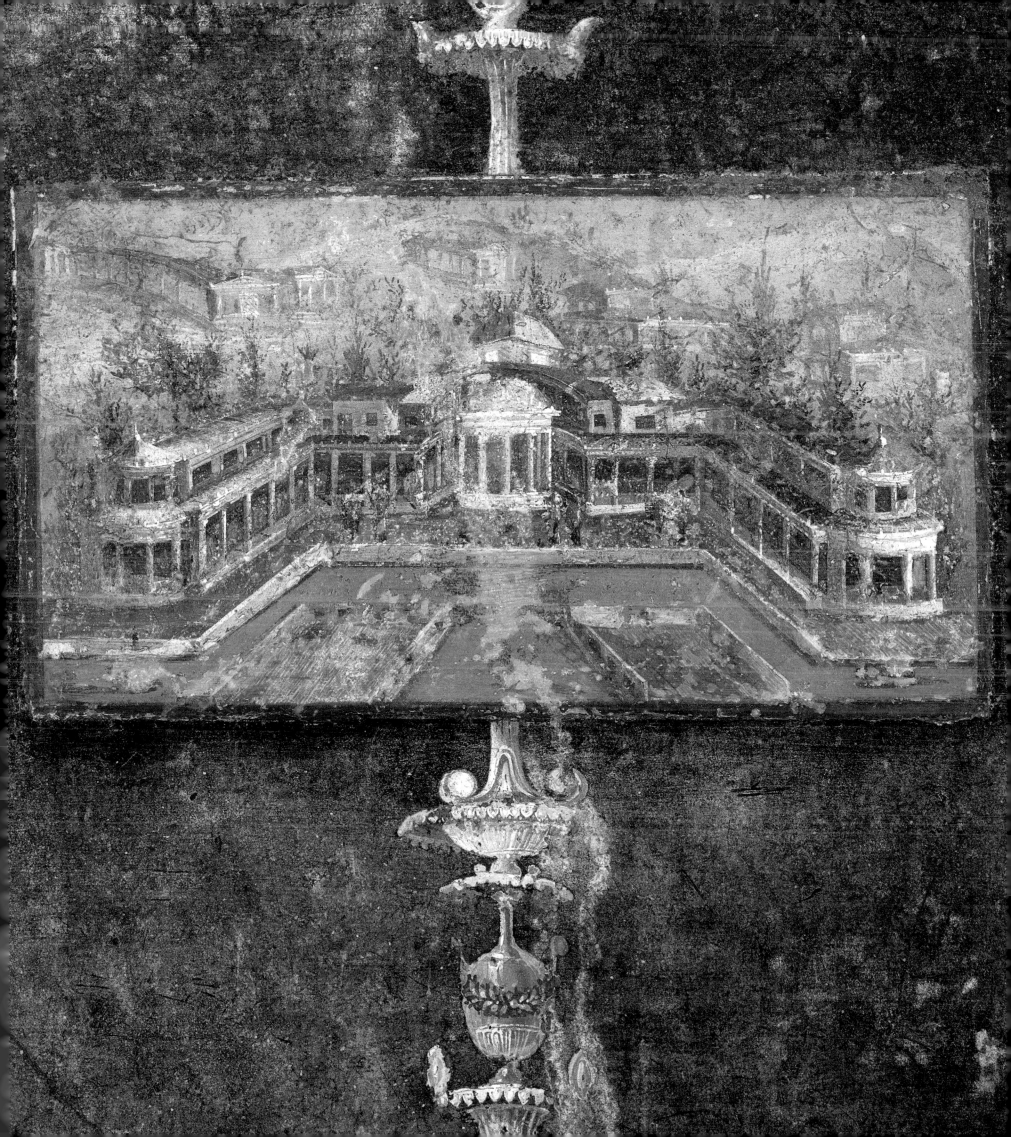

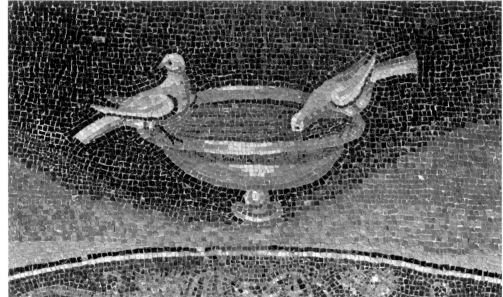

4 (below and right)
PARADISE GARDEN
C. AD 425–450
Mosaic on the left-hand blind arch of the crossing
Mausoleum of Galla Placidia, Ravenna, Italy

To convey the idea of the locus amoenus, *in this case
paradise, it was enough to depict a patch of grass in a
radiant green and a* labrum, *the basin of water typical
of classical gardens, on which two doves have perched.
Such ornamental abbreviations for natural details are
encountered everywhere in Europe, in both sacred and
secular art, up through the high Middle Ages.*

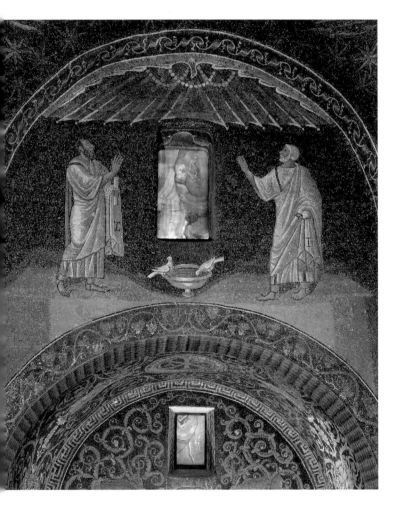

an event by using traditional pictorial signs—representing a *locus amoenus* (or
"idyllic spot"), for example, as a glade with a small stream running through
it and with trees filled with the twittering of birds. Such depictions were not
meant to represent identifiable locations, and in them there was no attempt to
produce accurate renderings of specific plants. To represent a natural setting, it
was enough to draw from a small repertoire of typical motifs. To suggest a gar-
den, for example, a simple *labrum* sufficed, a basin of water with birds perched
on its rim. This motif, already employed for this purpose in Pompeiian wall
painting (plate 2), appears in the mosaics of the so-called Mausoleum of Galla
Placidia in Ravenna, executed between AD 425 and 450 (plate 4). In a picture of
two apostles in the chapel, originally an oratory consecrated to Saint Lawrence
attached to the vanished palace church, the mere symbol of the *labrum* serves
to place them in a paradisial garden. Over and above the ongoing tradition
in which such symbols were employed, in quotations like these the spiritual
dimension of garden pictures from antiquity is still apparent. The well-known
topoi of traditional pictorial language are clearly employed as symbols; in such
contexts realistic depictions were simply not called for.

Medieval Images of the World and of Gardens

Christianity is based on the annunciation of the Word, equated in the
gospel of Saint John (1:1) with God himself. For this reason, those
who adopted this religion of the book tended to see pictures as an

inferior means of communication. At the beginning of the fifth century AD Neilos of Ankyra demanded that, although churches might display a cross at the east end, the side walls were to be whitewashed and kept free of pictures, so that the faithful might simply be moved to reverential contemplation of the brave deeds of the early martyrs, the servants of God to whom such houses of worship were consecrated. A mere two centuries later Pope Gregory the Great would rescind this ban on the introduction of pictures. In a formulation that would be cited through the entire Middle Ages, he decreed that pictures in churches were altogether appropriate, "so that those who cannot read can at least derive from the events pictured on the walls what they would not get from books." But what about praying before pictures? As late as 797, at the Council of Nicea, the proper place of pictures was still being intensely debated, and it was only at a synod in 843 that a final compromise was reached. Henceforth it was perfectly permissible to create expressions of divinity in works of art. Within the bounds of their illustrative and symbolic function, even the veneration of pictures was allowed. No excessive degree of verisimilitude could be attempted, to be sure, and exaggerated illusionism was considered undesirable. From a theological point of view, the use of a pictorial repertoire easily understood by the illiterate layman, one that was quite obviously formulaic (to judge from the surviving works of art), seemed perfectly desirable. But this theological position had little enough to do with the actual use of pictures in the Middle Ages. Religious instruction, like all other verbal communication, was for the most part imparted orally, in sermons and readings aloud from the scriptures. Theologically, it was inferred from this that hearing was superior to the other senses, even sight. Even so, pictures were by no means created solely for the edification of illiterates, as is perfectly apparent from the many lavishly decorated and illustrated manuscripts commissioned by the educated clergy. Pictures might be found in copies of the Bible intended for liturgical use, in gospel lectionaries and pericopes, and especially in psalters, many of which were adorned with highly allusive illustrations at the behest of ecclesiastical and secular dignitaries.

To appreciate how extremely complex medieval pictures could be, one need only study the world map (plate 6), over ten feet tall, from Ebstorf Abbey. Perhaps the most important goal of medieval Christian geography was to contribute to the salvation of souls, and accordingly it placed Jerusalem at the world's center. The "circle of the world," the *orbis terrarum*, was divided by the Mediterranean and its adjacent seas into three segments, Asia occupying the upper half, Europe the lower left, and Africa the lower right. The history of mankind begins with the Garden of Eden and Fall of Man in the east, as is pictured on this map, possibly the most detailed world map from the Middle Ages. The work was created, clearly enough, to illustrate geographical relation-

5
THE FALL OF MAN
end of the tenth century
Miniature from the *Commentary on the Apocalypse* by Beatus of Liébana, fol. 18r
Escorial, Royal Library of San Lorenzo

In the context of the earliest illustrations for Beatus's Commentary, of which nearly the entire series is preserved, this depiction of the Fall serves in place of a map to identify paradise as a specific geographical location. At the same time it marks the beginning of the story of the salvation, predetermined in God's plan for the Creation, the end of which is to come in the Apocalypse described by Saint John.

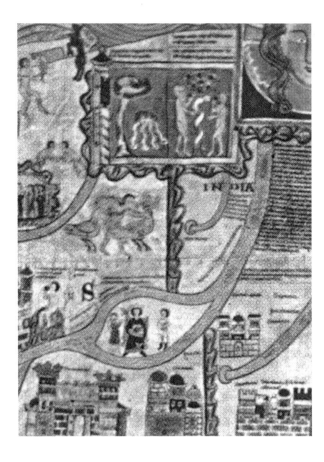

ships, but at the same time to trace the story of salvation. It is a visual expression of medieval notions of history, a worldview in which biblical events could be precisely located in time and space. Following the chronology of the Old Testament, these events are pictured in the spots where they occurred, located on the earth's surface—the stage, as it were, on which history is played out. History is seen extending westward and forward in time from its beginning at the very top of the map, in the east. Events from ancient history as related by classical authors have been integrated into this general progression, secular history incorporated into the story of the salvation. By calculating backward beyond the reigns of the medieval emperors to the founding of Rome, and further by way of the Greek Olympiads back to the reigns of the Jewish kings and to Abraham and Noah, it was possible to determine the exact date of the Creation, namely March 21, 5507 BC. Although this dating as presented in the *Sächsische Weltchronik* (Saxon World Chronicle) was not universally accepted, it was agreed that the Garden of Eden and the Fall of Man belonged to the first age of the world, which came to an end with the Flood. The pictorial narrative on the Ebstorf map carries this chronology forward to the sixth age, namely its own day, as evidenced by the names of cities and contemporary rulers.

The picture of the Garden of Eden marks its physical location and stands for the abstract concept of the Fall of Man, the event with which the history of mankind begins. The images on the Ebstorf map are not merely representations of actual places or events, and certainly not primarily so, but rather illustrations of complex historical and theological arguments. Their graphic blending of representation and symbolism precisely reflects the possibilities of conceptual communication tied to the word. Yet compared to verbal argument, such pictures are far more potent and suggestive, a fact that time and again subjected the medium to theological debate.

By contrast, there was never any doubt about the value of gardening and agricultural work, which had been celebrated by the ancients and were pleasing to God. Any number of documents, the eighth-century Salic Law and Charlemagne's *Capitulare de villis* among them, attest to the great importance of gardens and agriculture in the early Middle Ages. Further evidence is provided by the *Hortulus*, a poem written in the first half of the ninth century by Walafrid Strabo, a monk and later abbot of Reichenau, and by the Plan of Saint Gall, on which the monastery's orchard and medicinal and vegetable gardens are noted with as much care as the buildings themselves. The rule of Saint Benedict, with its doctrinal *ora et labora*, or "pray and work," encouraged the tending of monastic gardens as both a form of contemplation and an ascetic exercise. In his emphasis on gardening, the ancient idea that field work was beneficial to one's health lived on, long before the culture of the High Middle Ages once again created pleasure gardens designed solely for physical

6 (above and opposite)
THE EBSTORF WORLD MAP
c. 1300
Parchment, 141 × 140³⁄₁₆ in. (358 × 356 cm)
(destroyed in World War II)
Protestant Foundation for Women, Ebstorf
Convent, Ebstorf, Germany

At the top, namely in the Far East, the map shows the Garden of Eden surrounded by a turreted wall, in which the Tree of Knowledge, the Fall of Adam and Eve, and the rivers of paradise are all presented.

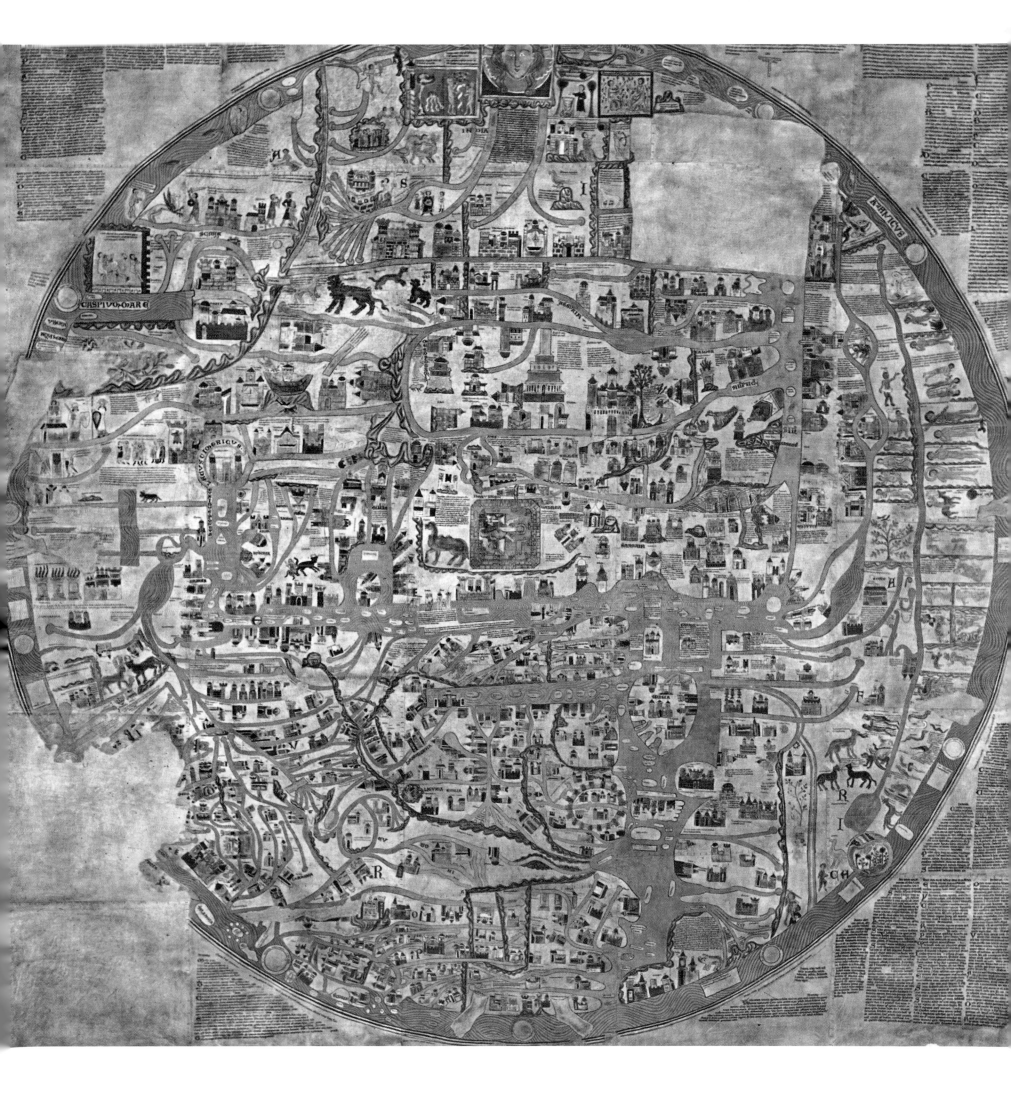

recreation and appreciation of nature. It is documented that a *viridarium*, or pleasure garden, like the one described by the Dominican friar Albertus Magnus in his *De vegetabilibus* from around 1260 (7.1.14), was created at the court of Emperor Frederick II.

Court and Domestic Gardens and the Garden of Love

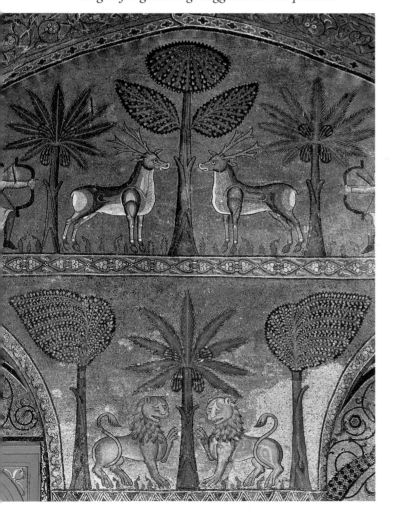

Since antiquity, paintings of gardens employing stylized symbols had served as indications of power and dominion. Among the few surviving examples from the Middle Ages are those executed in the palaces built by the Normans after their conquest of Sicily, occupied by the Arabs until 1061. A first brief description of Palermo's so-called Palazzo Reale, the newly constructed palace of King Roger, dates from 1154. It includes references to "pictures of every kind" and elaborate wall decorations with "splendid pictures" (plate 7). The ruler's palace was meant to seem like a Garden of Eden built of stone. This intent is clearly expressed in an Arabic inscription in the Zisa, one of the smaller of Palermo's Norman palaces. Executed in decorative Naskhi script, it reads: "In this exquisite palace you find the greatest king of the century... here we have glimpses of the earthly paradise." The widespread Arab notion that a ruler should reside in an earthly paradise was upheld in Byzantium as well. Norman Sicily functioned as a cultural melting pot, a place where ideas from the Roman East and the Arab world were blended before being disseminated through the whole of Europe. The image of the garden became a symbol of peaceful dominion that was readily understood and universally shared.

Anyone who pretended to the values of courtly society and wished to demonstrate his exalted social standing had his house decorated with painted gardens. In the patrician palaces of Florence, for example, garden paintings were commissioned as status symbols. Most of these wall decorations have been lost, but fortunately one of the city's medieval palaces still preserves such paintings from the late fourteenth century. It was originally built for the Davizzi family; then in 1578 it came into the possession of the merchant and scholar Bernardo Davanzati, whose name it bears to this day. In one of the opulent rooms on the third floor of the Palazzo Davanzati (plate 8), the lower walls still present illusionistic paintings of tapestries. Above these is a painted arcade, beneath which pairs of courtly lovers are pictured in a garden.

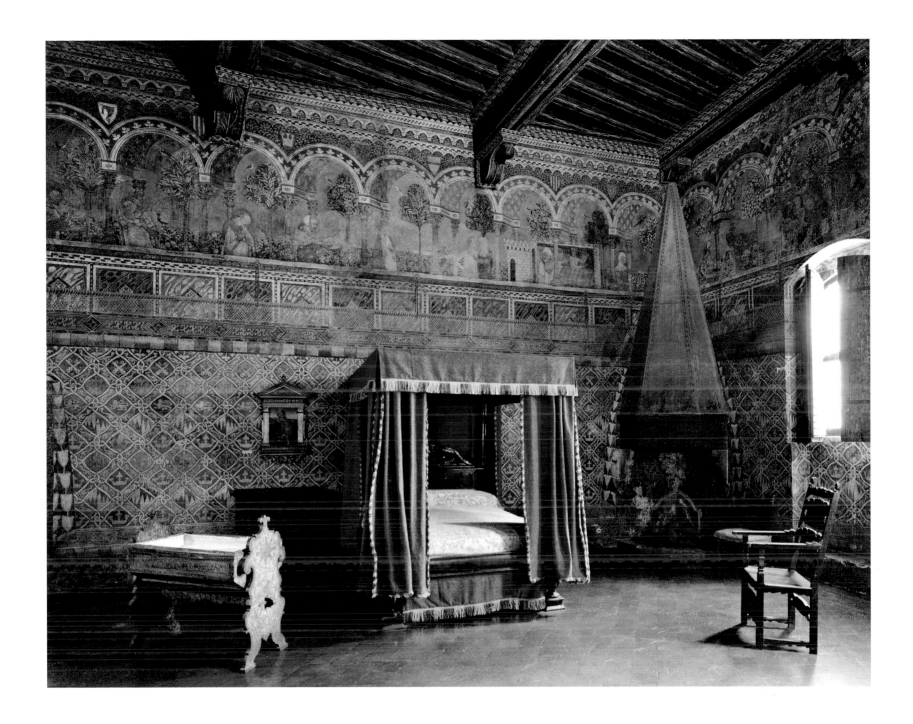

In ancient Rome gardens were consecrated to Venus, the goddess of love, and even after the decline of the ancient world the idea persisted that gardens were especially conducive to lovemaking. The idea took on new vigor in the fifteenth century, especially after the rediscovery of Lucretius's *De rerum natura*, which begins with a eulogy to the supremacy of Venus (1.6f.). In anticipation of marriage it was not uncommon to have the new couple's bedchamber decorated with paintings portraying heroic deeds, exemplary virtues, or wedding rituals and aspects of conjugal bliss set in gardens and landscapes.

The garden pictures in the Palazzo Davanzati were presumably commissioned for just such an occasion. They were meant to be both decorative and

8

COUPLES IN A GARDEN
c. 1395
Fresco
Palazzo Davanzati, Florence

The painted wall decoration depicts couples in sumptuous contemporary clothing engaged in courtly pastimes in a garden beneath painted arcades. In addition to demonstrating the social status of the owner of the palace, the picture illustrates the well-known tragic love story from The Chatelaine de Vergi.

9 (below and opposite)
GARDEN OF LOVE
c. 1490–1500
Miniature from Guillaume de Lorris and
Jean de Meung's *Roman de la rose,* fol. 12v
British Library, London

*The description of the garden, shaded by trees and
threaded with little streams, follows the rhetorical
traditions of the* locus amoenus, *that pleasant glade
celebrated by the ancient poets. In the framework of
the allegorical action of the* Roman de la rose, *the
love garden serves as an ideal setting for music and
a dance in which Courtoisie, the personification of
courtliness, takes part.*

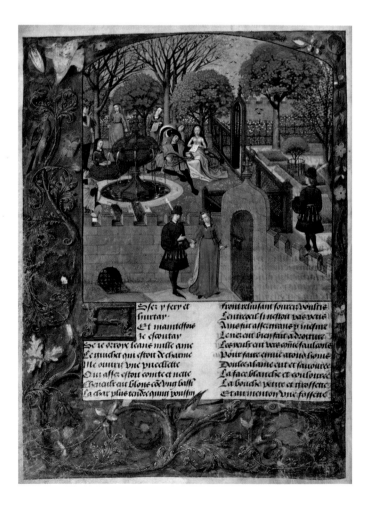

ostentatious, a clear indication of the owner's prestige. And following the
tradition of wall decoration in antiquity, they served to bring the abundant
greenery of the garden indoors for year-round enjoyment. As it happens, they
also narrate the tragic love story from *The Chatelaine de Vergi,* a verse epic
in which a noble lady employs her dog in the exchange of messages with a
knight at the Burgundian court, then along with her lover is driven to sui-
cide by court intrigues. Like the tales from Boccaccio's *Decameron*—whose
framing action happens to be set in a garden—*The Chatelaine de Vergi,* writ-
ten toward the end of the thirteenth century, was among the literary subjects
repeatedly illustrated in wall paintings. Such tales were widely disseminated,
as familiar to the illiterate as to scholars. One might hear recitations of them,
hear them read aloud from manuscripts—many of them richly illustrated—
learn of them through pictures of all kinds, hear them retold in sermons, or
see them performed in religious or secular plays and pageants. Perhaps the
most popular of the era's courtly verse epics was the *Roman de la rose* (plate 9),
and it is certain that its legions of admirers did not gain their knowledge of it
through solitary reading. The poem, whose allegorical figures embody the ide-
als of courtly love, was begun by Guillaume de Lorris before the middle of the
thirteenth century and completed by the cleric Jean de Meung, presumably
between 1268 and 1285. It takes the form of an extended dream vision in which
the narrator goes in quest of the rose, the symbol of his love. A testimony
to the wide dissemination and great popularity of this material is the richly
illuminated manuscript produced around 1500 for Engelbrecht II, count of
Nassau-Vianden, a knight of the Order of the Golden Fleece and governor
of Burgundian holdings in the Netherlands. The text faithfully conforms to
a printed edition of the work, and the sumptuous illustrations were executed
separately in a Bruges workshop. One of these shows the lovers, dressed in red
and blue, arriving at the exquisite garden of Deduit, the very embodiment of
pleasure. They have been led there with the aid of Oiseuse, the personification
of leisure. Nothing that conflicts with the ethic of courtly love is admitted into
the garden; wickedness, hate, greed, envy, and miserliness are banished from
it as surely as are old age and poverty.

The garden of love motif is also found on tapestries—the showiest picto-
rial medium of the time—commissioned by the Burgundian court. There the
theme of love could have political overtones as well. Visions of the peaceful
reign of Venus suggested the return of a realm of lasting peace like the one
prophesied for the progeny of Venus's son Aeneas after he had fled from Troy.
The founding of Rome was given this plausible mythical explanation by Virgil
in his *Aeneid,* which was written to legitimize the rule of Emperor Augustus
and would become a core European text for many centuries to come. As the
progenitor of the *imperium romanum,* Aeneas was considered to be the mythi-

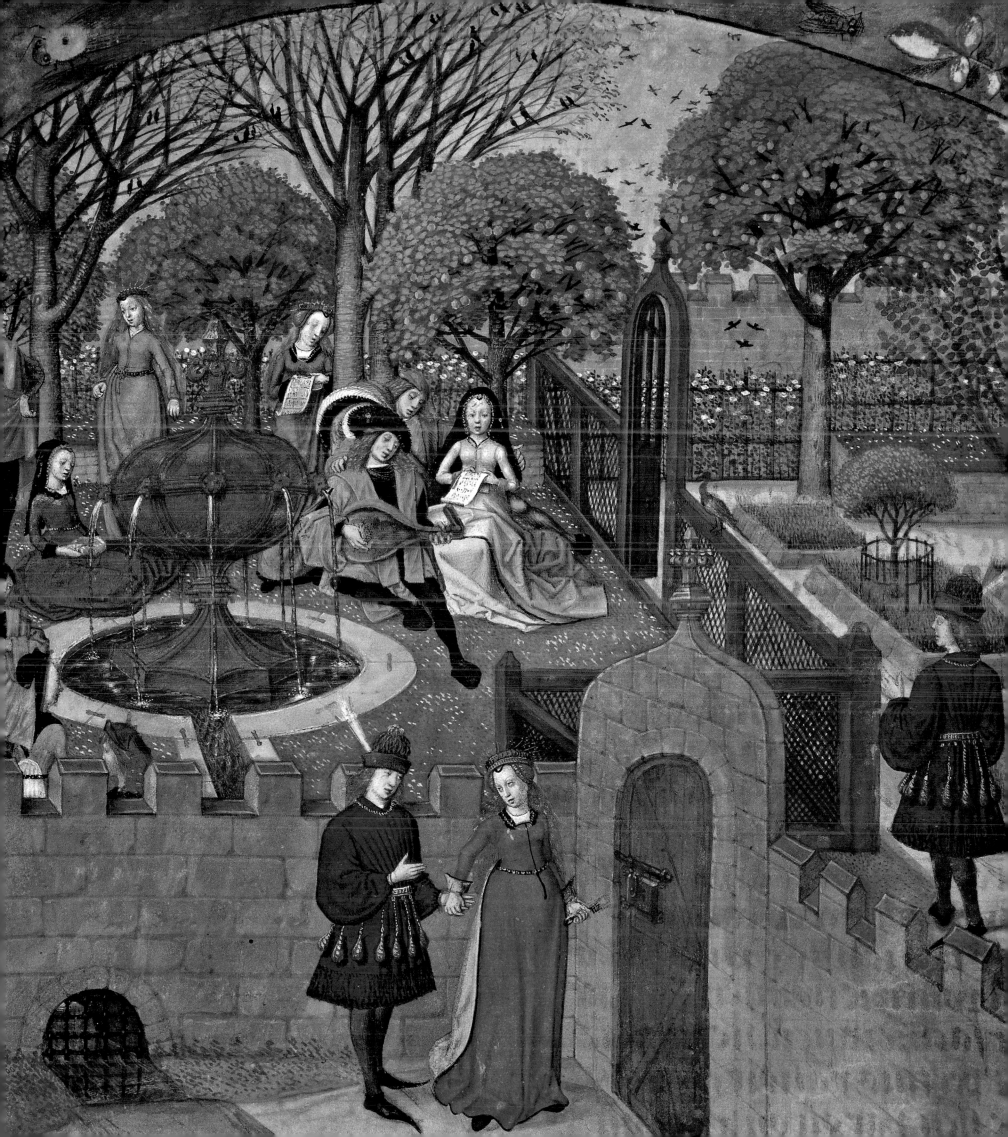

cal forefather of emperors, kings, and popes, who saw themselves legitimized by the pagan myth and avidly propagated it.

Tending to gardens was by now and would long continue to be a favorite activity at European courts. Gardening had been held to be an appropriate form of physical exercise even for members of the upper classes since antiquity. With the rediscovery of much ancient literature, the idea that gardens were the ideal settings for philosophical speculation fused with the monastic tradition of gardening as a form of contemplation to create the new, idealized, secular garden celebrated by the humanists. Petrarch, for example, praises the gardens and surrounding forests of the Vaucluse in his *Vita solitaria* as ideal spots for self-reflection. On his "rambles through the landscapes of the soul," Petrarch enjoyed the imaginary companionship of Augustine, Seneca, Cicero, and Quintilian. His descriptions of gardening and country life are studded with literary allusions, and were greatly influenced by the ideals of ancient aristocrats as reflected in the classics. He recommends moderate exertion in the garden or in hunting as an ideal complement to hours of philosophical discourse and solitary study.

Other indications of the increasing idealization of country life are the many treatises on gardening from this period, some of them elaborately illustrated. All of them point out the health benefits of such activity in addition to the nourishment it provides. Examples are the *Tacuinum sanitatis*, translated from the Arabic, and the *Ruralia commoda* (plate 10) by Piero de' Crescenzi of Bologna. The latter, an agricultural handbook composed in Latin between 1304 and 1309, was an instant success, and was translated into any number of European languages. The translation commissioned by Charles V of France in 1373 was widely disseminated, both in lavishly illuminated manuscripts commissioned by wealthy patrons, and later in a printed edition from 1486. The arrival of comparatively inexpensive printed books meant that instructional texts like these became available to an increasingly broad public, but they failed to satisfy an aristocratic desire for more luxurious copies as evidence of status and wealth. It would be a mistake to dismiss such a demand for exquisitely illustrated and ornamented books as being reactionary, however, for the illuminations in certain manuscripts are among the most progressive and accomplished examples of pictorial art produced in the late Middle Ages. Along with tapestries and the works of goldsmiths, book illustrations were the most important pictorial medium before the gradual rise to prominence of relatively inexpensive panel painting. And the need to surround oneself with luxury articles of all kinds as part of the aristocratic lifestyle, later handily formulated as *noblesse oblige*, was unquestionably the most important stimulus to artistic production and aesthetic innovation for centuries.

10
WORK IN AN INNER-CITY GARDEN
c. 1475–1500
Miniature from Piero de' Crescenzi's
Le Livre de prouffits champestres et rurauls, fol. 165r
British Library, London

The illustration shows various figures at work in an urban herb garden under the supervision of its owner. Its layout and plantings are precisely described. The sumptuously illustrated manuscript was produced at a time when this popular agricultural handbook was already available in numerous printed editions.

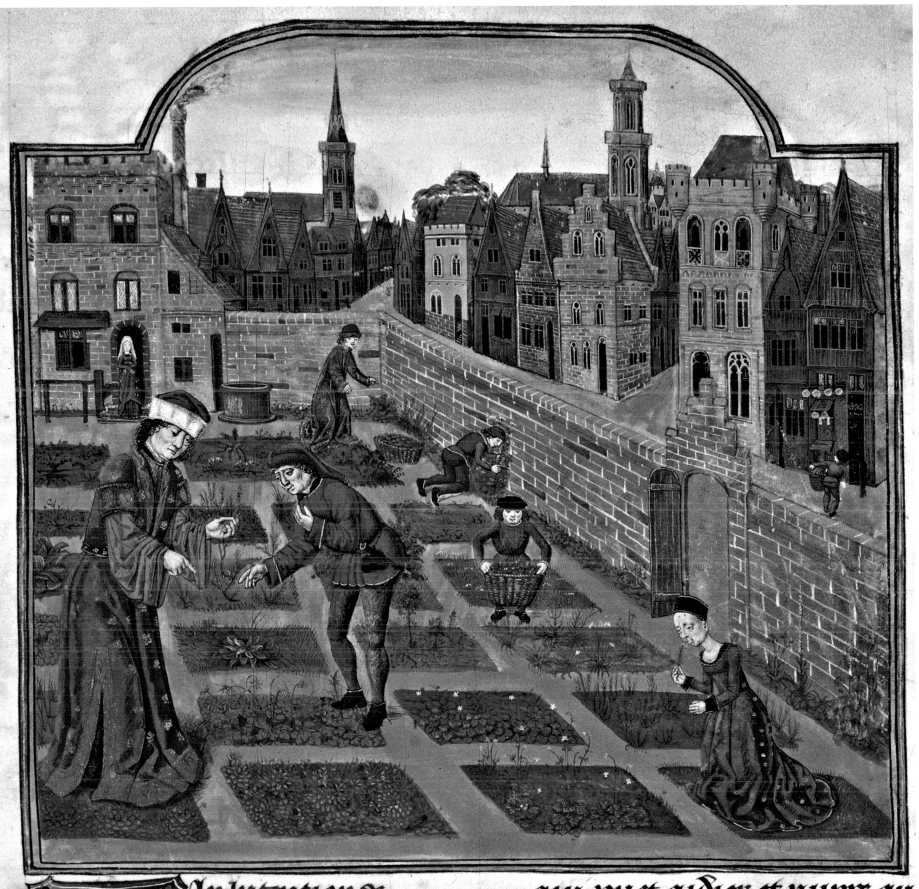

Ay intention de
parler des gar
dins et de lart
de leur labour

gui puet aidier et nupre au
corps Car ce vault par esp
ctal au corps de ceulx gui
demeurent aur champs gui

Visions of Paradise

The majority of medieval illuminated manuscripts were books of hours intended for private devotions, whose contents essentially duplicated the official prayer books of the clergy. The popularity of this genre is evident from numerous surviving examples, some of them lavishly decorated and bound, like the one commissioned shortly before his death in the year 1416 by Jean de France, duc de Berry, one of the most important art collectors and patrons of his time. Of the fifteen books of hours in his collection, the so-called *Très Riches Heures* (plate 11) are the most famous to this day. The manuscript's depiction of Paradise, including the Fall of Man and the expulsion of Adam and Eve, does not accompany any specific text, nor in the context of the manuscript was it meant to illustrate the book of Genesis. The remarkable picture appears on the verso of a blank page, across from a depiction of the Annunciation to the Virgin, the opening image from the office of the Blessed Virgin that is central to all books of hours. The result is a revealing juxtaposition of scenes that can be interpreted as conveying a complex theological message. For just as the gate of the Garden of Eden was closed forever by the temptation of Eve, through the Annunciation to the new Eve, the Virgin Mary, Eve's name and fate were forever redeemed. In the words of the office for Sext: "Through Eve the gate was closed to all, and through the blessed Virgin it was opened again."

The pictures in books of hours were meant to lend immediacy to the texts beyond their theological lessons and inspire meditation and mystical contemplation. The *Garden of Paradise* (plate 12), painted at the beginning of the fifteenth century and unique in the art of its time, is an image unquestionably associated with late medieval piety and private devotion. Its composition makes it clear that it was conceived as a single panel from the start. It depicts a *hortus conclusus* surrounded by a battlemented wall, intended to be read as the enclosed garden symbolizing Mary's virginity. This serene spot closed off from the outside world is filled with lush foliage and flowers. All the plants and animals are painted with extreme accuracy, so that it is possible to identify the various plants, twelve kinds of birds, and even a number of insects. The plants symbolize timelessness, for all are in full bloom at once: peonies, lilies, lilies of the valley, carnations, columbines, and primroses. The figures of saints, not all of which can be identified, are amusing themselves in ways that reflect the courtly ideal, and in fact the *Paradise Garden* appears to have been patterned not so much after the biblical Eden as the courtly garden of love, which as a *locus amoenus* becomes a symbol of heavenly love. Nothing illustrates the idyllic nature of the picture more vividly than the little dragon, scarcely larger than

11
Limburg Brothers (?)
Garden of Eden
c. 1410/16
Miniature from the *Très Riches Heures* of the duc de Berry, fol. 25v
Musée Condé, Chantilly, France

The depiction of paradise placed on an unlined sheet of parchment presents a vision of a garden in the ideal shape of a circle and protected by a golden wall. In accordance with the period's sense of luxury, the architectural details are patterned after courtly goldsmithing.

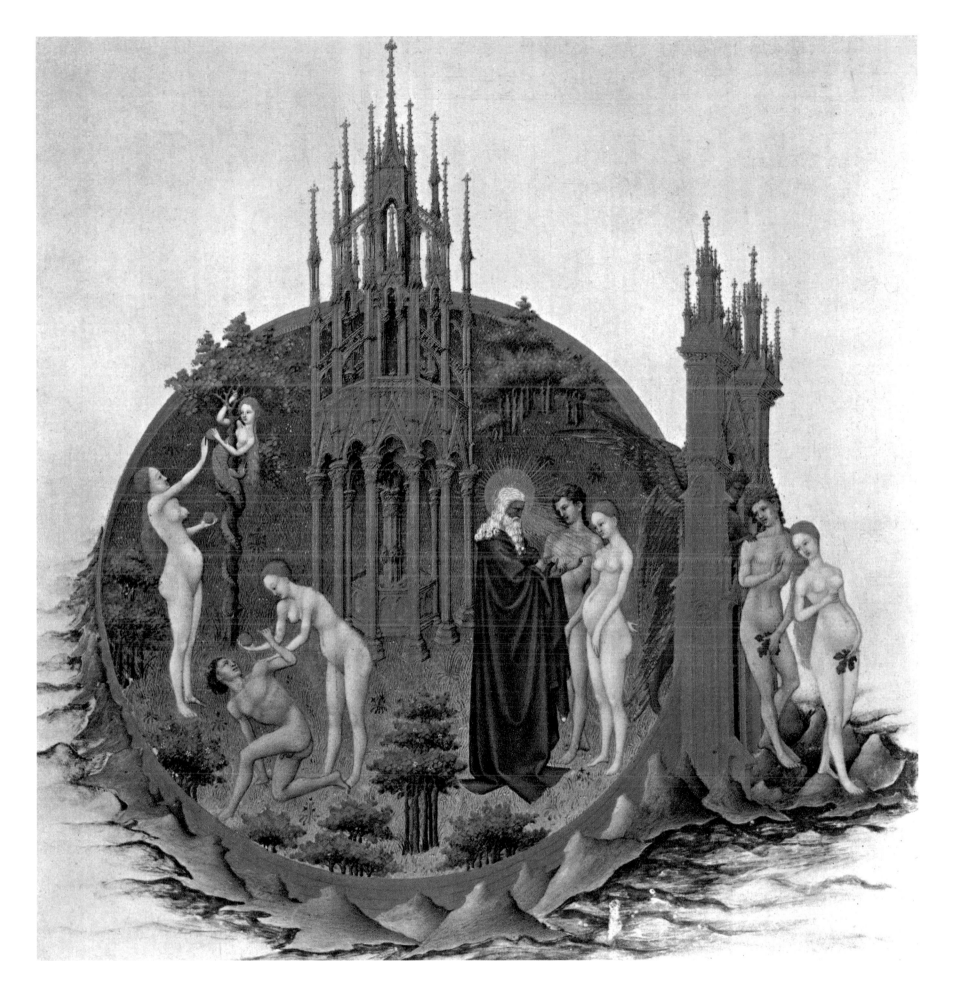

12 (above and opposite)
Anonymous, Upper Rhine
GARDEN OF PARADISE
c. 1410–20
Oil and tempera on wood, 10⅜ × 13⅛ in.
(26.3 × 33.4 cm)
Städelsches Kunstinstitut, Frankfurt

This small painting was intended for viewers who could only imagine the blessed consorting with saints in a manner reflecting the courtly conventions of their own time.

Details on pages 5 and 39

a dachshund, that serves as an attribute for Saint George. Possibly the most pitiable dragon in Western art, it is lying, quite dead, on its back. It is hardly a coincidence that it is couched in a patch of periwinkle, according to ancient popular belief a potent defense against evil. Everything in the picture can be interpreted in light of the Christian message of the salvation. Yet quite aside from its theological import, a picture like the Frankfurt *Garden of Paradise* also appealed to viewers as a work of art. The wealth of detail so skillfully worked into this depiction of an imaginary place would not have been required simply to illustrate an article of faith; it invited careful study and provided viewers with the delight of seeing familiar features of the world around them compressed into a charming picture.

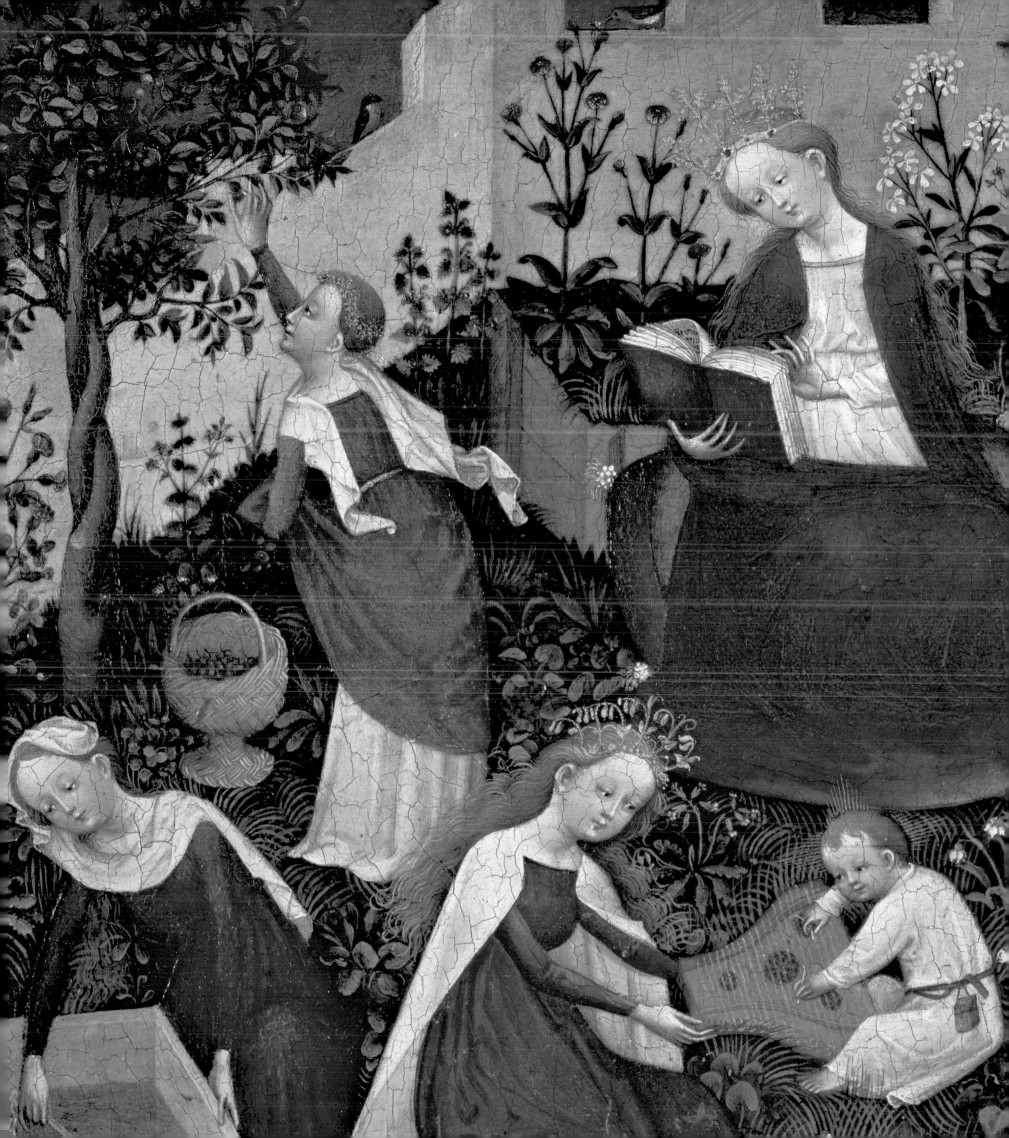

13 (Detail from page 42.)
Stephan Lochner (c. 1400–1451)
MADONNA IN THE ROSE BOWER
c. 1450
Oil and tempera on oak panel, 19¹³⁄₁₆ × 39¹¹⁄₁₆ in.
(50.4 × 39.8 cm)
Wallraf-Richartz-Museum, Cologne, Germany

*The grassy bank and rose arbor define the sphere of
the Madonna. They can also be read as an abbreviated* hortus conclusus, *whose seclusion seems further
underscored by the punching in the gold ground.*

The Enclosed Garden

To judge from the surviving examples, the most popular devotional pictures of the waning Middle Ages were clearly those featuring Madonnas in idyllic gardens. A beautiful example of this pictorial type found all over Europe is the *Madonna in the Rose Bower* (plate 13), attributed to the Cologne painter Stephan Lochner. The painting, executed around 1450, is conceived as a piece of theater, in that two angels are seen drawing aside a curtain of exquisite gold brocade to reveal a glimpse of heaven. At the very top edge of the picture are the figures of God the Father and the dove of the Holy Ghost. Beneath them the Madonna, crowned as Queen of Heaven, sits enthroned, surrounded by angels. The ground at her feet is thickly dotted with violets, daisies, and strawberries. The wealth of flowers hints at the splendor and abundance of the vegetation in paradise. Moreover, the individual flowers and plants are executed with extreme fidelity to detail, and can be understood as symbols suggesting various interpretations. The rose, for example, is a common symbol for the Virgin. According to legend, its thorns appeared only after the Fall of Man, and in the Middle Ages it stood for love as well as for the death and resurrection of Christ. In medieval allegorism, the interpretation of the holy scriptures above and beyond their literal meaning, the rose could invite any number of other constructions relating to Mary based on its beauty, its scent, and its evanescence. Multiple meanings also attached to the lily, after the rose the most frequently pictured flower in Christian art. As early as the time of Saint Ambrose (2.393f.) the lily was already an established symbol for Christ. In depictions of the Last Judgment it symbolized the spiritual authority that qualified him to judge who should be saved. Because of its whiteness, signifying purity, it served as a symbol of Mary's virginity, referred to, borrowing from the Song of Solomon (2:2) as a "lily among thorns." In Lochner's picture the brooch Mary wears presents a tiny image of the Virgin with the unicorn in her lap, an allusion to the immaculate conception that underscores the picture's central message.

In order to produce a plausible picture of the sphere of heaven, Lochner relied on such precious materials as gold, crimson, and azure. The *Garden of Paradise* (plate 12), executed several decades before the *Madonna in the Rose Bower*, made do with an azure sky instead of a gold ground. Neither solution is necessarily more "modern" than the other; both were employed in an attempt to represent the virtually unimaginable splendor of heaven in a convincing picture. The same desire is evident in a picture by Jan van Eyck, a painter greatly admired by his contemporaries for his realism, from roughly the same time as Lochner's work. In his so-called *Madonna at the Fountain* (plate 14) he portrays

the Madonna, nearly filling the picture space, standing in a rose garden. Like the fountain in the foreground, resembling the work of a goldsmith, the length of brocade with gold embroidery behind the Madonna lends a sense of utter luxury. The cloth is supported by angels, whose wings shimmer with the colors of the rainbow and who claim for themselves the same degree of reality as everything else in the picture. Earlier art historians argued that van Eyck's extreme realism served to desacralize the main figures, but in fact it makes them especially believable. It is not that the painter meant to bring the heavenly vision down to earth. This is evident from the fact that he took up the Byzantine image of the Maria Elousa, in which the infant seated on the Virgin's arm nuzzles against her cheek. The garden extending to the back behind a hedge of roses also evokes the *hortus conclusus* and the paradisial garden of the Song of Solomon (4:12), which is also suggested by the brass fountain crowned with a lion. With it he alludes to the passage, later applied to Mary, reading: "The fountain of gardens: the well of living waters" (4:15). It is this *fons hortorum*, which could also be understood as the bourne of life, that is here intended.

Everything that van Eyck included in his *Madonna at the Fountain* could be explained and at the same time interpreted following the principles of exegetics. This fourfold interpretive method was based on the medieval notion that each word, the *vox* or *significans*, meant only one thing, the thing it named. This literal meaning originated with man, in that it was Adam who gave things their names. On the other hand, as Thomas of Aquinas argues in his *Summa Theologiae* (pt. 1, qu. 1, a. 10), the thing created by God, the *res*, has many different meanings. For inasmuch as God himself wrote the book of Creation, the meaning of things was God-given. Building on this idea, Western theology early on developed doctrines of multiple textual meanings, which culminated in the often-cited mnemonic regarding the fourfold sense of scripture: "The literal sense tells what happened; the allegorical what you should believe, the moral how you should act, the anagogic what you should strive for." According to this concept, which was also taught by Saint Augustine, a word in the historical sense stands for the thing named, or more precisely, in accordance with the Latin *res*, both the thing and the situation. Next there is the allegorical sense, which places that meaning in the context of the salvation. Third comes the moral or tropological sense (from the Greek *tropos*, or "manner"), the meaning of the thing for the individual soul in this world. Finally, there is the fourth, or anagogic sense (from the Greek *anago*, "to refer"), which is oriented toward the hereafter.

Such fourfold interpretation of scripture could also be applied to pictures, such that, for example, the garden in van Eyck's *Madonna at the Fountain* signified in the historical sense the concrete setting for the sacred figures. According to this literal approach, paradise conceived as a garden referred to a concrete

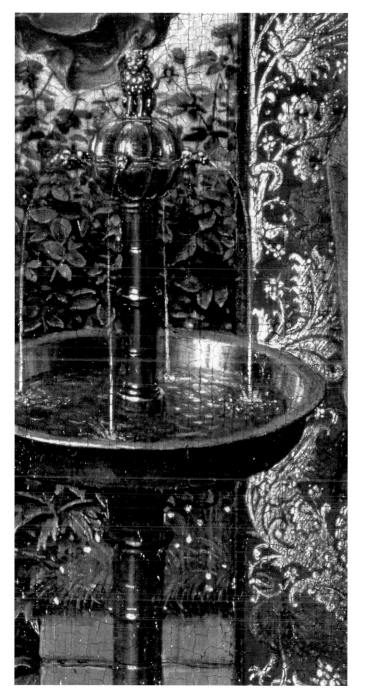

14 (Detail from page 43)
Jan van Eyck (c. 1390–1441)
MADONNA AT THE FOUNTAIN
1439
Oil on wood, 9¾ × 7⅛ in. (24.8 × 18.1 cm)
Koninklijk Museum voor Schone Kunsten, Antwerp

On the frame, in pseudo-Greek letters, is van Eyck's motto: ALS IXH XAN. *This "best I can" appears to have been added as a kind of litotes, or deliberate understatement, intended to heighten the viewer's appreciation of the painting's extreme fineness, its virtually indescribable wealth of detail, and its extraordinary realism.*

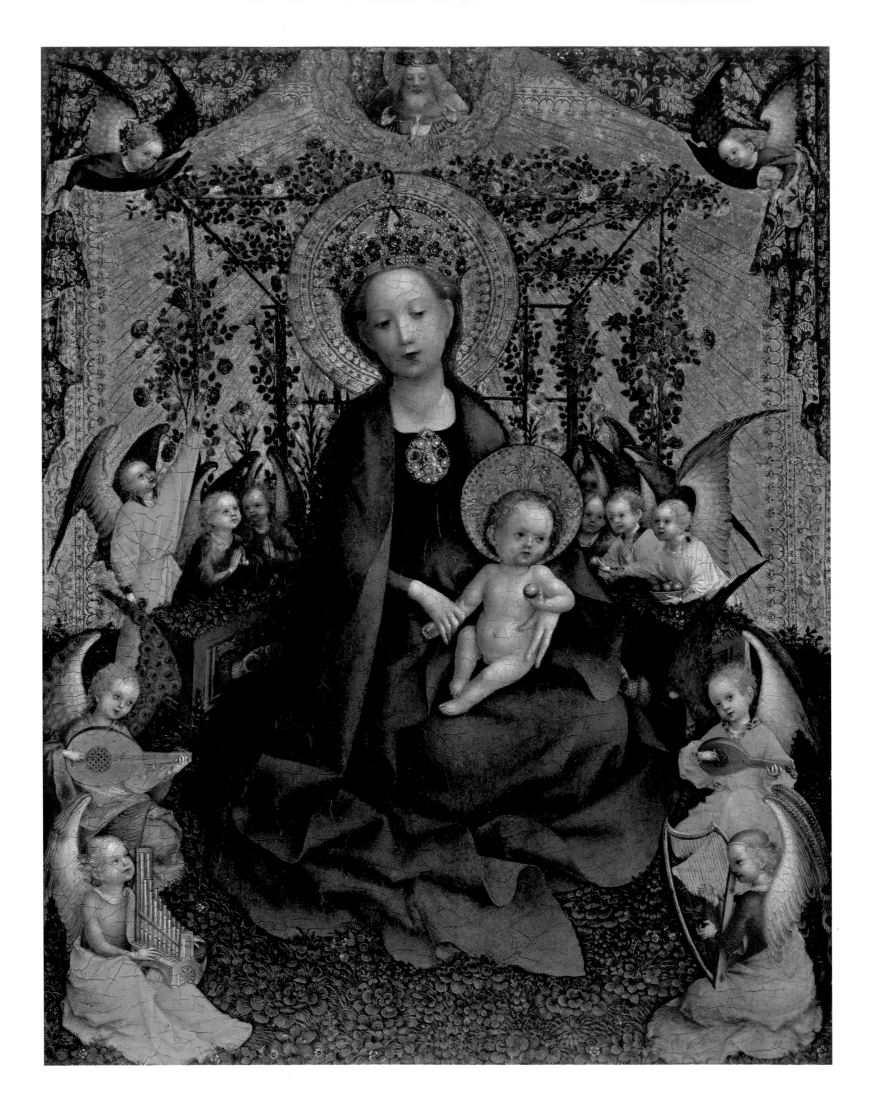

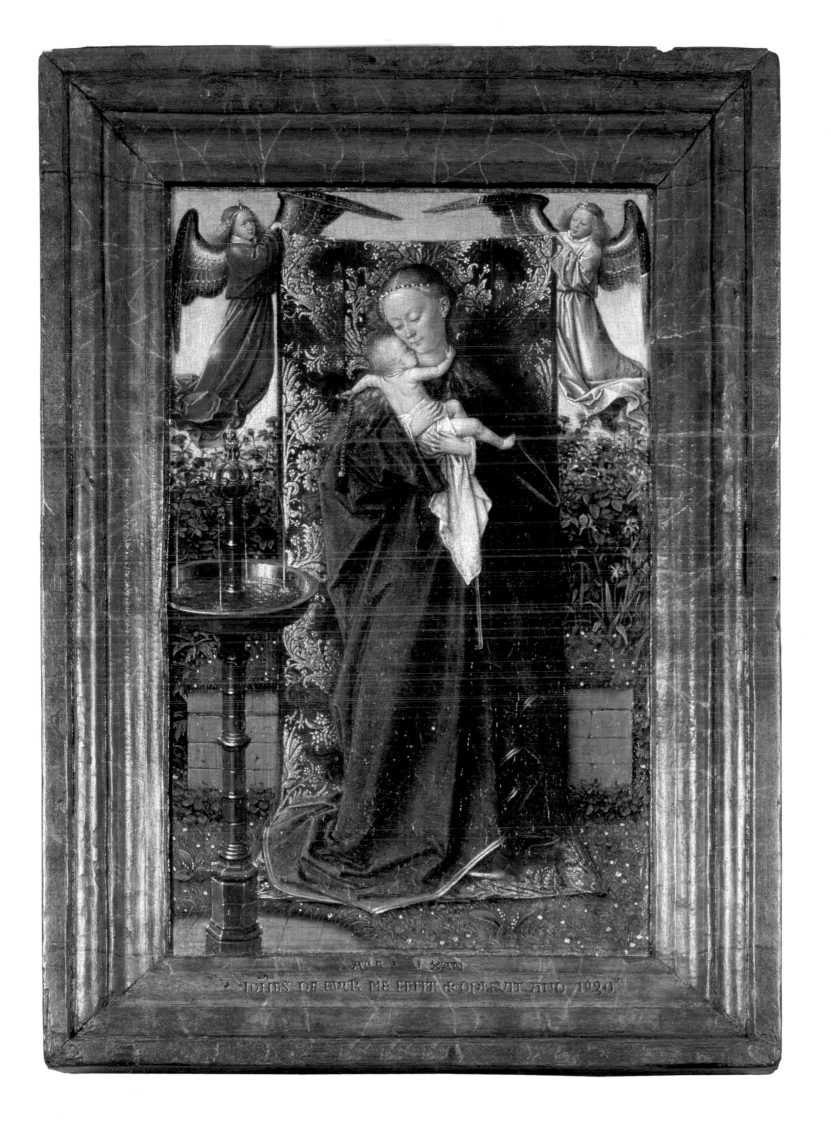

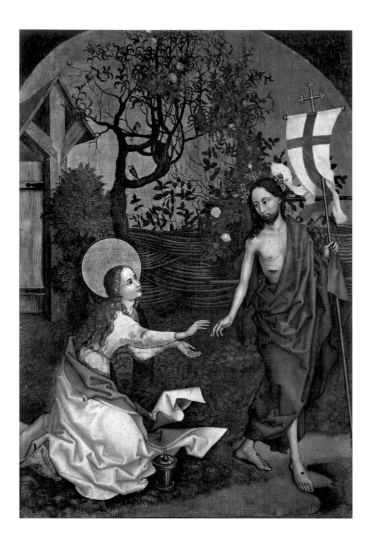

15
Martin Schongauer, workshop (c. 1430–1491)
Noli me tangere
c. 1475–80
Portion of the center panel of the former high-altar
retable from the Dominican church in Colmar
Oil and tempera on wood, c. 45¹¹⁄₁₆ × 34 ¼ in.
(116 × 87 cm)
Musée d'Unterlinden, Colmar, France

*It was most important that an altarpiece's individual
panels be legible. In their compositions the central
figures and actions were carefully emphasized. Six
of the altarpiece's twenty-four scenes are set in a
garden. Wherever the biblical narrative specifies the
setting, as in Mary Magdalene's encounter with the
risen Christ, it is suggested by a woven fence.*

historical location identifiable on a map. In the allegorical sense, the garden could stand for paradise per se, or—with a nod to the Song of Solomon's "My sister, my spouse, is a garden enclosed, a fountain sealed up" (4:12)—stand for the Mother of God. Moreover, like "Jerusalem," a common synonym for paradise, the garden could also be interpreted as an allegory of the church. Tropologically, i.e., with regard to the life of the individual, the garden could stand for the soul of the faithful, and anagogically, could stand for the paradise of heaven. Over the course of the Middle Ages this exigetical method was increasingly applied to secular content, and ultimately used to produce new spiritual or secular texts. Thus allegorism gradually achieved the status of a universal interpretive method.

The term *disguised symbolism* has become accepted in art criticism to characterize the countless symbolic implications of the motifs so realistically presented in the paintings of Jan van Eyck and other painters of his time. The formulation is unfortunate, for it mistakenly suggests that pictures contain hidden, or secret, meanings. Allegorical thinking, that is, thinking in comparable images and symbolic allusions, was widespread in the Middle Ages. There is no question but that a certain amount of knowledge was required to understand the symbolic content of such pictures; however, their symbolism was by no means "disguised." Many pictures of this kind could be seen in public places such as town halls as well as in churches.

One of the most impressive altarpieces of the late Middle Ages once adorned the high altar of the Dominican church in Colmar. It was painted in the workshop of Martin Schongauer, probably between 1475 and 1480, and in the nineteenth century it was sawed into pieces (plates 15, 16). The twenty-four surviving panels suggest that the original work was nearly ten feet high and thirty-six feet wide when fully opened. Inside, in front of a splendid gold ground, were pictures of Christ's Passion. On the outside, visible when the wings were closed, were seven scenes from the legend of the Virgin and the childhood of Christ. The sequence begins with a depiction of *The Mystic Hunt* (plate 16), in which the interplay of the individual pictorial elements serves to visualize the immaculate conception of the Virgin. An allusion to the "garden enclosed" of the Song of Solomon, the setting itself is a symbol of virginity. At the same time, the *hortus conclusus* could also be associated with the closed gate in the prophecy of Ezekiel (44:1f.). The enclosed garden thus became an allegorical prefiguration of the birth of the Savior, further expressed in the image of the mystical hunt of the unicorn. In the *Physiologus*, an early Christian compendium of animal symbolism, the unicorn is already equated with Christ, who "made his home in the womb of the truly virginal Mary, the mother of God, and the word was made flesh and dwelt among us" (John 1:14). The *Physiologus* described the unicorn as a small animal, similar

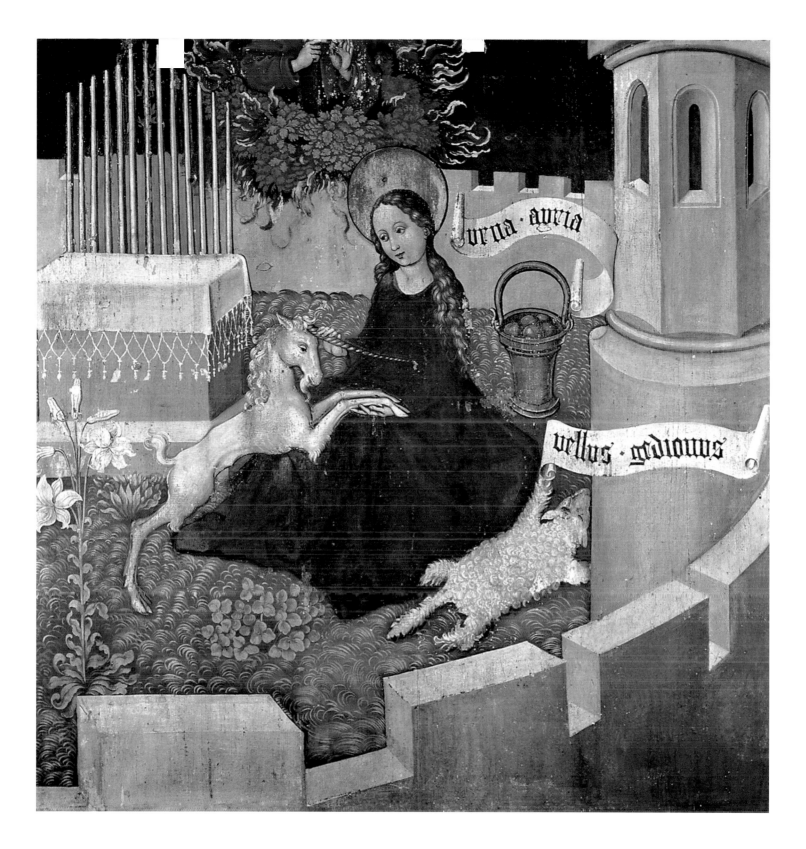

16
Martin Schongauer, workshop
THE MYSTIC HUNT
c. 1475–80
Portion of the center panel of the former high-altar retable
from the Dominican church in Colmar
Oil and tempera on wood, c. 45¹¹⁄₁₆ × 45¹¹⁄₁₆ in. (116 × 116 cm)
Musée d'Unterlinden, Colmar, France

The enclosed garden, traditionally a symbol of Mary's virginity, is here filled with other symbols as well. In the legend of the mystical hunt the unicorn, captured resting in the lap of a virgin, stands for the Passion of Christ.

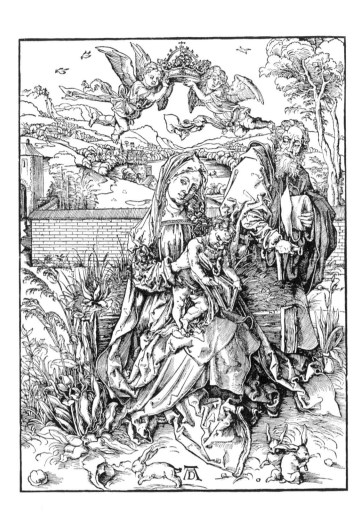

17
Albrecht Dürer (1471–1528)
THE HOLY FAMILY WITH THREE HARES
1498
Woodcut, 15½ × 11¼ in. (39.5 × 28.5 cm)

to a young goat, but with a single horn in the middle of its head. It might be captured by seating before it a chaste, exquisitely dressed woman, whereupon it would leap into her lap. Based on this conceit, later taken up by the church fathers, the late Middle Ages developed a rich repertoire of allegorical imagery like that in Schongauer's painting, until the Council of Trent classified the mystical unicorn as an inappropriate motif and forbade depictions of it.

In the Colmar retable the notion of the virgin birth is expressed in other motifs as well. There is the lily, for example, a symbol of innocence and purity, and accordingly the immaculate conception, to which the golden vessel and the fleece refer as well, recalling a story from the book of Judges (6:36–40). The fleece was seen, like the passage in Numbers (17:17–24) to which the altar in the painting alludes, as a prefiguration of the virgin birth. Schongauer's compositions were widely disseminated in the form of prints. Long before significant numbers of books were being printed, prints of pictures were produced and sold in great quantites. The fact that pictures were created after pictures, then to serve as patterns for still other pictures, led to the standarization of the pictorial vocabulary and assured that visual motifs and their allegorical meanings were widely understood. In this process perhaps no other artist had such a lasting influence on his contemporaries, thanks to the distribution of his pictorial ideas in prints, as Albrecht Dürer. Widely admired for his naturalism, Dürer took up the motif of the garden again and again (plate 17).

One of the most common mistakes made in dealing with pictures from early modern times is assuming their considerable realism to be an indication that no symbolism was intended, or that they are in fact anti-allegorical. As it happens, since the Middle Ages the practice of allegorism, the search for interpretations and symbolic meanings, was based on a precise knowledge of the composition and peculiarities of things. In it every object, owing to its various attributes, could serve as a symbol for several different things at once, or even allude to various things thanks to a single peculiarity. The practice of allegorism was nourished by encyclopedic works like Bartolmaeus Anglicus's *De proprietatibus rerum* (On the order of things), written before 1240 and reprinted up until the seventeenth century. Although they cataloged multiple associations that might be made for a given object, these books were not prescriptive; they did not provide anything like a restrictive code of fixed meanings. The sheer diversity of possible meanings enhanced the possibilities of pictorial communication, and beginning in the late fourteenth century it contributed to the gradual development and acceptance of realistic pictures of the kind painted by Jan van Eyck. Needless to say, the contemporary public also contributed to this development; dazzled by the skill with which artists might emulate reality, it began taking an interest in illusionistic pictures and their painters.

Pictorial Rhetoric

The importance accorded to the medium of the picture by Europe's intellectual elite is particularly reflected in the writings of Leon Battista Alberti. Alberti published treatises on any number of subjects: philosophy, poetry, the writing of history, the natural sciences, and technology, as well as the fine arts. At the beginning of his career he produced his treatise on painting, which was published in Latin in 1435 and which he translated into Italian the following year. This was followed by a treatise on architecture, published in 1451/52, and a book on sculpture, completed around 1464. Alberti's distinctions between the art mediums and a growing general awareness of the picture's special qualities left behind the thinking of the Middle Ages, to which any distinction between two- and three-dimensional images was altogether foreign. The precedent and model for a genre-based theory of art was Vitruvius's work on architecture, the only major treatise of its kind from antiquity. The mere fact that Alberti produced his treatise on painting at the beginning of his writing career, long before he turned to architecture, indicates the importance attributed to painting at the time and to the medium of the picture per se.

Alberti's treatise on painting was intended to create a new respect for the art and the artists engaged in it. As a means to that end, he applied to pictorial art the ancient theory of poetry and the rules of rhetoric, thereby giving it new stature as a form of communication equivalent to the written word. In his *Ars poetica*, the Roman poet Horace coined the phrase *ut pictura poesis*—a poem should be like a picture (361). Based on that maxim, intentionally misunderstood by painters and art theorists, the reverse doctrine gained currency; namely, that what was true of pictures was true of poetry as well: a painting should be like a poem. Paintings should not only be skillfully made but also conceived as art, and be simultaneously pleasing, instructive, and evocative, so as to be as convincing as possible and inspire moral thoughts and actions. As he placed such high demands on painting, Alberti failed to discuss in his earliest treatise painted gardens and landscapes; to his thinking they could only serve as background for the *historia*. He does mention gardens in his later work on architecture, *De re aedificatoria*. There he characterizes architecture as an intellectual discipline and a social art, inasmuch as ideal architecture reflects the social and political organization of the state. Along with references to such technical building issues as suitable ground plans, proportions, and column orders, he also includes hygienic considerations, for like the ancients Alberti was of the opinion that the proper design of living spaces was essential to a healthy life. Accordingly, a dwelling should always have "delightful gardens

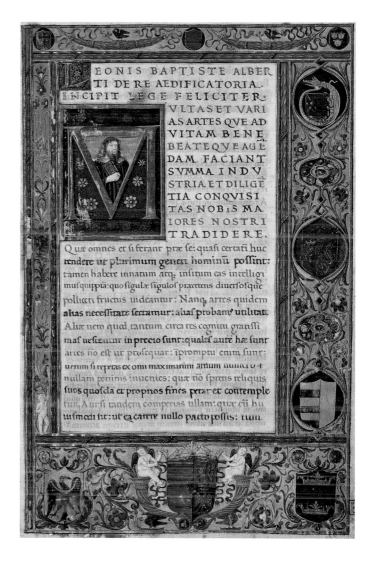

18
Leon Battista Alberti (1404–1472)
De re aedificatoria, Florence, after 1450, fol. 1
Biblioteca Estense, Modena, Italy

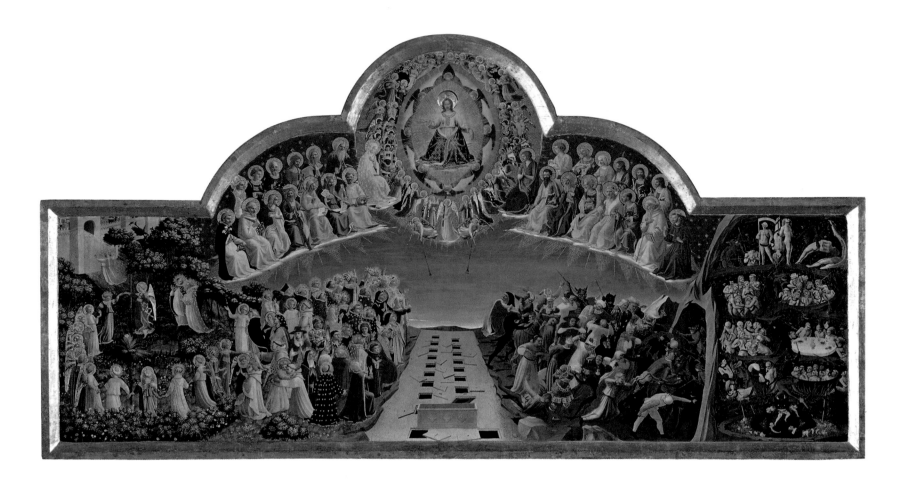

19 (above and opposite)
Fra Angelico (1387–1455)
LAST JUDGMENT
1432–35
Tempera on wood, 41⁵⁄₁₆ × 82¹¹⁄₁₆ in.
(105 × 210 cm)
Museo di San Marco, Florence

*The saved dance in a circle on a tree-studded meadow
ringed with low shrubbery. The meadow takes the
form of the* locus amoenus, *traditionally understood
as a symbol of paradise.*

and plantings and a garden portico, in which one can seek out the sun and
also the shade." It is worth noting that following classical notions Alberti not
only saw actual gardens as ideal places for physical and spiritual refreshment,
he found that similar benefits might come from the contemplation of painted
gardens and landscapes. For "gazing at the loveliness of a painted landscape, at
harbors, fishing and hunting, bathing, country folk at play, flowers, and foliage,
cheers the mind . . . looking at paintings of gushing springs and little streams
is particularly beneficial to anyone suffering from fever." Alberti found such
depictions appropriate in the context of garden design "because [they] are
the most charming by far"; for the decoration of public buildings and for the
residences of distinguished personages, however, he recommended narrative
pictures, which should be patterned after "paintings and literary works" treat-
ing exalted subjects.

Between 1432 and 1435, at about the same time that Alberti was compos-
ing his thoughts on painting, the Florentine painter Fra Giovanni da Fiesole,
later known simply as Fra Angelico, was painting his *Last Judgment* (plate 19).
This painting in the church of the Camaldulensian monastery Santa Maria
degli Angeli in Florence is among the many works mentioned with admira-
tion by the painter's biographer Vasari in 1550. The top of the horizontal pic-
ture has a trefoil shape, and in the center arch Christ sits enthroned in heaven

as World Judge, surrounded by a gloriole of angels. To his left and right are double rows of saints, along with Mary and John the Baptist as intercessors. The depictions of angels waking the chosen with their trumpets follow the description of the Last Judgment in the gospel of Saint Matthew (24:31). And as in Matthew (25:31–33), the blessed are being separated from the damned: "And when the Son of Man shall come in his majesty, and all the angels with him, then shall he sit upon the seat of his majesty. And all nations shall be gathered together before him, and he shall separate them from one another, as the shepherd separateth the sheep from the goats: And he shall set the sheep on his right hand, but the goats on his left." A double line of graves stretching in perspective toward the horizon divides the lower portion of the picture into two halves, serving to underscore this separation. At the same time, this use of central perspective lends breadth to the picture space. On the right the damned are being driven into a dark abyss by the devil's minions, but on the left representatives of all social classes are seen dancing in a circle. An angel is leading them across a carefully tended, idyllic meadow, closed off at the back by a wall. This is an abbreviation of the heavenly Jerusalem described in Revelation (21:12–14). Here at last stands the open *porta coeli,* the gate of heaven, out of which a gleam of light falls onto the meadow. Both in art and in popular collections of *exempla,* heaven—conceived as the New Jerusalem—takes the form of a group of splendid buildings or a church, just as church architecture was thought to provide an image of heaven. Fra Angelico enhanced this motif by combining it with the new Garden of Eden in the form of the meadow.

Art theorists, drawing on the rules of rhetoric, dealt with the effect pictures have and discussed the possible emotional responses to a pictorial representation as compared to those demanded from a good speech. Thomas of Aquinas had already insisted that pictures on Christian subjects should not only provide instruction but at the same time contribute to a "stirring of devotional fervor." A long ecclesiastical tradition even considered pictures superior to texts as tools in the propagation of the faith. As William Durandus insisted in his *Rationale divinorum officiorum* (1.3.4) from 1286, the spirit is moved far more by the contemplation of a picture than by the written word. To illustrate the joys of heaven in the *Divina commedia,* composed between 1307 and 1321, Dante created the image of a sea of light. Fra Angelico relied on the expressions and gestures of his figures, which he rendered with minute precision. This was what earned him the highest praise from Vasari, who marveled at the painter's moving facial expressions, the consciousness of sin and wrongdoing visible in the faces of the damned and the utter bliss illuminating those of the saved.

Pictures appealing to the viewer's feelings by way of the emotions depicted were in demand as altarpieces, of course, but also within the framework of private devotions. And because of all the subjects associated with the Passion, the

20
Sandro Botticelli (c. 1445–1510)
CHRIST ON THE MOUNT OF OLIVES
1500–1504
Tempera on wood, 20⅞ × 13¾ in. (53 × 35 cm)
Cathedral, Capilla de los Reyes, Granada, Spain

Botticelli's picture is more than a mere illustration of Christ in Gethsemane. Thanks to details like the sarcophagus and the burgeoning olive trees, the garden setting is essential to the picture's message.

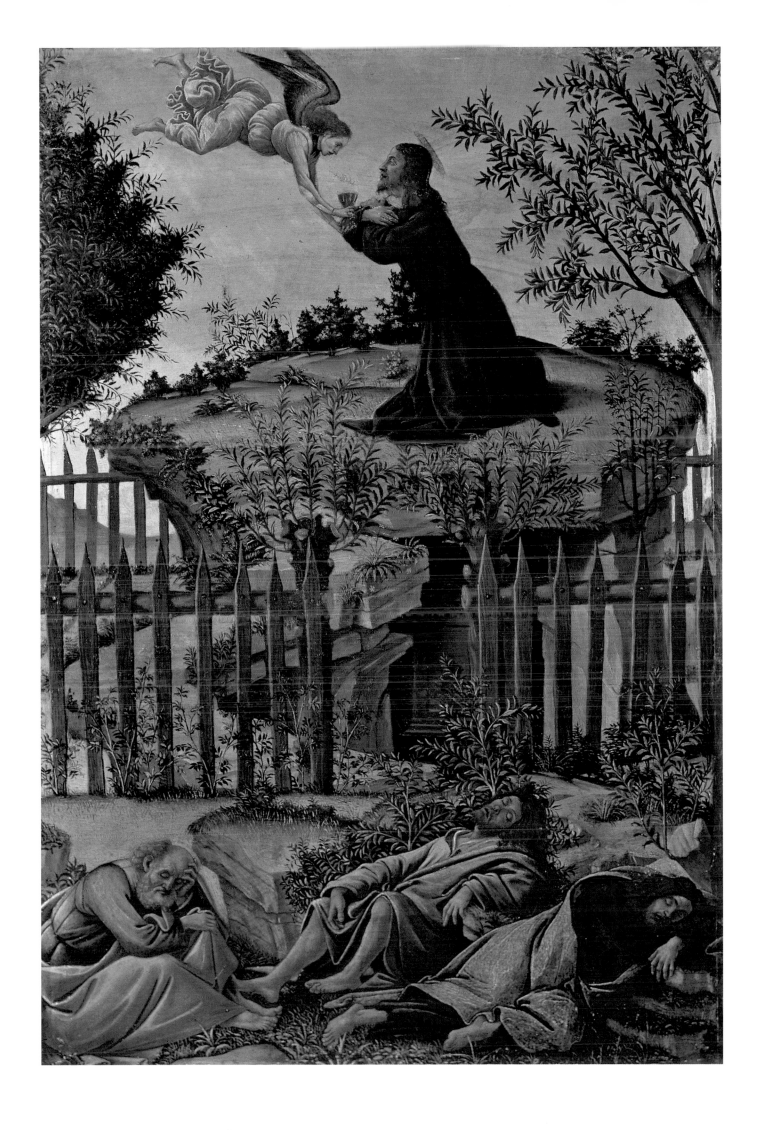

Detail from plate 21 on page 53

scene on the Mount of Olives was considered especially conducive to meditation on Christ's suffering. This subject—rarely treated before in Florentine painting—became increasingly popular toward the end of the fifteenth century. Sandro Botticelli's *Christ on the Mount of Olives* (plate 20) shows how a garden could serve as more than a mere setting; as a pictorial motif charged with meaning, it was in itself capable of inspiring meditation on Christ's betrayal and the subsequent Passion. This remarkable painting once adorned the door of a reliquary commissioned for the Capilla Real in Granada by Isabella I of Castille, the construction and lavish decoration of which occupied the queen in the years before her death in 1604. The picture is based on the gospel report that after the Last Supper Christ made his way with his disciples to the Mount of Olives (Matthew 26:30–46). At a farm known as Gethsemane he stepped away from the three who had accompanied him that far in order to pray alone (Mark 14:30–46). "Father, if thou wilt, remove this chalice from me: but yet not my will, but thine be done. And there appeared to him an angel from heaven, strengthening him" (Luke 22:42f.). The painting is clearly divided into three zones. In the foreground are the three disciples, who have fallen into a sound sleep. On the left is Peter, recognizable from his beard; next to him is James, also mentioned in the biblical account; and John, easily identified from his youthful appearance and red cloak, lies in the right foreground. Looming up out of the garden, set off by a picket fence, is a slab of bare rock on which Christ has chosen to pray. Botticelli quite deliberately chose to picture more in his painting than simply Christ's solitary prayer and the sleeping disciples. With his inclusion of the angel with the chalice, who almost touches Christ, he illustrates the moment, mentioned only in the gospel of Luke, in which Christ is given new strength. The sarcophagus visible in the cave beneath the rock alludes both to Christ's sacrificial death and the promise of salvation and resurrection associated with it. This idea is also expressed by the burgeoning branches of the two olive trees that frame the approach to the tomb and the mount. Botticelli has reduced the amount of possible landscape scenery so as to create an evocative setting filled with symbolic motifs rather than a picture space that pretends to render a specific visual impression.

The special qualities of such a picture, produced on commission, can only be explained, both in its format and its motifs, in the light of its function, the specific context for which it was painted. This is also the case with Botticelli's so-called *La Primavera* (plate 21), the largest panel painting on a mythological subject from the fifteenth century. This tempera painting was already singled out by Giorgio Vasari in 1550, who saw it as a picture of the Graces crowning Venus with a wreath of spring flowers. It has since given rise to many diverse interpretations, though scholars have long since virtually agreed upon the identity of its figures. Since Vasari's time the female figure standing in the cen-

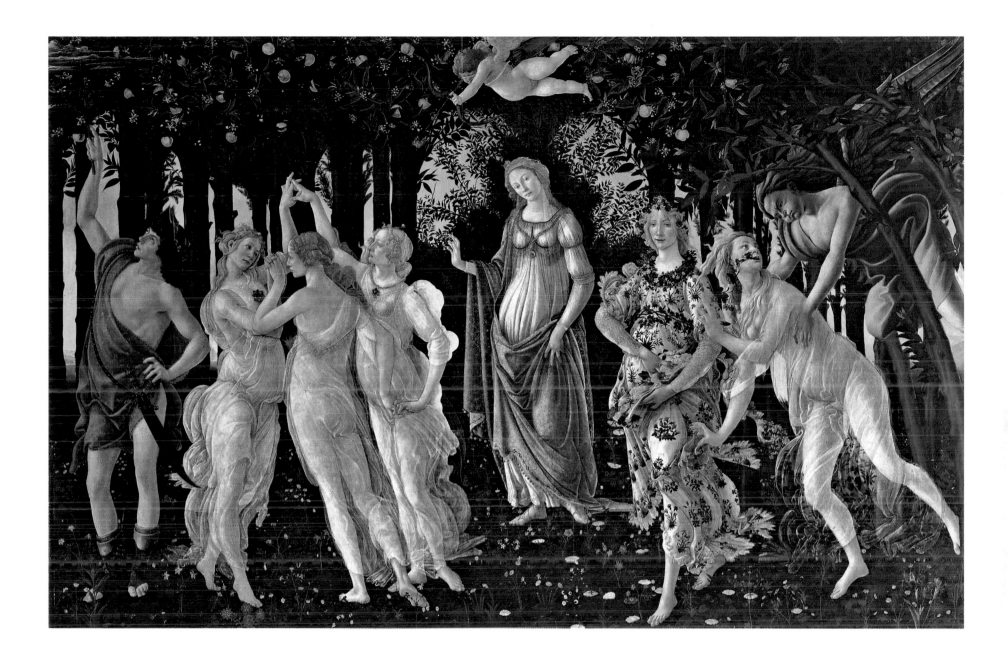

ter of the picture has been taken to be a clothed Venus, above whom hovers a small Amor with a blindfold. The other figures and groupings, arranged in a line, can be identified with the aid of ancient texts relating to the goddess of love, her realm, and her retinue. For example, in Lucretius's *De rerum naturae* (5.737–40) one reads that the all-creating Venus is accompanied by Spring, Amor, Zephyr, and Flora. One of Horace's odes names all the figures, the Three Graces—whose ring dance is also mentioned by Seneca in his treatise *De beneficiis* (1.3)—and Mercury, who, as Virgil relates in the *Aeneid* (4.245f.), drives away clouds with his caduceus. In Ovid's *Fasti* (5.193–214), one learns that spring awakens only after the wind god Zephyr has violently inseminated the nymph Cloris and she has transformed herself into Flora, who breathes out flowers: "When she speaks, spring roses waft from her mouth: Cloris was

21 (above and opposite)
Sandro Botticelli
La Primavera
c. 1480
Tempera on wood, 79¹⁵⁄₁₆ × 123⁵⁄₈ in. (203 × 314 cm)
Galleria degli Uffizi, Florence

This allegory of love created for the bridal chamber of Semiramide Appiani has become a touchstone for art historians, exemplifying the possibilities and limitations of iconographic analysis. The setting is a grove of orange trees, identified as an orchard by the absence of any other trees and by the fact that it is obviously carefully tended.

Details on pages 52 and 54

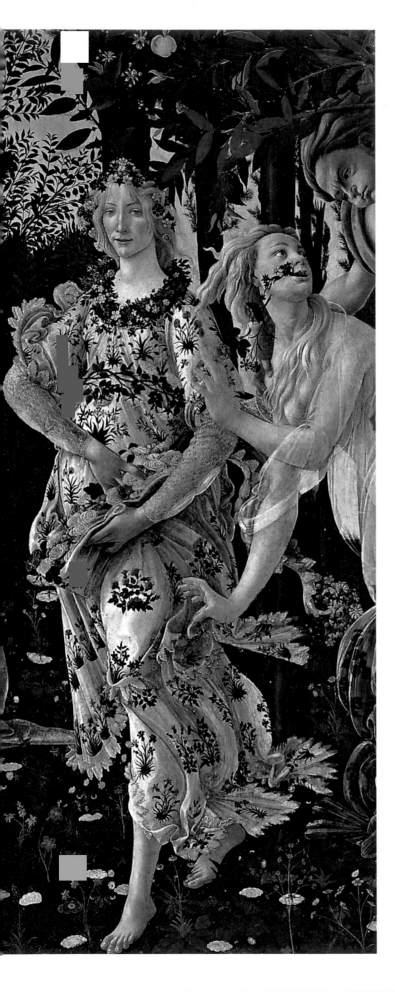

I, who am now called Flora." And in fact on the right side of his picture Botticelli precisely renders this scene: the wind god embracing the nymph, her flowery breath, and her transformation into Flora, who strews roses out of her gathered skirt onto the ground that is already sprinkled with flowers.

Today it is difficult to imagine that a single painting could have been based on such a diverse collection of classical texts and still seem so carefully thought out. But one has to recognize that in Botticelli's day the ancient writers were not just read and recited; many of the most important classical texts were memorized, at least portions of them. The ancient *auctores* not only provided writers with examples of proper phrasing, they constituted a treasury of wisdom. In their works were hundreds and thousands of verses that condensed psychological experiences and everyday maxims into the most pointed form, and scholars produced compilations of such verses, arranged in alphabetical order for easy reference. A collection of this kind was called a *florilegium*, a gathering of flowers. Ancient philologists had already begun this practice of collecting and memorizing such "flowers" and sparring with them in social gatherings, a form of scholarly amusement revived in the Renaissance. It is likely that games requiring a knowledge of these classical *exempla* were played in circles close to the Medici, for example, where the humanist and poet Politian, considered the founder of textual criticism with his *Miscellaneorum centuria* published in 1489, served as tutor to the children of Lorenzo the Magnificent. Some scholars have suggested that it was Politian who counseled Botticelli, for in his poetic works, the *Rusticus* and the *Stanze per la Giostra*, the realm of Venus is described in images similar to those presented in *La Primavera*.

According to an inventory from 1498, the painting was intended as an adornment for the bridal chamber of Semiramide Appiani. A notarized contract relating to her marriage to Lorenzo di Pierfrancesco de' Medici was signed by his guardian, Lorenzo the Magnificent, on October 17, 1480. As mentioned above in connection with the wall paintings in the Palazzo Davanzati (plate 8), it had long been the custom in Florence to commission new decorations and expensive furnishings for rooms to be occupied by newlyweds. *La Primavera* was originally hung above a *lettuccio*, a wide, sofalike couch that could be used as a daybed. There were other paintings in this richly furnished room as well, all of which could be associated with the ideal of Christian marriage and the procreation so necessary for a family's continuity. In Botticelli's painting the motif of the orchard in full bloom fits in with the general theme of love and reproduction. For the notion of fertility is also expressed in the splendid carpet of flowers, in the blooming orange trees, and in the numerous ripe fruits glowing in the dense foliage. The orange trees themselves, bearing both blossoms and fruit, invite further interpretation. In Florence at this time oranges were commonly called *palle medicee* or *mala medica* and served as symbols of

the Medici. There was a perfectly logical basis for this symbolic use of them, for since the fourteenth century there had been a small grove of orange trees in the inner courtyard of the old Medici palace, and with a certain amount of superstition their survival was associated with the family's well-being. Their growth, flowering, and general condition were carefully observed well into the sixteenth century—and not only by members of the extended family. All these ideas were addressed in Botticelli's painting as well as in the rest of the room's furnishings. They were not intended to illustrate a familiar story; instead, in a sophisticated pictorial language they invited viewers to come up with endless possible interpretations relating to the theme of love.

A book produced by the Venetian publisher Aldus Manutius in 1499 serves as an indication of how greatly ingenious stylization of love was valued at the time, and shows how many variations on the motif of the love garden there might be. Its title, *Hypnerotomachia Poliphili* (plate 22), can be translated as "the dream of the love struggle of Poliphilos." The name Poliphilos means simply "he who loves Polia." Richly illustrated with woodcuts, the book relates the story of a lover who in a dream sets out on a journey to his beloved, and on the way passes through a utopian art and architecture landscape that is described in minute detail. Just as in the *Roman de la rose* (plate 9), the garden with its hedges and arbors is here treated as an ideal setting for courtly pastimes.

One of Aldus Manutius's regular customers was Isabella d'Este, whose erudition led contemporaries to refer to her as the "tenth Muse." On her marriage to the margrave Francesco II Gonzaga in 1490 she moved to Mantua, where she was given an apartment in the southeast tower of the Castello di San Giorgio. In the following summer she set out to decorate her rooms in a suitable manner. One of them was furnished as a study, her famous *studiolo*, which would also serve as a library. Next to it was a small "secret garden," a *giardino segreto*, complete with a fountain and plantings of sweet-smelling citrus and jasmine. It was her intention from the start to decorate these rooms with paintings, by that time indispensable adornments to any princely residence. She even had earlier wall frescoes whitewashed over to make room for panel paintings.

The pictures she commissioned for her *studiolo* were apparently interrelated as elements of a complex overall program. The program opened with a depiction of Parnassus, the home of the Muses, by the Mantuan court painter Andrea Mantegna (now in the Louvre). Related to this painting was another picture that the astrologer Pomponius Gauricus referred to in 1503 as "the bellicose Pallas of our Mantegna." Known today under the title *Minerva Chases the Vices from the Garden of Virtue* (plate 23), the work presents a complex and richly allusive program of its own. It was presumably structured on the basis of classical texts, and the various inscriptions incorporated in it are also assumed to have been supplied by some learned philologist like Paride da Ceresara,

22
GARDEN FROM A DREAM
1499
Woodcut from Francesco Colonna's
Hypnerotomachia Poliphili, Venice, Aldus
Manutius 1499, fol. 373

who was active at the Mantuan court. Based on them, it was Mantegna's task to invent a pictorial vocabulary for a subject not yet codified, namely the struggle of the virtuous intellect against all-too-human vices. The tree at the left edge, who lifts up her branches in supplication, provides a clue to an understanding of the picture. A band of inscriptions in Latin, Greek, and Hebrew that winds around her trunk makes it clear that hers is a universal appeal: "Come ye divine attendants on the Virtues, you who have returned to us from heaven, expel these monstrous vices." The arts and sciences, represented by the goddess Minerva—in Greek, Athena or Pallas—are shown to be virtue's guardians. Minerva is charging into an idyllic garden that has been taken over by unpleasant-looking personifications of vices, most of them identified by labels. She seems to be heading for the rock structure on the right, which a ribbon with inscriptions indicates is a prison in which the mother of all the Virtues is being held. Her daughters, the rightful owners of the garden—the Virtues Justice, Strength, and Moderation—are gazing down on the event from above, waiting for her return in a gloriole of clouds. The battle between Virtues and Vices is situated in a garden, which in the context of the allegorical painting becomes a meaningful motif itself. At least indirectly, the pattern may have been the so-called *Tabula Cebetis*, a description of a fictional Greek picture in dialogue form from the first century B.C., rediscovered only shortly before. It deals with a vast allegorical *pinax*, or painting, on human life. There the

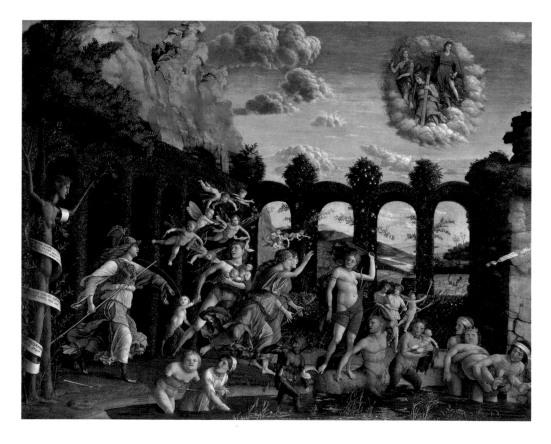

23 (left and opposite)
Andrea Mantegna (1431–1506)
Minerva Chases the Vices from the Garden of Virtue
1502
Tempera on canvas, 63 × 75⅝ in. (160 × 192 cm)
Musée du Louvre, Paris

In the garden of the Virtues, who have fled into exile, Minerva, goddess of the arts and sciences, battles with the hideous Vices. Sloth, Idleness, and other depravities have taken possession of the idyllic garden, here intended to symbolize the human spirit.

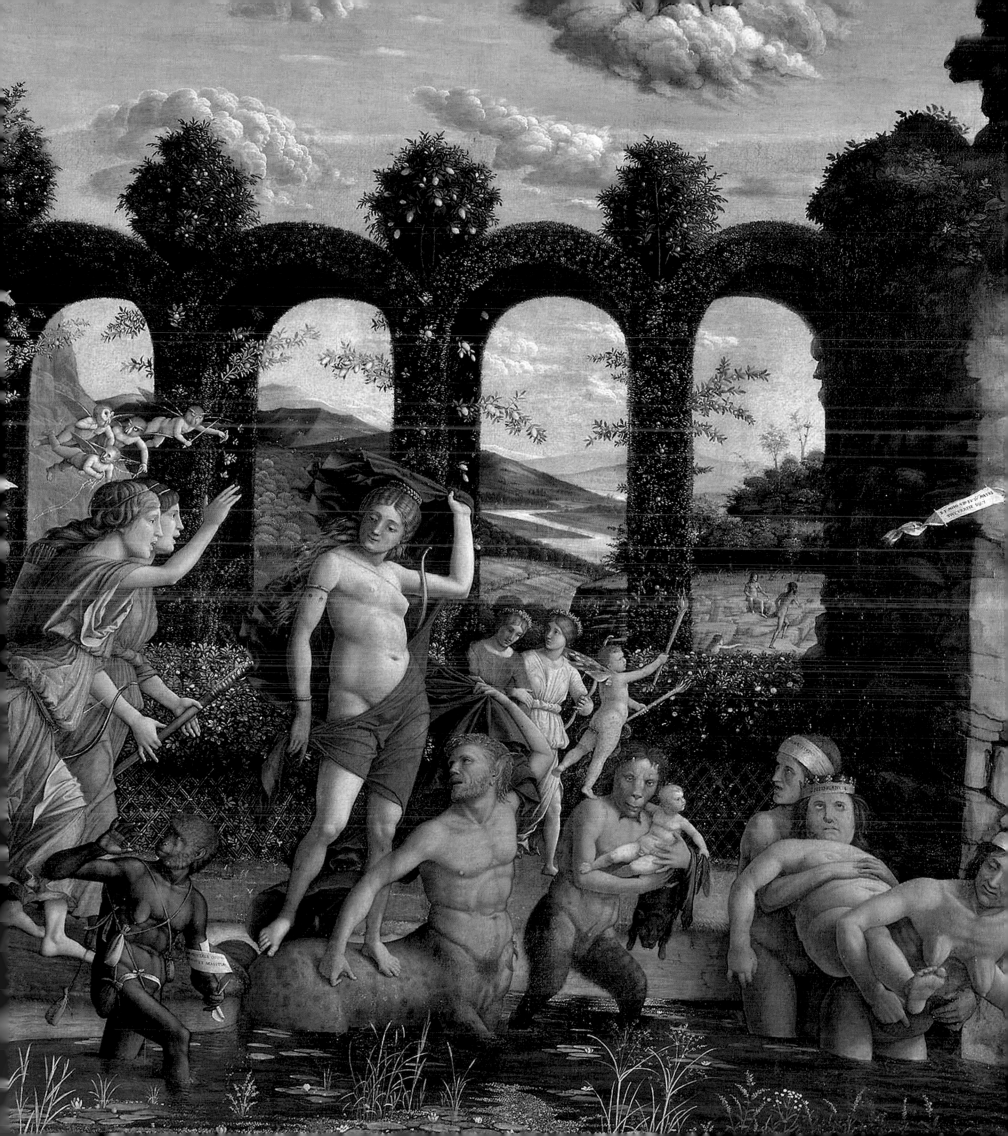

setting—and an important symbol—is a spot walled off from the rest of the landscape. Mantegna's unusual picture also reflects the tradition, familiar from tropological or moral interpretation of the Bible, of representing the human soul and the human intellect with the image of a garden. However, Mantegna's is not a Christian garden of the soul, but rather a symbol of the human spirit cleansed of the disgraceful vices of base human existence through engagement in the arts and sciences. At the same time, in this picture of a place consecrated to the Muses and liberated by Minerva, there is a recollection of the spot chosen by the ancient philosophers for their learned discourse, the philosophers' garden that Isabella d'Este had also re-created in her *giardino segreto*.

In elevated circles the garden was not only appreciated as a symbol, it was more importantly a favorite setting for social gatherings. It appears in this role in an unusual picture whose subject is only partially indicated by its customary title, *The Festival of the Archers* (plate 24). According to the inscription on its frame, dated 1493, and to surviving documents, the painting was a gift from one Peeter de Gramme. The phrase "eternal peace to his soul," appearing in its dedication, suggests its memorial function, yet it was hung not in a church but in the meeting hall of the Antwerp shooters' guild, Oude Voetboog. Another feature of the hall's decor was a gilt iron key nearly five feet long (1.5 m). The key was displayed in public once a year to announce the *vrijen brom* staged by the guild, a free banquet for both men and women. In view of this custom it is surely no coincidence that such a key appears in the center of the picture, against the back of the baldachin sheltering the commissioner of the painting and host of the banquet, which may in fact have taken place in a garden. But by the end of the fifteenth century the garden had long been associated, even among city dwellers, with allegories of love, and this may have been what was intended in Peeter de Gramme's memorial painting. Prominent in the foreground are a man and a woman facing each other. He is carrying two wine pitchers, and his clothing marks him as a servant. She, like some of the other figures, has portraitlike features, and thanks to these the painting becomes a group portrait as well. With her right hand she is holding out a red carnation, a common feature in portraits of married couples from this time. The morris dancers in the middle distance, the owl on a pole above the back fence, in front of the tower on the right, and the birdcage hanging above the baldachin are motifs common in wedding iconography. To contemporaries, the motif of the garden alone would have indicated that the scene had to do with love, espousal, and marriage. They would have been perfectly familiar with the garden of love from secular wall painting (plate 8), book illumination (plate 9), engravings, and tapestries. Secular scenes were still unusual in panel painting of the period, although they were common enough in textile pictures—to contemporary thinking a much more important medium. The

painting commissioned by Peeter de Gramme is reminiscent of tapestries not only in its subject matter but also in the way it is presented—the glowing colors, the figures arranged with almost no overlapping, the extremely high horizon. Moreover, it is important to note that in this period it was highly unusual to decorate important spaces with panel paintings. The accepted practice was to employ tapestries or—as a less expensive substitute—wall paintings. The painting's similarity to tapestry in both form and function reveals a desire on the part of this urban guild to emulate courtly conventions, not only in its social events but in its art as well.

One painter who profited richly from the growing demand for panel paintings on the part of the urban upper class was Jakob Cornelisz van Oostsanen. His picture *Christ as Gardener* (plate 25), one of his earliest works, dates from 1507. The date appears on the prominent unguent jar, and along the hem of Christ's robe there is a Latin inscription referring to the picture's subject. The text is taken from the description in the gospel of Saint John (20:14–18) of Mary Magdalene's encounter with the risen Christ. Kneeling in tears in front of the tomb, she took the man who appeared to her to be a gardener until he spoke to her, whereupon she recognized him. He then commanded her not to touch him, and to inform his disciples of his resurrection. Other scenes relating to the miracle are presented in miniature in the background. On the left, for example, Mary Magdalene is seen at the empty tomb (John 20:11), farther back in the landscape the three Marys appear together (Matthew 28:9f.), and in the remote distance Jesus is pictured outside the city gate with the pilgrims to Emmaus (Luke 24:13–15). Finally, seen through a kind of niche in one of the buildings, there is an extremely tiny suggestion of the meal at Emmaus (Luke 24:28–30). All these details provide subject matter for devout meditation, especially the motif of the resurrected Savior, characterized as a gardener with a spade in his hand. Viewers would have readily understood that the garden here tended by Christ is to be perceived tropologically as a symbol of the human soul. In addition to being moved by the picture's content, they would have been dazzled by the meticulousness with which the artist rendered such details as the exquisite garments.

25
Jakob Cornelisz van Oostsanen (c. 1472/77–1533)
Christ as Gardener
1507
Oil on oak panel, 21½ × 15¼ in. (54.5 × 38.8 cm)
Staatliche Museen, Gemäldegalerie, Kassel, Germany

All the carefully rendered details in this flourishing garden have symbolic significance and encourage reflective study and contemplation.

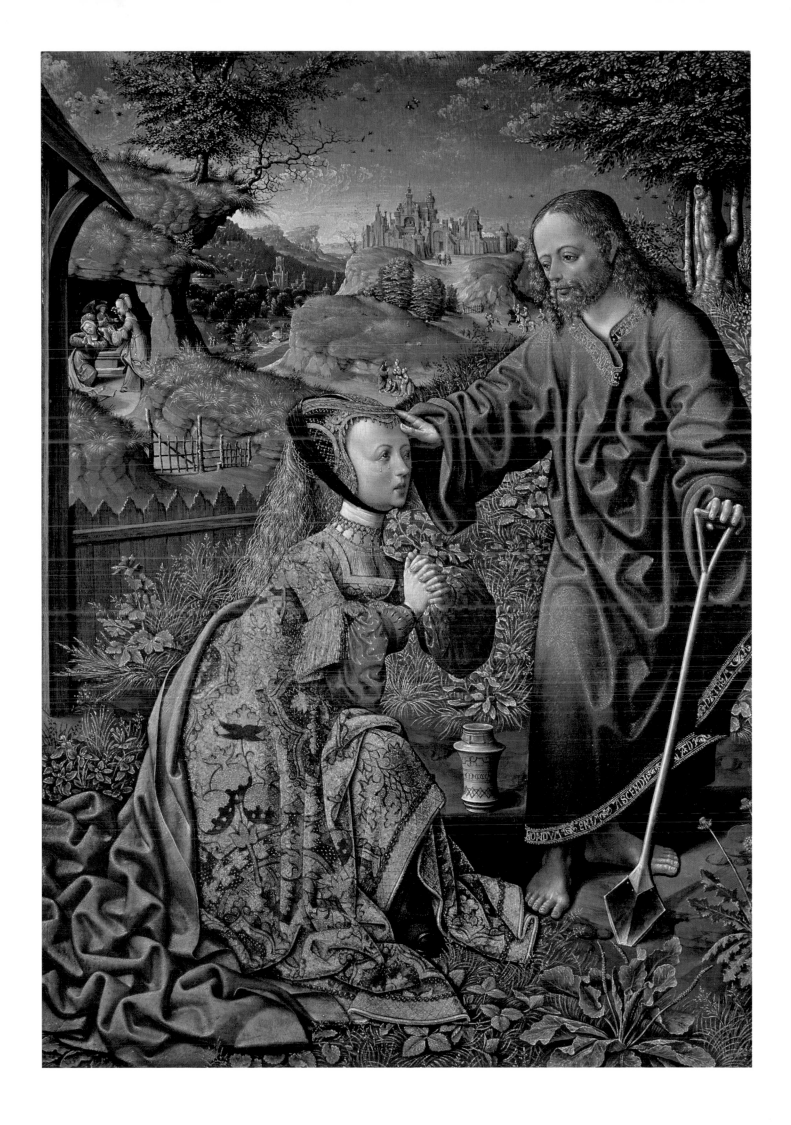

Precedents and Symbols

26 (above and opposite)
Albrecht Altdorfer (c. 1480/85–1538)
SUSANNA AT HER BATH AND THE
STONING OF THE OLD MEN
1526
Oil on linden wood, 29⁷⁄₁₆ × 24⅛ in. (74.8 × 61.2 cm)
Bayerische Staatsgemäldesammlungen,
Alte Pinakothek, Munich, Germany

Eschewing the naturalism of Albrecht Dürer, Altdorfer cultivated an emphatically imaginative aesthetic, producing fantastic inventions for a growing number of appreciative collectors. Given its rather large format, the painting was presumably intended to adorn a reception room at court.

Details on pages 63 and 64

Albrecht Altdorfer was another painter who commanded the admiration of connoisseurs and collectors of his time with his virtuosic and highly idiosyncratic pictorial style. His painting *Susanna at Her Bath and the Stoning of the Old Men* (plate 26), for example, can hardly have been intended for private devotions so much as to express artistic bravura. Painted in 1526, it is documented to have been in the collection of the Bavarian dukes by 1598. But it must already have been in Munich by 1537, when another painter attached to the court made a reference to its composition. It was presumably commissioned by Duke Wilhelm IV of Bavaria or some other member of the house of Wittelsbach. The painting, for which a detailed preliminary drawing survives, presents in the setting of an expansive garden a story related in the thirteenth chapter of the book of Daniel, a text considered apocryphal by both Protestants and Jews. Altdorfer skillfully included in his composition several of the story's different episodes. In the foreground he shows Susanna at her bath, staged as a decorous footbath. She is attended by several handmaidens: one is combing her hair, another fetching water, still another securing the garden gate—all as described in the Vulgate—and one bringing oils and salves. Lurking in the shrubbery on the left are the two elders, who according to the biblical narrative forced themselves upon her, threatening to accuse her of adultery with a young man if she refused to lie with them. The story continues on the right, inside the elaborate structure that forms the architectural backdrop. There the two old men are seen making their accusations, and are convicted of false testimony by the young Daniel. In their final appearance, the two liars are seen being stoned in front of the building.

The garden, with its various identifiable plants, forms a serene contrast to the bustle inside the palace. It is an idyllic *locus amoenus*, recalling—not without reason—the enclosed garden from Marian iconography. Susanna's chastity and fidelity are illustrated by a number of symbolic details. There is the enclosed garden itself, a symbol of virginity; the dog in her lap stands for loyalty; the lily in the hand of the servant girl fetching water and any number of other plants and flowers are familiar symbols from depictions of the Virgin. Violets, carnations, lilies of the valley, primroses, and forget-me-nots, all from the language of flowers in the Song of Solomon, stand for the qualities of the ideal bride, and traditionally symbolized the Madonna's virginity, obedience, and humility. The fountain and the unguent jar are also Marian symbols. With the inclusion of all these borrowings from Marian iconography in his description of the garden, Altdorfer uncovers the allegorical significance of the

Susanna story. Its deeper meaning lay in Susanna's similarity to Mary, obvious not only to learned exegetes, and the parallels between the accusation brought against her and slanderous doubts about the Madonna's virgin birth. Such a picture was generally understood as an *exhortatio ad virtutem*, or admonition to virtuous conduct.

At this time illustrations of piety and mythological scenes were established components of the decorative repertoire for noble residences and palaces. A Latin conversation primer published in Leipzig in 1508, in effect a promotional piece for the University of Wittenberg, includes a reference to the purpose of pictures of virtue displayed in such settings. It takes the form of a conversation between Meinhard, a student who wishes to study in Wittenberg, and Reinhard, who is dissuaded by his friend from acting on his original desire to transfer to the University of Cologne. This "dialogue" was writting by Wittenberg's town clerk, Andreas Meinhard, from Pirna, at the behest of Martin Polichs von Mellerstadt, the university's first rector. A portion of the conversation takes place in the palace, where Meinhard describes the numerous pictures to his companion. He expressly emphasizes their didactic function, explaining that they are not addressed solely to the palace's aristocratic residents but also to the servants and to common folk who happened to visit. The *exempla* from Roman history depicting faithful servants and slaves were especially intended for the edification of the latter. The apartments of Sophie von Mecklenburg, the wife of Duke Johann I of Saxony, were also decorated with pictures whose subject matter reflected their setting; everywhere were "pictorial representations of almost numberless tales of marital bliss, wives faithful to their husbands, piety, chastity, and to summarize in a few words almost all the virtues and vices." If the paintings in her apartments were gender-specific, so were those in her husband's chambers, picturing the deeds of Hercules and love scenes from Ovid's *Metamorphoses*.

The Golden Age (plate 27), painted by Lucas Cranach the Elder around 1530, would appear to belong in the latter context. In it nude men and women amuse themselves in a garden enclosed by a high wall. Even the fig leaves, added later, fail to detract from the eroticism of the scene, conveyed by the three couples dancing in a circle and others in intimate conversation, playing in the water, and sharing a bunch of grapes. The scene has been identified as being based on Hesiod's *Works and Days* (109–15), which describes the Golden Age in which mankind, free from toil and sorrow and ageless as the gods, could devote itself to constant revelry. This same *aurea aetas* is also described in Ovid's *Metamorphoses* (1.89–112) as a time when men still lived from hand to mouth without a care. Ovid expressly states that at that time agriculture was still unknown and cities were not surrounded by walls. Cranach, with his image of people living peaceably together in a walled and cultivated garden—a deviation from

Detail from plate 26 on page 62

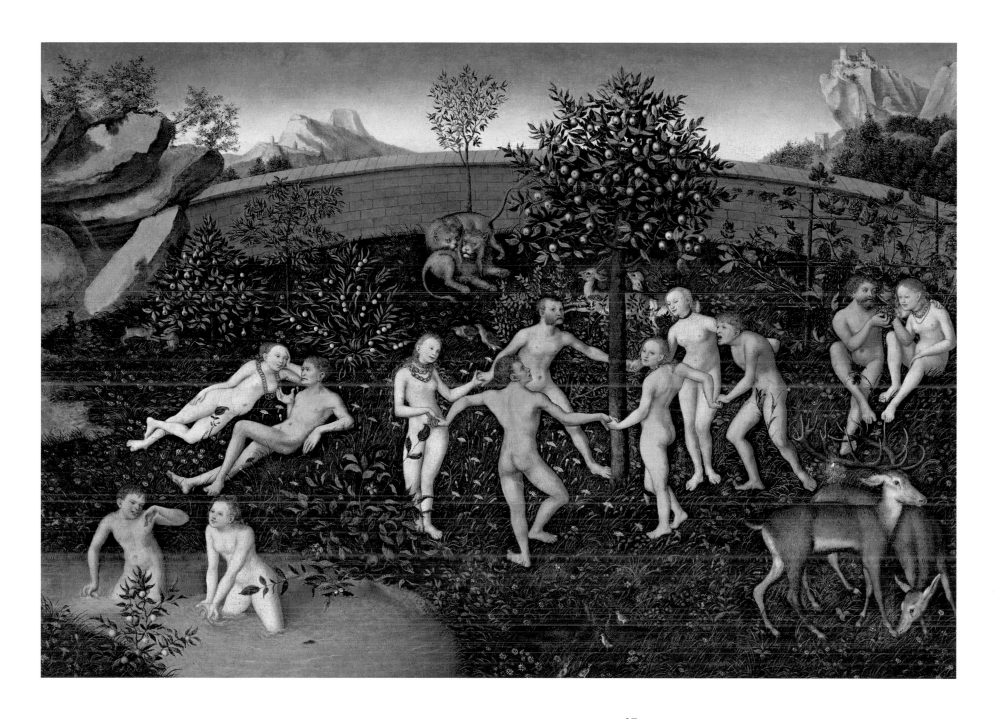

the literary sources—created a highly expressive picture, a perfect evocation of paradise. The garden, an image with an unbroken tradition as the *hortus conclusus* in pictures of the Virgin and as a setting for love, was a visual cipher for paradise that was universally understood. In addition, in a palace context a picture like this of the *aurea aetas* conveyed a political message. As in Palermo's Norman palaces, it held the promise of a return of the Golden Age, one that in Cranach's time had also been discovered in the primeval world described by Tacitus in his *Germania*. The joyous times that were to begin with the rule of the Saxon dukes were described in panegyrics and any number of paint-

27
Lucas Cranach the Elder (1472–1553)
THE GOLDEN AGE
c. 1530
Oil on wood, 28¾ × 41⁵⁄₁₆ in. (73 × 105 cm)
Bayerische Staatsgemäldesammlungen,
Alte Pinakothek, Munich, Germany

Going beyond descriptions of the Golden Age in classical literature, Cranach chose a garden as the symbol of a peaceful, untroubled existence in nature, an image both plausible and generally understood.

Detail on page 6

ings, most of them surviving in multiple versions. In one representation of the Golden Age, now in Oslo, the political message is particularly clear, in that the Saxon electors' Hartenfels Palace, near Torgau, appears in the background. With their readily understood visions of paradise, these symbols of felicitous Saxon rule made ideal gifts, and were used to cement political alliances in diplomatic exchanges. This is how the painting could have found its way into the collection in Munich, where the panel was inventoried in 1598 as one on which "naked women and men are dancing in a circle under a tree in a garden, others bathing in a flowing stream."

Not all the facets of every allegorical garden scene were immediately grasped by contemporary viewers. On the predella of a painting by Lucas Cranach the Younger in Wittenberg's town church, it was therefore considered appropriate to attach a poem explaining *The Lord's Vineyard* (plate 28). It characterizes the clearly recognizable representatives of the Reformation shown in a vineyard, here symbolizing the church, as the good workers, the Catholic priests as the bad ones. In Psalm 79 (80 in Luther's numbering, verses 9–13) and in Isaiah (5:7) Israel is compared to a vineyard, and in the Song of Solomon (2:15; 8:11) the vineyard appears as the realm of the messiah that would be realized in the New Testament. Hence both the church fathers and medieval theologians had likened the church to a vineyard, an image retained even in Protestant exegetics. Cranach's painting expressly refers to this conceit, and the allegory based on it draws mainly on a parable from the gospel according to Saint Matthew (21:33–39). In it evil husbandmen withhold the fruits of the vineyard from its owner and kill his servants, and are then appropriately punished. One also recalls the parable, also in Matthew (20:1–16), about the workers in the vineyard who all receive the same pay, even though they had not worked the same number of hours. That parable concludes with the admonition: "So shall the last be first, and the first last." This remarkable picture was commissioned by the children of the reformer Paul Eber as an epitaph to their father, who died in 1569. It must have been they who devised the richly allusive program, never before presented in this form. However, it was left to Cranach to find the appropriate pictorial motifs with which to communicate the desired message.

It is possible to get a sense of just how much freedom a painter might be granted in commissioned works from Titian's surviving correspondence, especially his letters to Philip II of Spain having to do with the famous mythological paintings—*poesie*—the painter produced for the king with a certain regularity. They clearly indicate how one is to envision the relationship between painter and patron and how picture subjects were determined. At least as important as their mythological content were their diverse compositions and how they related to the ensemble of a room's paintings, the coordination of which lay ultimately in the hands of the artist. The results of such freedom were pictorial

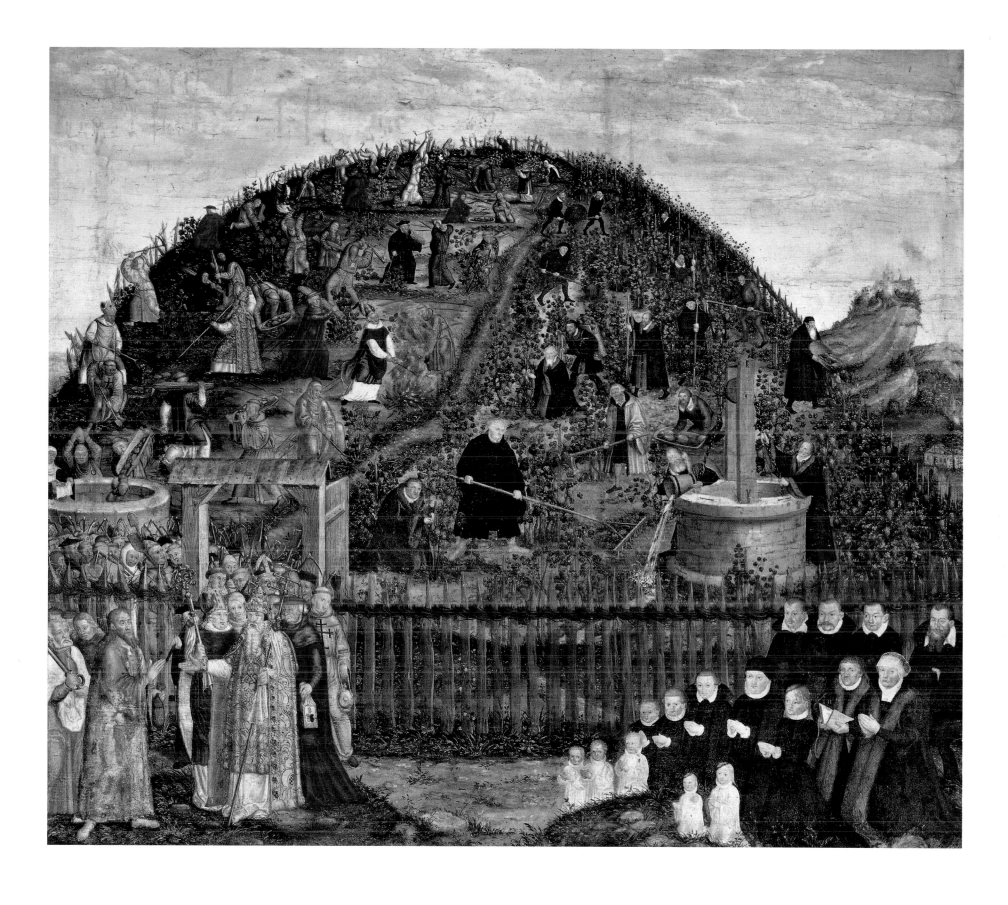

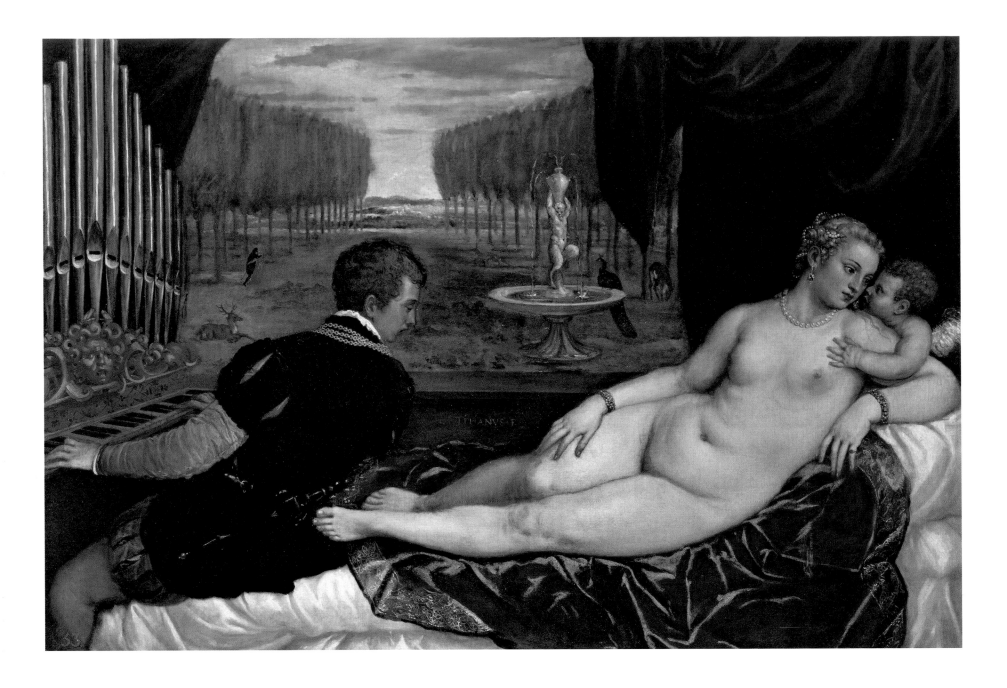

29 (above and opposite)
Titian (Tiziano Vecellio) (c. 1488–1576)
VENUS AND AMOR WITH THE ORGAN
PLAYER
c. 1550
Oil on canvas, 58¼ × 85 ⁷⁄₁₆ in. (148 × 217 cm)
Museo del Prado, Madrid

The various motifs in the background of this garden landscape underscore the erotic nature of the composition, conceived as a fairly obvious reflection on voyeurism.

inventions for which the artist was solely responsible, works that can no longer be explained by consulting the writings of the ancients. And since the pictorial ensembles once so carefully coordinated in format and content no longer survive, many a painting from them now seems enigmatic. An example is Titian's *Venus and Amor with the Organ Player* (plate 29), painted around 1550, which has given rise to numerous diverse interpretations. It pictures an elegantly dressed musician seated at a positive organ, the carved ornaments of which include a Gorgon's head. He has turned toward a nude Venus reclining on a splendid couch. The winged infant Amor, her son, nestles against her shoulder. Extending back from these figures is a garden featuring allees of identical trees.

It is apparently meant to be a garden of love, as suggested by the presence of the deer, the peacock, and the intertwining couple traditionally included as allusions to carnal pleasures. The fountain, topped by a satyr balancing a water jar on his head, also has erotic connotations. In the *Dialogo dei colori* published by Titian's friend Ludovico Dolce in 1565, which includes a lengthy disquisition on the symbolic meanings of plants, animals, and mythological figures, the satyr is identified as a symbol of *lascivia*, or lecherousness. The musician's indiscreet gaze blatantly underscores what is expressed in the garden with its symbolic motifs. He stares as if spellbound at that portion of the goddess's anatomy that anatomists refer to—in homage to her—as the *mons veneris*. The organist's clothing alone makes it clear that this is not a representation of some ancient myth, and at the same time it is perfectly apparent from the presence of the winged Amor that this is no actual event. Juxtaposing a clothed musician and an unclothed woman was a definite breach of decorum, inconsistent with the social norms and moral concepts of the period. Conventions were strict, and even an immodest décolletage was considered the stuff of scandal. In 1531 Andrea Alciati had expressed what was expected of a lady in his widely read *Emblematum liber* (196), namely "famam, non formam": a woman was to be celebrated for her good reputation, not her beauty.

Beauty versus reputation was the issue in the biblical story of Susanna (plates 26 and 30), as well as in countless other traditional tales illustrated by painters, often with an explicit display of female charms. It would appear that a certain ambivalence between moral admonition and blatant immorality was valued in this period. Titian's painting deals quite directly with the issue of the roving eye. At that time the eye was considered the sense organ most directly associated with sensuality, for which reason it was generally assumed that lust was fanned primarily by the sight of a desirable person. In the first Epistle of Saint John (2:16) this pernicious "concupiscence of the eyes" is mentioned in the same breath as the concupiscence of the flesh, "which is not of the Father, but is of the world." Pictures could also be positively dangerous for the same reason, unless one was able to bring one's emotions under control through constant practice—contemplation of pictures, for example. Titian's painting falls precisely in the middle of this tug-of-war between curiosity and self-control. The Gorgon's head on the front of the organ could be an allusion to the musician's gaze. According to mythology, the Medusa, one of the serpent-haired Gorgons, was killed by the hero Perseus, who avoided being turned to stone at the sight of her by fixing on her mirror image in his shield as he lopped off her head. Henceforth Minerva carried the Medusa head on her aegis or on her shield. The so-called Gorgoneion was considered a protective talisman. Here it can be interpreted either as an expression of the stonelike paralysis of the awestruck musician, as a protective amulet against sexual desire, or as a

visual reference to the spellbinding skill of the painter himself. The possible ways the organ can be interpreted are similarly diverse. Its tones, like all music, can be thought of as symbolizing ephemerality, a quality that could allude to Venus's beauty. The organ pipes might make one think of Pan's pipe, which is glossed in books of emblems as symbolizing a rejection of the desires of the flesh and a turning toward culture. The picture's enigmatic quality and its erotic motif were doubtless what made it so popular, for *Venus and Amor with the Organ Player* survives (plate 29), with only slight variations, in several different versions.

Voyeurism was also unquestionably the theme of Jacopo Tintoretto's *Susanna and the Elders* (plate 30) from circa 1555. The biblical Susanna story was a favorite subject for painters wishing to legitimize an erotic rendering of the female body. And unlike Altdorfer (plate 26), by far the majority of them used the story as an excuse to portray a female nude. Rarely was this nude featured as prominently, however, as in Tintoretto, who placed her quite literally in the foreground. According to the extremely brief but precise description in Carlo Ridolfi's *Le maraviglie dell'arte*, in 1648 the work was owned by the Flemish painter Nicolas Régnire, who since 1626 had lived in Venice, where he called himself Niccolò Reinieri. That Ridolfi included Tintoretto's painting among the "artistic marvels" to be admired in Venice was doubtless in no small part owing to its prominent female nude. The alabaster-white body, with the features of a classical statue of Venus, stands out against the dark background of the surrounding greenery. Tintoretto borrowed Susanna's pose from the classical Venus iconography, thereby dramatizing the issues of female beauty and morality being dealt with in the moral discourse of the period. The figure seems charged with eroticism, although one breast is hidden and her pudenda are not so much revealed as implied. She is shown seated, without her handmaidens, on the edge of a tank of water sunk in the ground. She is surrounded by the accessories of her toilet, arranged as in a still life. The spot is shaded by trees, recalling the note in the biblical account that the "weather was hot." Susanna appears completely pensive, sunk in contemplation of her own image. Her mirror leans against a rose hedge, which together with the pergola framed by herms and the pool in the background lend the painting an amazing depth. The two old men can be seen at the ends of the hedge. They are not menacing Susanna, but are simply mute voyeurs absorbed in contemplation of her beauty. The picture's depth and the dramatic lighting effects create an impression of extreme calm. The garden is arranged like a stage set. Perhaps no other painter has related the story of Susanna, compressed into a single moment, with such vividness. In the branches of the tree sits a magpie, which invites interpretation if only owing to its unnatural proximity to the human figures. But the magpie is a highly ambiguous symbol, and could mean any number

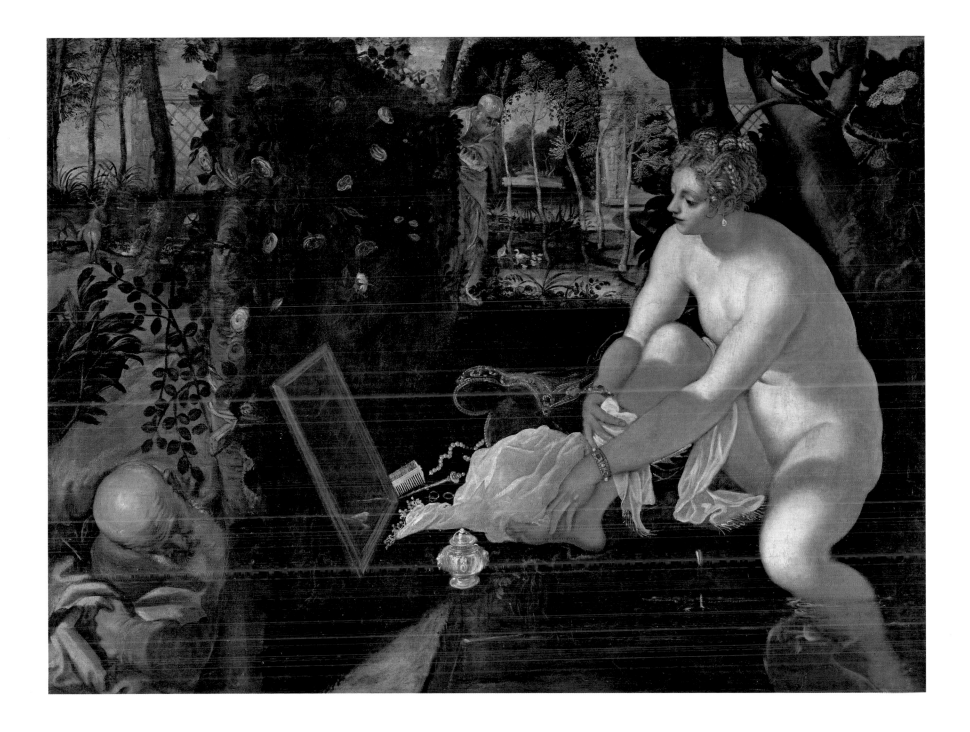

of things. It was considered garrulous and was held to be monogamous, but it could also be taken as a bad omen. The picture does not achieve its effect thanks to any particular symbolic motif, however, so much as to the complicity of the viewer, who cannot help but gaze at the nude displayed in such a brazen manner. Like Titian in his *Venus and Amor with the Organ Player* (plate 29), Tintoretto here comments on the issue of voyeurism, yet his painting conveys a clearer moral message: the viewer is perfectly aware of the end that awaits the lecherous old men.

30 (above and opposite)
Jacopo Tintoretto (1518–1594)
SUSANNA AND THE ELDERS
c. 1555–57
Oil on canvas, 57½ × 76¼ in. (146 × 193.6 cm)
Kunsthistorisches Museum, Vienna

Thanks to its prominent placement of the female nude, the picture is an erotic showpiece, but given the story on which it is based, it is also an exemplum *of reprehensible voyeurism and its consequences.*

New Views—Ancient Ideals

Detail from plate 31

Among the obligatory amenities of the sixteenth-century princely court were increasingly lavish gardens. Whereas Leon Battista Alberti had still recommended gardens mainly for their health benefits, they were now generally understood as expressions of aristocratic taste, symbols of a paradisial world ruled by an ideal monarch. A thriving garden, perceived as a symbol of the state, was at the same time seen as the ultimate expression of the fusion of nature and art; when cultivated as gardens nature was rendered artistic—became a *terza natura*, as the humanist and historian Jacopo Bonfadio termed it in 1541. To describe the successful blending of art and nature in the ideal garden—a sort of re-creation of the Golden Age—Bartolomeo Taegio also spoke of this "third nature" in his dialogue *La villa*, from 1559. Quite apart from their allegorical significance, gardens filled with costly appointments provided princes an opportunity to display their exalted stature. Increasingly, gardens became prestige objects, their elegant layouts readily appreciated as indications of wealth. *Noblesse oblige*, it was said—nobility has its obligations— so those who wished to maintain their high rank were required to flaunt it with appropriately lavish expenditure on every aspect of their lives. One way to do so was to acquire pictures by famous painters; a garden filled with expensive plants and animals, however, was also a highly effective indication of the owner's status (plate 31). Brilliant displays of courtly splendor were recognized as a ruler's greatest propaganda tools, their magnificence perceived as an expression and summation of his many virtues. In his *Nicomachean Ethics* (4.2) Aristotle asserted that "the magnificent man is like an artist," and "will also furnish his house suitably to his wealth." Vitruvius also insisted that in the design of buildings and houses, it is always necessary to consider the occupants' social standing; thus, "for a person of middling condition in life, magnificent vestibules are not necessary, nor tablina nor atria . . . but for nobles . . . princely vestibules must be provided, lofty atria, and spacious peristylia, groves, and extensive walks, finished in a magnificent style" (6.5.2). Whereas Vitruvius did not even mention gardens for the lower classes, he felt them to be a necessity for the nobility; according to ancient notions, those who owned gardens lay claim to high social rank. Because gardens had been such an important aspect of the ideal lifestyle of antiquity, princes of early modern Europe wishing to emulate that style felt obliged to have them as well. That the splendor of their gardens was understood in precisely this sense is clear from the rhapsodic reports of contemporary visitors—also from the scolding of those critical of the worldly vanity so evident in garden fever. Among the latter was the philospher Justus Lipsius, who in his *De constantia libri duo* excoriated those all-too-covetous

POGGIO

persons who "misuse gardens for vain and idle ends." In a dialogue with his friend Carolus Langius, whose garden is described as a place for conversation, he opens the philosophical discourse with criticism of wealthy flower sellers and their vain pride in new and rare plants. "I am convinced," he concludes, "that the garden was invented for modest pleasure and not for vanity, for rest and not for idleness." To be sure, Lipsius himself was always eager to acquire rare plants for his garden in Leuven; along with his books and his dogs, he confessed, it provided him with solace in the face of everyday troubles. Borrowing from the stoicism of Seneca, in his philosophical writings Lipsius stylized the garden as the ideal setting for meditation on what is truly worth striving for.

In aristocratic circles especially, spending time in the garden, like hunting, was considered a form of recreation as restorative as it was appropriate. A handbook for princes recommended imitating Solomon, "who employs male and female singers [as well as] planters in his pleasure garden." The garden of the Vatican Palace, laid out by Bramante shortly after 1500 for the art-loving Pope Julius II, became the model for any number of later courtly gardens. In that famous complex, now known as the Cortile del Belvedere, the principle

31 (above and opposite)
Justus van Utens, called Giusto Utens
(1570–1609)
VIEW OF THE MEDICI-VILLA
POGGIO A CAIANO
c. 1599
Oil on wood, 55½ × 93⁵⁄₁₆ in. (141 × 237 cm)
Museo Storico Topografico "Firenza com'era,"
Florence

This imaginary bird's-eye view comes from a series of seventeen lunette pictures commissioned by Grand Duke Ferdinando I de' Medici for the decoration of the Villa Medicea at Artimino. They document the power and prestige of the Medici family as well as the practice, common by the end of the sixteenth century, of decorating important rooms with topographical views and chorographic pictures of one's own estates.

of terracing, held to be "antique," was for the first time employed in exemplary form, following classical villa architecture. Contemporaries marveled at the garden's enormous scale as well as its countless antique sculptures, expensive plants, and exotic animals. The *View of the Vatican Gardens* (plate 32) by the Flemish painter Hendrik van Cleve, painted in 1587, shows what this much-admired garden looked like in the sixteenth century. Interest in the subject is evidenced by the fact that three versions of the picture survive to this day. The elaborate terraces and varied plantings are shown in great detail, and strolling members of the papal court can be seen absorbed in conversation. Beyond the garden there is a view of Rome, behind which rise the Alban Hills. Unquestionably the picture diverges from the topographical reality, yet to that age it was a precise description satisfying the broad popular interest in geography. In the medium of the panel picture, the *View of the Vatican Gardens* numbers among the earliest chorographs, or pictorial representations of specific segments of the earth's surface, the chief function of which was descriptive. Soon such pictures would be in great demand all over Europe.

Triggered by the new interest in geography, the view of a specific place now took its place beside the symbol-laden garden picture, capable of a variety of meanings, and pictures primarily intended as demonstrations of status and prestige. Of course, one cannot overlook the fact that the Garden of Eden was also a very specific place in an identifiable geographical location. Even the discoveries triggered by Columbus did nothing to curb the production of teleological narrative painting and a firm belief in the inevitable apocalypse that would bring time to an end. All that was new was that now the fabulous found a place in the world of ordinary experience. Cannibals, cephalopods, and dragons were no longer placed at the world's edges, close to the limit of what could be imagined, but simply in the New World, in America. The story of the salvation and the revelation as narrated in the Bible retained its validity. So it is hardly surprising that Abraham Ortelius, who with his *Theatrum orbis terrarum* created the first modern atlas, assigned to paradise a specific, identifiable location. On a map of the pilgrimages of Saint Paul, published in 1598, he located paradise in Syria, and identified it as a city, not a garden. The location of the lost Garden of Eden was much debated at the time, with many people adopting the theory of the origin of the world espoused by Ioannes Goropius Becanus. In his investigation of the *Origines Antwerpianae*, Becanus presented proof that paradise had been situated in the Netherlands, and that in the Garden of Eden Adam and Eve—how could it have been otherwise?—spoke Dutch. Even the famous geographer Gerardus Mercator, whose atlas would be the eponymous model for all subsequent collections of maps, pondered the precise location of the Garden of Eden in 1577—though he tended to place it in the Near East. He showed himself to be even more determined than Ortelius to present with his

Detail from plate 32

atlas a cosmographic work on the Creation, the origin of the world, its whole history, and its contemporary appearance. The universality Mercator claimed conformed to the interests and views of his contemporaries. Human existence and surrounding nature were thought of in the context of the chronology set by the story of the salvation, which had begun with the Creation. Nothing had changed since the Middle Ages, and it would be a long time yet until over the course of the eighteenth century "scientific" study of the Bible and physicotheology gave way to science in the modern sense.

Painted gardens, whether as chorographic representations or allegorical pictures, were perfectly suited for the realization of the ancient ideal of decorating living spaces with "realistic renderings of quite specific things" and realistic landscapes. One way of implementing the concept was to bring the garden into the house by means of illusionistic painting. A remarkable example is the ceiling of the Sala della Pergola in the Palazzo Rospigliosi Pallavicini in Rome (plate 33), the palace Scipione Borghese built for himself on Monte Cavallo. According to surviving account books, the painting of the ceiling lunettes was commissioned from the Netherlandish painter Paul Bril, whose name appears there a number of times between August 2, 1611, and August 2, 1613. Bril subcontracted the

32 (above and opposite)
Hendrik van Cleve (c. 1525–1589)
VIEW OF THE VATICAN GARDENS
1587
Oil on wood, 29⅛ × 36¼ in. (74 × 92 cm)
Musée Royaux des Beaux-Arts de Belgique,
Brussels

A growing interest in geography over the course of the sixteenth century went hand in hand with a growing demand for illustrations of specific places. Hendrik van Cleve produced a great number of them.

painting of the twenty putti, grouped in pairs in the spandrels, to Guido Reni. Reni's authorship is assured by a series of engravings after them published by Carlo Cesio. Contemporaries were enchanted by them, and in his *Vite*, written after the middle of the seventeenth century, Giovanni Battista Passeri praised them for their otherworldly, angelic beauty. With their painting Bril and Reni managed to imitate the reality of nature with deceptive accuracy by painterly means, a skill considered crucial by contemporary art theorists. Exploiting the possibilities of illusionistic painting, they simultaneously produced the sort of room decor recommended by Vitruvius in a manner appropriate to their time.

Another sequence of pictures that served to expand interior space was a series of nine tapestries presenting the story of Vertumnus and Pomona (plate 34), from Ovid's *Metamorphoses* (14.623–771), in a garden landscape. Each of the tapestries depicts an ornate pergola and a few restrained figures scaled to match the garden architecture. Surrounded by the entire series, a courtly gathering was transported out into a garden. The series is thought to have been designed by Jan Cornelisz. Vermeyen, who is described as "practiced in geometry, surveying, and other sciences" by his first biographer, the painter and writer Karel van Mander, in his *Schilder-Boeck* from 1604. The extraordinary popularity of the series is apparent from the fact that five editions of it survive from the sixteenth century alone, all of them bearing the Brussels city mark. The piece illustrated here comes from an incomplete edition ordered from the Brussels weaver Willem de Pannemaecker by Philip II around 1560. A series woven after the same cartoons that is now in Vienna was acquired by the governess of the Netherlands, Mary of Hungary, in 1548 from a certain Joris Wezeleer, an art dealer who specialized in decorative pieces for the court, primarily goldsmithing and tapestries. Archduke Albrecht von Habsburg and the Spanish infanta Clara Isabella Eugenia, who ruled the Netherlands jointly beginning in 1598, later commissioned other editions of the series, using them as gifts in their diplomatic relations with other courts.

As already mentioned, wall paintings served as less expensive substitutes for costly tapestries, and in the Netherlands countless city palaces and villas were decorated with them. Especially popular, in addition to chorographic representations, were illustrations of seasonal labors. They could be combined into decorative and allusive programs consisting of any number of scenes, depending on the size of the room. Pieter Brueghel the Younger's *Spring* (plate 35) comes from a four-part series executed between 1622 and 1635. Twenty-four surviving versions of his picture attest to the extraordinary popularity of the composition, based on a design by Pieter Bruegel the Elder. The younger Pieter, his oldest son, had inherited his workshop and design material, and employed numerous assistants producing paintings after the same stock of preliminary drawings. The finished works bore the name of the workshop's

33
Paul Bril (c. 1553/54–1626)
Guido Reni (1575–1642)
CEILING OF THE SALA DELLA PERGOLA
1611–12
Palazzo Rospigliosi Pallavicini, Rome

Paul Bril's illusionistic ceiling paintings virtually draw the garden inside. Guido Reni enriched the design of the ceiling with putti, which were admired by contemporaries for their highly varied, animated poses.

34

Workshop of Willem de Pannemaecker (active 1535–1578)
After a design by Jan Cornelisz. Vermeyen
(c. 1500–1559)
VERTUMNUS AND POMONA
c. 1560
Tapestry, 14 ft. 1 in. × 21 ft. 3 in. (430 × 648 cm)
Patrimonio Nacional de España, Madrid

The tapestry series illustrates Ovid's story of the love of Vertumnus, the ancient Italian god of the changing year, for the nymph Pomona, who had dedicated herself wholly to garden work and wanted nothing to do with men. Hoping to win her, Vertumnus turned himself into various working men. But it was only after the god took the form of an old woman and convinced her of the folly of remaining single, then turned back into the handsome youth that he was, that she submitted to his wooing.

director, which became a virtual trademark. It did not guarantee that the master had had a hand in the work, only that its execution was of a distinguished quality. As a successful entrepreneur, Brueghel assured his survival by means of mass production and skillful marketing to an art market that was already saturated. His younger brother took a different path.

Jan Brueghel, unlike Pieter the Younger, was little influenced by his father, who died when he was only an infant. Jan developed his own highly idiosyncratic idiom. He specialized in small-format works in fine painting, with which he supplied a constantly growing market of upper-class, well-to-do collectors. After finishing his apprenticeship in Antwerp, he traveled to Italy, where he found patrons in the cardinals Ascanio Colonna and Federico Borromeo, who greatly admired his flower paintings and intricate landscapes, narrative scenes, and genre paintings. His cabinet pictures were in particular demand because of their exceptional painterly finesse; their subtle use of color and radiant palette earned him the nickname Flueweelen-Brueghel ("Velvet Brueghel"). In 1610 he was named court painter to the archdukes, by which time he was already a painter in great demand. As early as 1599 it was noted by Blasius Hütter, the secretary to Archduke Albrecht von Habsburg, that Jan Brueghel was "the best master for small figures." Around 1616 Jan Brueghel painted for a princely decorative program his *Allegory of Spring* (plate 36). The painting, executed on copper, shows a typical seventeenth-century garden terrace in resplendent bloom. On it there are a number of mythological figures painted by Hendrik

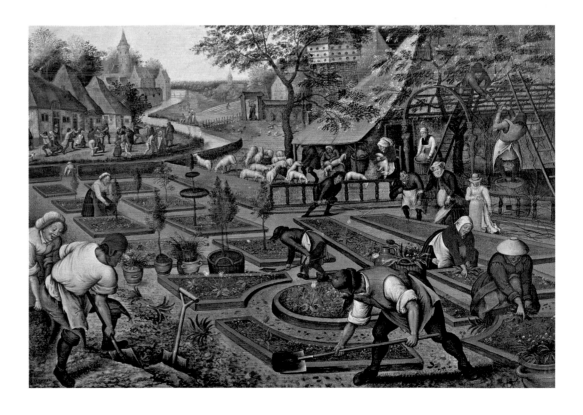

35
Pieter Brueghel the Younger (1564/65–1637/38)
Spring
between 1622–35
Oil on wood, 16¹⁵⁄₁₆ × 23¼ in. (43 × 59 cm)
Muzeul National de Arta, Bucharest, Romania

Part of a series of four pictures of seasonal activities, this painting illustrates spring chores in a garden. The edges of the raised beds are being firmed up, the soil prepared, and the first plantings set out.

Detail on pages 80–81

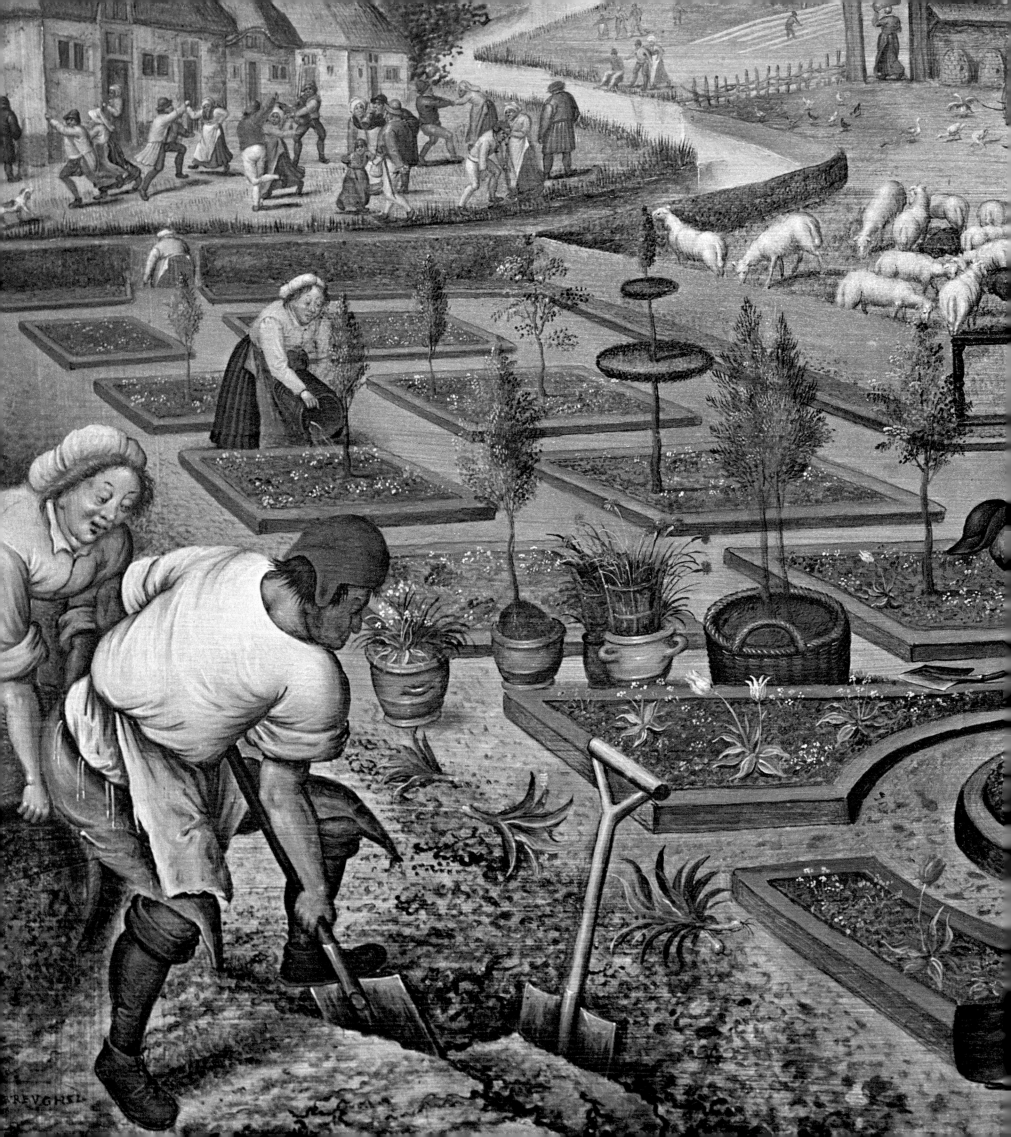

36
Jan Brueghel the Elder (1568–1625)
Hendrik van Balen (1575–1632)
ALLEGORY OF SPRING
c. 1616
Oil on copper, 22⁷⁄₁₆ × 33½ in. (57 × 85 cm)
Bayerische Staatsgemäldesammlungen,
Alte Pinakothek, Munich

*In a garden that also serves as a symbol of benign rule thanks to the
view of Château Mariemont in the background, Flora, the traditional
personification of spring, sits enthroned, accompanied by the goddess
Ceres and her retinue. Triptolemus, who at Ceres' behest spread the
practice of agriculture that she invented, steps in from the left. Behind
him are a monk and a nun, who in the context of this evocation of a
season represent the church's approval of the contemplation of nature.*

van Balen. For these, just as in Botticelli's *Primavera* (plate 21), Ovid's *Fasti* (4.507–62; 5.183–260) served as a source. With its view of Château Mariemont in the background, the picture of a flourishing spring garden is precisely situated in the realm of the Netherlandish rulers Isabella and Albrecht. In addition to its evocation of the classical *aurea aetas*, it reflects the idea, derived from medieval princely iconography, that a ruler's residence is an earthly paradise.

At the Archducal court emphasis was placed on the spiritual benefits that could be derived from gardening and other outdoor pursuits. Enjoyment of nature was encouraged with the creation of parks and gardens and edicts limited woodcutting and hunting rights. One result of this interest was the restoration of Château Mariemont, erected by Mary of Hungary as a hunting lodge. It was now redesigned in the style of an Italian villa by the engineer Pierre Le Poivre. In 1612 Jan Brueghel captured the château and its parklike garden in a chorographic view (plate 37). The smooth transition from the palace garden into the surrounding landscape was intended to reflect the amicable relationship between the sovereigns and their subjects and the subjection of the countryside around Mariemont to Archducal authority. As early as 1539 the prelate Antonio de Guevara, who tutored princes at the court of Charles V, had urged his charges to take an example from the labors of the humble peasant, which were pleasing to God. He assured them that field work was a form of worship appropriate even to a ruler. It was in this sense that the governors of the Habsburg Netherlands engaged in farm labor themselves. Isabella and her ladies-in-waiting worked in the fields during haying season at Mariemont, an activity that was illustrated by Jan Brueghel. Field work was considered a courtly virtue, the ultimate demonstration of humility. With his picture of Château Mariemont, Brueghel also made a contribution to courtly pictorial propaganda. The estate grounds were meant to yield harvests, but in line with Vitruvius's urging that one "artificially correct what unfavorable conditions nature presents by chance" (6.1), the painter gave them a scenic loveliness rather than representing them in precise detail. Nevertheless, the resulting picture was a convincing illustration, just like the view of the Heidelberg Castle garden painted by Jacques Fouquières. The so-called *Hortus Palatinus* (plate 38) had been laid out at the behest of the Elector Palatine Friedrich V by the French architect and engineer Salomon des Caus. In 1616, even before it was completed, a set of engravings was published that illustrated its design. Among the views is one corresponding to the Fouquières painting, showing the large terraces and the garden parterres, the grove of Seville oranges, and the terrace with beds of annuals. In the painting one can only imagine the large grotto and the pools and fountains. The large-format picture shows the garden in an idealized form that was ultimately never achieved, but as a representation of the prince's imposing property, it too served as an effective showpiece when hung in one of the castle's halls.

Detail from plate 36

37
Jan Brueghel the Elder
Château and Park Mariemont
1612
Oil on canvas, 6 ft. 1 in. × 9 ft. 7 in. (185 × 292 cm)
Musée des Beaux-Arts, Dijon, France

The portal in the right foreground marks the entrance to Albrecht and Isabella's estate. The painting emphasizes the smooth transition between the garden and the carefully harvested woods and fields, which were just as much a part of the display of princely authority as the palace and garden themselves.

In imitation of this princely convention of decorating residences with views of one's own palaces and estates, it became increasingly fashionable in middle-class circles to hang in one's home seemingly realistic renderings of landscapes, palaces, gardens, and parks. These not only conformed to the classical ideal of decoration and were soothing to look at, as Alberti had stressed, but were also effective status symbols. And those who had no gardens of their own could create the flair of a courtly ambience with a picture like Sebastian Vrancx's *Banquet in an Italian Palace Garden* (plate 39). Italian garden design as depicted by Vrancx was highly admired in elite Antwerp circles, and they attempted to replicate it to the best of their ability. The appearance during the pause between courses of a Commedia dell'Arte troupe—seen here on the right—was also a reflection of contemporary custom. Moreover, the event lent itself to a moralistic interpretation based on the parable of the poor Lazarus

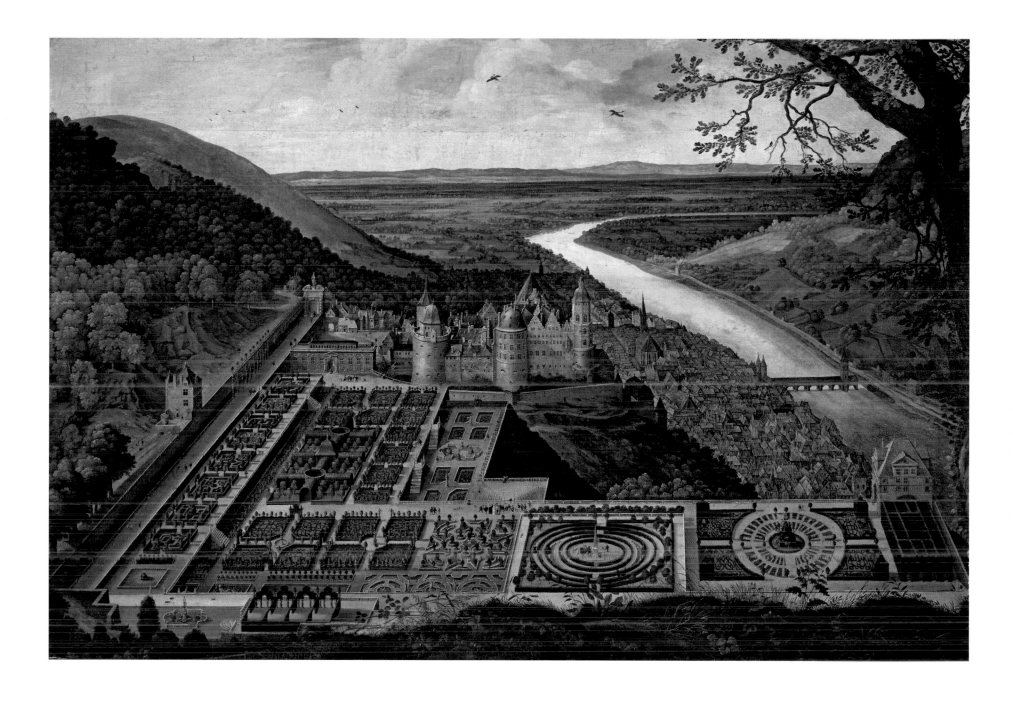

38

Jacques Fouquières (c. 1580/90–1659)
HORTUS PALATINUS
before 1620
Oil on canvas, 5 ft. 10¼ in. × 8 ft. 6½ in.
(178.5 × 263 cm)
Kurpfälzisches Museum, Heidelberg,
Germany

In this idealized view of the planned garden for the Heidelberg Palace, the L-shaped lower terrace with squares of flower beds flanks a pool with allegories of the Rhine and Neckar rivers and a personification of the Rhine symbolizing the territory of the Palatinate. Like the overall garden layout, the nearby statues of Ceres and Flora were meant to represent the principality's flourishing condition.

Detail on pages 86–87

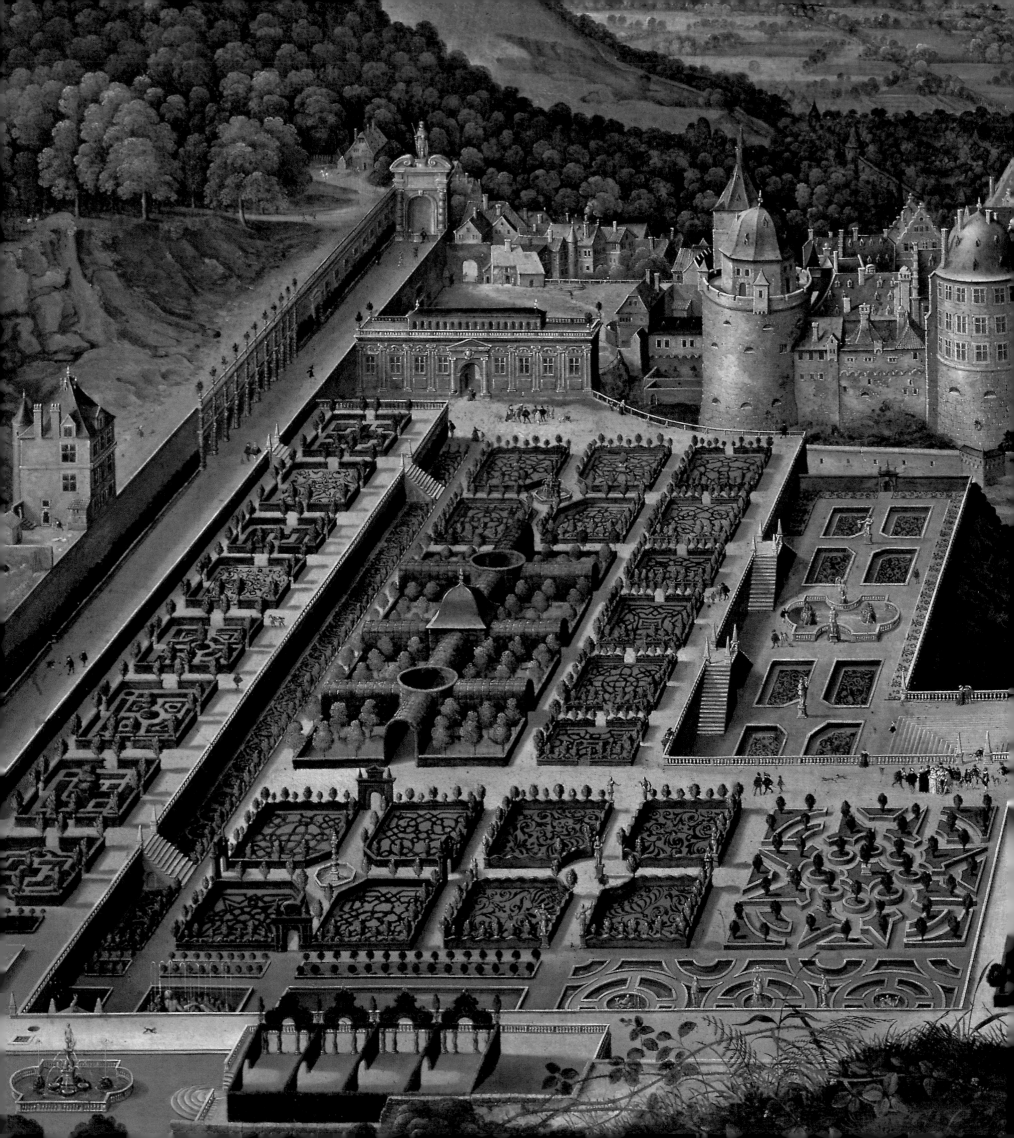

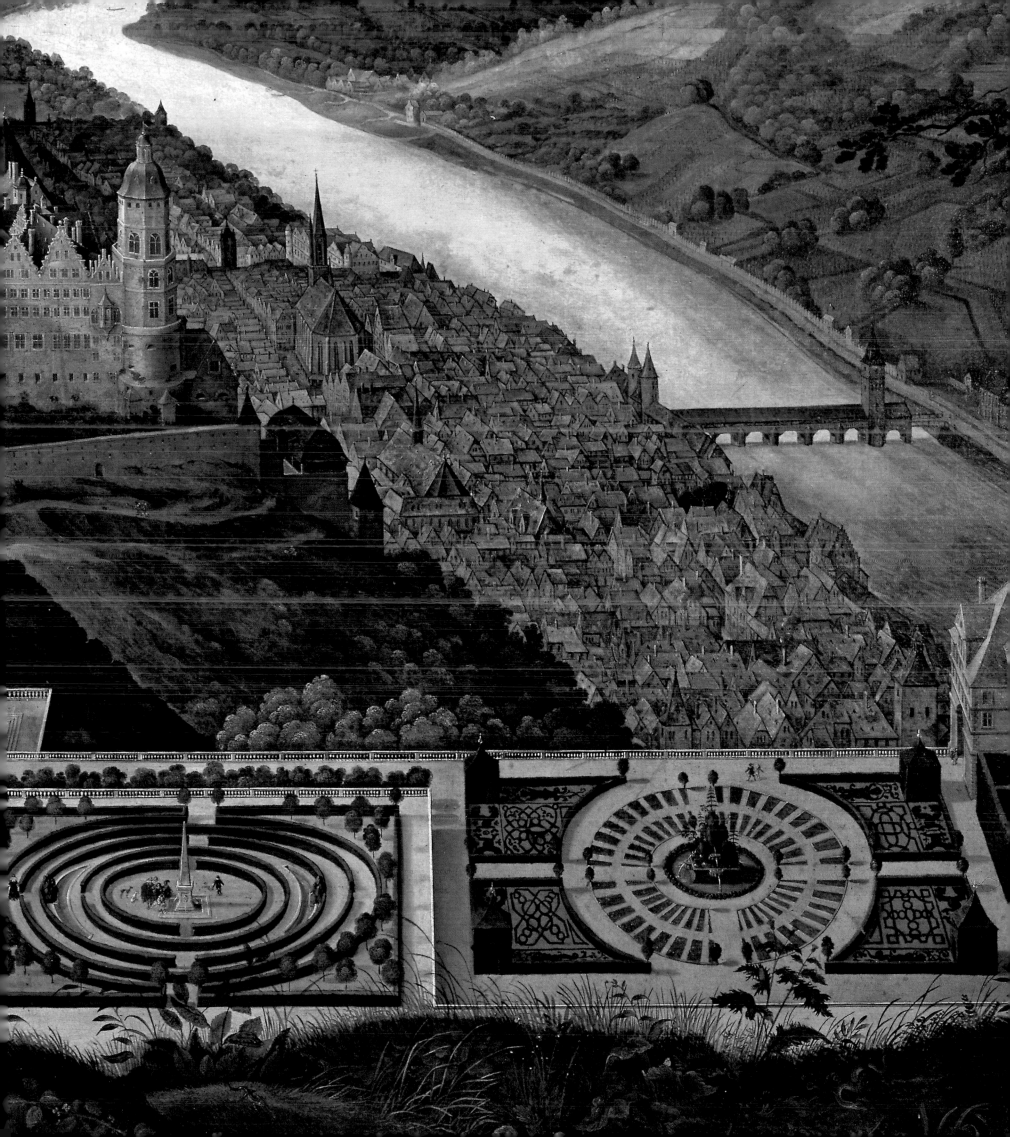

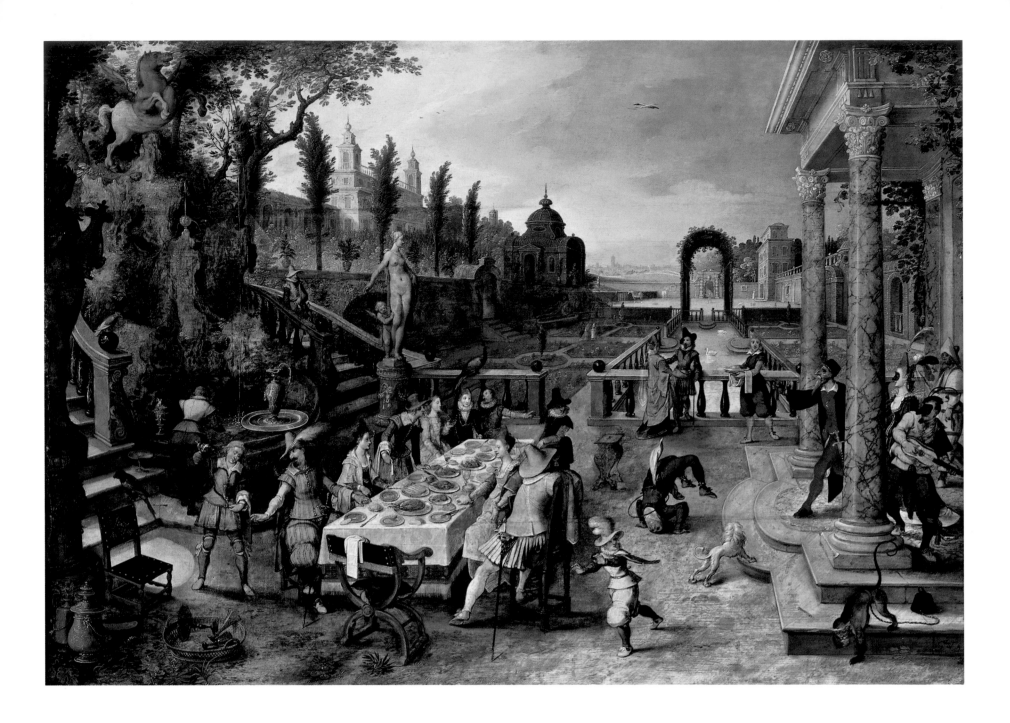

39
Sebastian Vrancx (1573–1647)
Banquet in an Italian Palace Garden
c. 1610/20
Oil on oak panel, 35¹³⁄₁₆ × 49⅝ in. (91 × 126 cm)
Szépművészeti Museum, Budapest

This painting illustrates the type of Italian garden design imitated by the Antwerp upper class at the time. Such a picture also inspired contemplation and discussion. For example, the Pegasus above the fountain on the left—the winged horse whose hoof striking the ground unleashed the spring of poetic inspiration on Mount Parnassus, home of the Muses—was a symbol universally understood.

presented in the gospel of Saint Luke (16:27–31). In it an evil rich man condemned to the torments of hell begs that his five brothers be warned of what awaits them. Here five men and their wives are gathered around the groaning table; the empty chair at the head of the table could be a reference to the deceased rich man.

Another reflection of actual garden architecture is the picture of a grotto that Jan Brueghel painted around 1620, on which Hendrick de Clerck added the figures of Odysseus and Calypso (plate 40). Odysseus's sojourn in the realm of the nymph Calypso, described by Homer, has been transferred to a garden grotto of the sort that Salomon de Caus had designed between 1600 and 1602 for the park adjacent to Albrecht and Isabella's palace in Brussels. In that grotto, which de Clerck and Brueghel must surely have seen, some 24,000

abalone shells and 800 *porcelaines* had been turned into a glittering imitation of nature. There was also a water organ, like the one shown in the painting to the left of the center.

A less elaborately decorated grotto was illustrated by Peter Paul Rubens in his so-called *Garden of Love* (plate 41). In this painting, produced after 1632, a number of young women and their admirers have convened in a garden, identified by the fountain figure of a Venus with milk spouting from her breasts as belonging to the realm of the love goddess. Among her attendants are the Three Graces, who are ornamental to the background grotto as fountain figures, and the winged cupids, by means of which Rubens transports the figures in contemporary costume into the realm of myth. The actual focus of the

40
Hendrick de Clerck (1570–1629)
Jan Brueghel the Elder
ODYSSEUS AND CALYPSO
c. 1620
Oil on copper, 13⅝ × 19½ in. (34.6 × 49.5 cm)
Collection Johnny van Haeften Gallery, London

In the Odyssey *(5.63–74) Homer describes the home of the nymph Calypso as an idyllic, carefully cultivated natural setting. In this cave, imagined by Jan Brueghel as a garden grotto, Hendrick de Clerck painted the man and nymph, whose intertwining legs would have suggested to contemporaries that they were engaged in intercourse.*

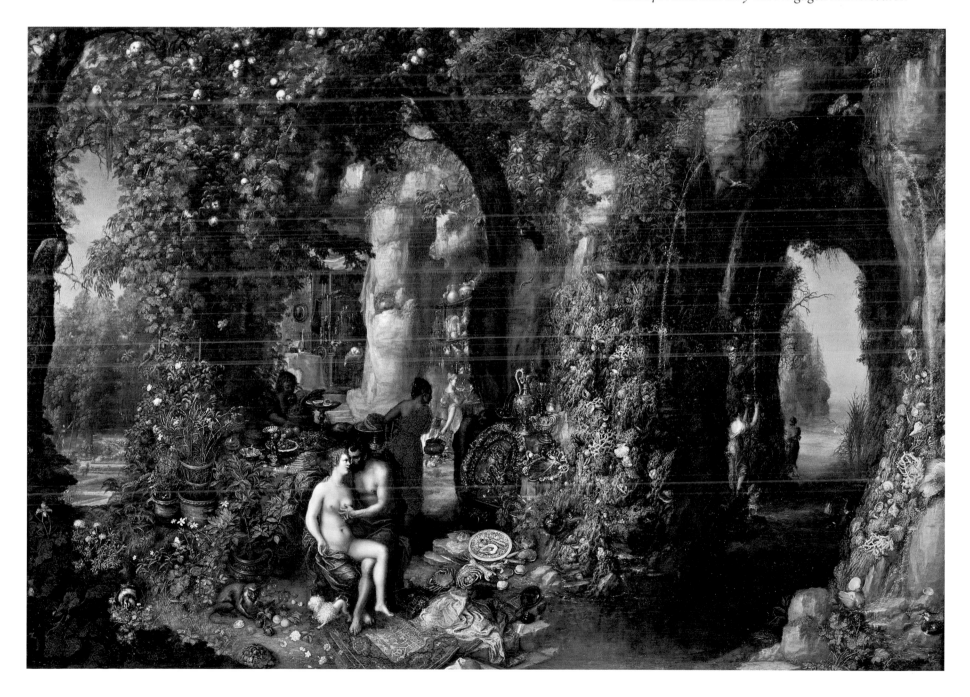

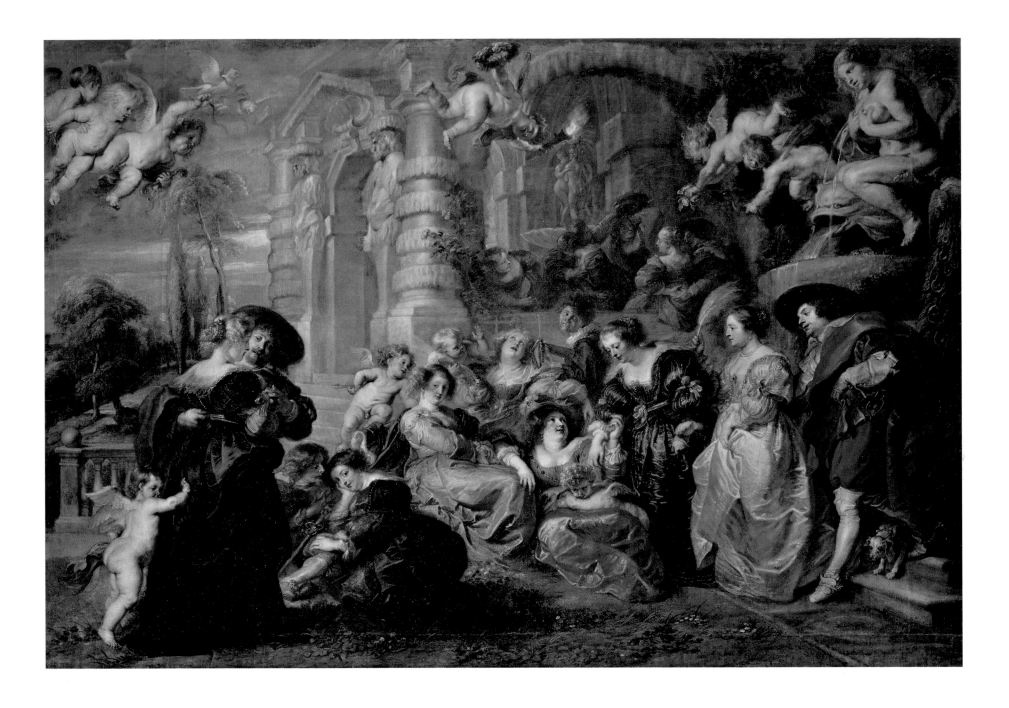

41
Peter Paul Rubens (1577–1640)
GARDEN OF LOVE
after 1632
Oil on wood, 6 ft. 6 in. × 9 ft. 3½ in. (198 × 283 cm)
Museo del Prado, Madrid

In this painting, referred to in 1645 as Conversatie
à la mode, *Rubens pictured an amorous encounter
between the sexes—the sort that was conventional
at court—with both erotic allusions and moral
appeals to moderation. With its garden and grotto
setting, the picture is connected to the erotic court
culture that in the Netherlands had a vivid tradition
since the late Middle Ages.*

scene, characterized in 1657 as a "conversation of virgins," appears to be the marriage yoke being flown in by putti, accompanied by Venus's doves. With it the depiction becomes an illustration of the seduction of marriage, altogether conforming to convention. This picture of cultivated courtly eroticism must have been directed at members of the Brussels court. The monumental work was repeated in numerous copies, and although it was painted at about the same time as Rubens's second marriage, to Helene Fourment, it is doubtful whether it was intended to be autobiographical. Like many members of Antwerp's upper class, Rubens himself, as though in obedience to the stoic recommendations of the philosopher Justus Lipsius, commissioned an extensive garden that he used for relaxation. There was a parterre with a fountain in the center adorned with a sculpture, and a lush, box-bordered tulip bed reaching through a four-columned gate. There were arbors, caryatids in stone and

42 (below)
Peter Paul Rubens and workshop
PETER PAUL RUBENS WITH HELENE FOURMENT
AND NICOLAAS RUBENS IN THE GARDEN
c. 1630
Oil on wood, 38⁹⁄₁₆ × 51³⁄₈ in. (98 × 130.5 cm)
Bayerische Staatsgemäldesammlungen,
Alte Pinakothek, Munich

Detail on pages 92–93

In its composition and motifs, this painting is
not unlike the family portraits posed against the
background of their own parks commissioned by
aristocrats in the southern Netherlands. Both the
elaborate garden structures and the floral splendor
displayed were luxuries reserved for the upper classes,
and thus clear evidence of social distinction.

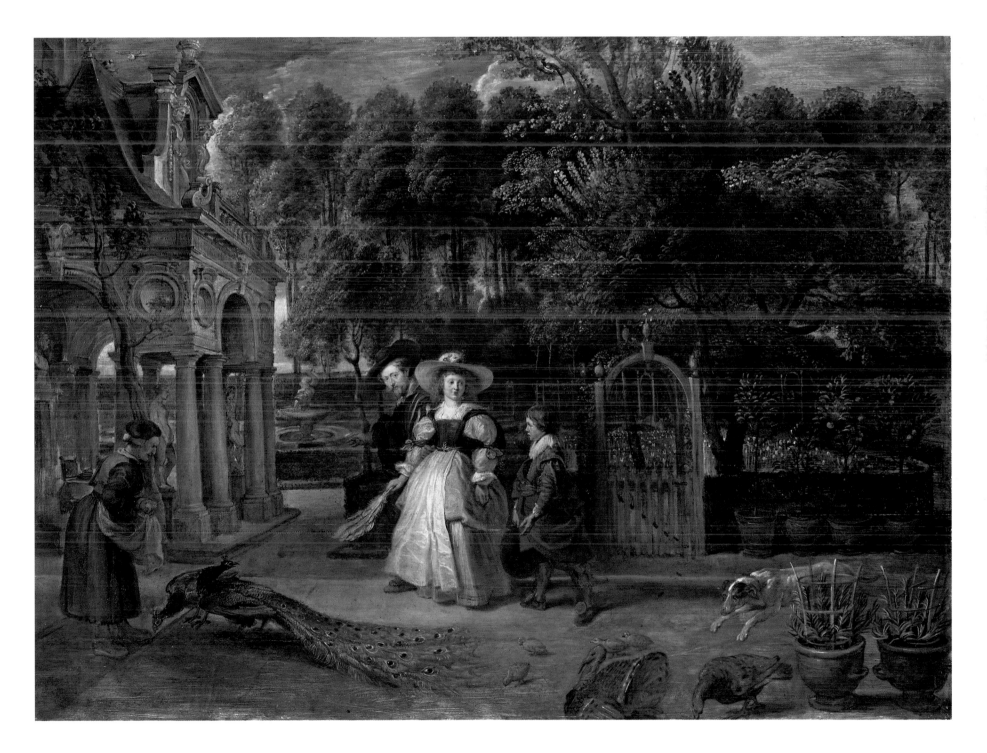

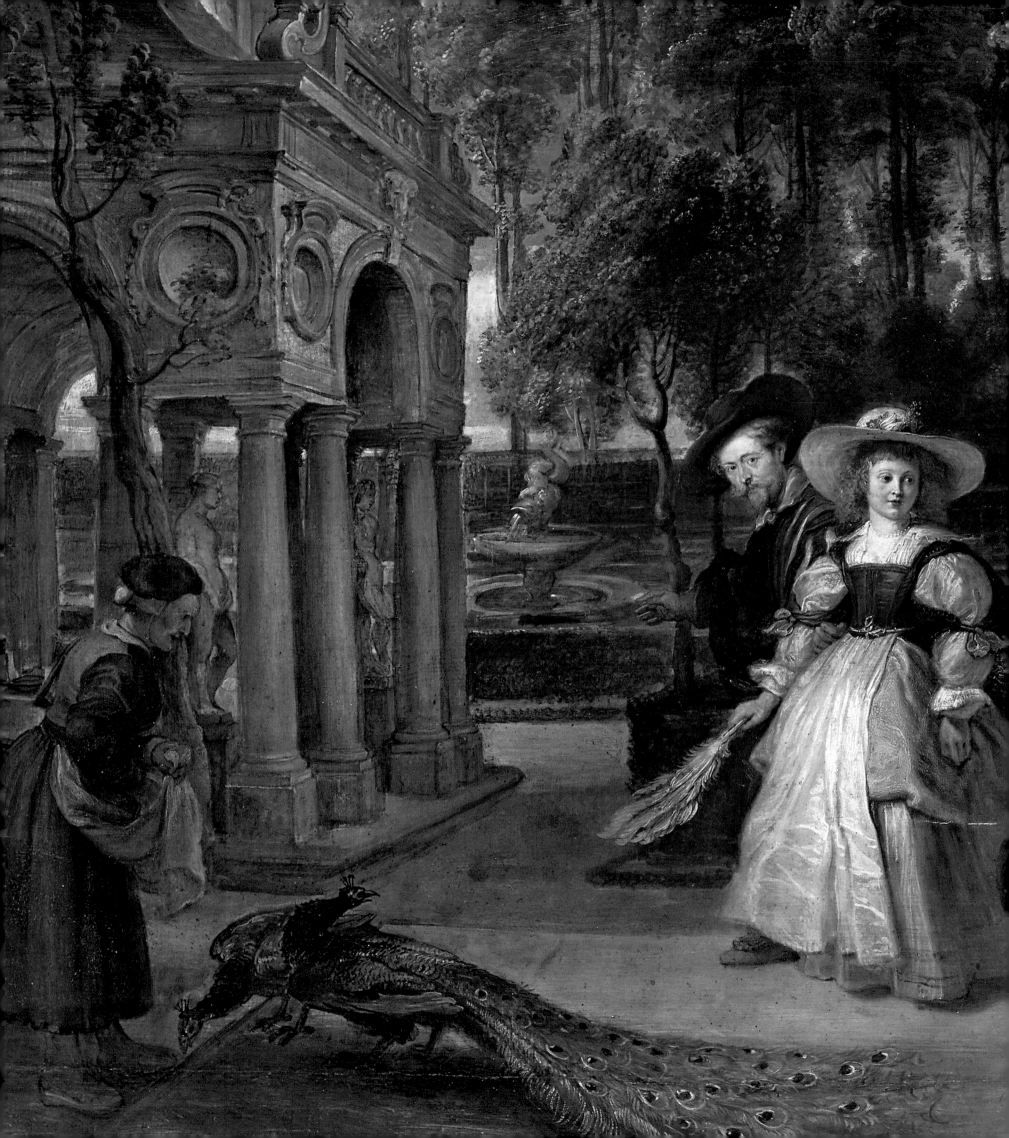

wood, climbing roses, a pergola, orange trees planted in large tubs, trellised vines, and various birds—perhaps even a parrot and other rarities—as can be seen in a painting of his garden. The place also boasted fruit trees and other useful plants, even Roussillon pears and figs that found their way to his table. The garden, which can now be reconstructed only on the basis of descriptions and paintings, was a major part of the ostentatious setting Rubens created for himself. His assumption of social prestige is obvious from a portrait, painted around 1630, by which time he had been ennobled, showing himself in the garden with his wife and child, known as *Peter Paul Rubens with Helene Fourment and Nicolaas Rubens in the Garden* (plate 42). By creating his garden and picturing himself as its owner in his paintings, he demonstrated his credentials as a member of Antwerp's urban elite in a way that anyone could understand.

Through cultural exchange between the courts of Europe it had become customary that portraits adhere to a degree of decorum; dignified poses and serious expressions were expected. According to these unwritten but widely accepted rules, it was considered improper for a sitter to give free rein to his emotions—to smile, for example. In this period, when the assertion that it was difficult to make Archduke Albrecht smile was taken as a form of praise, one

43
Frans Hals (1580–1666)
ISAAC MASSA AND BEATRIX
VAN DER LAEN
c. 1622
Oil on canvas, 55⅛ × 65½ in.
(140 × 166.5 cm)
Rijksmuseum, Amsterdam

Just as in Titian's picture of Venus and the organ player (plate 29), the peacocks, the fountain, and the strolling couple underscore the garden's symbolic significance. In this portrait of a married couple, the garden clearly serves as a garden of love.

searches in vain for even the slightest smirk in official portraits. Even in the northern Netherlands the people patterned themselves after the court, and it was generally considered, as one contemporary put it, that a man "should control his laughter." If for this reason alone, Frans Hals's portrait of *Isaac Massa and Beatrix van der Laen* (plate 43), painted around 1622, represents a breach of custom. Hals took up the type of the outdoor husband-and-wife portrait developed by Rubens in his *Self-portrait with Isabella Brant in the Honeysuckle Bower* (Munich, Alte Pinakothek), and gave it a wholly new twist. In his painting he portrays a well-dressed couple seated in highly relaxed poses in a garden. It is obvious that this is a wedding portrait, and not only from the prominently displayed ring on the woman's right forefinger or the fact that, following traditional iconography, she sits on her husband's left. In this painting the garden, the classical realm of Venus, serves as a status symbol and an allusion to the motif of the love garden. Even the plants can be interpreted as symbols. The grapevine, seen winding around the tree trunk between the pair, had been described by Andrea Alciati in his *Emblematum liber* (12) as a symbol of friendship surviving death. As a symbol of unswerving loyalty it is prominently featured on the title page of Jacob Cats's *Houwelijck*, from 1625, the era's most popular book on marriage. The ivy twining across the ground can be interpreted similarly, for since antiquity it had been a symbol of faithfulness, just like the sea holly in the foreground (in the Netherlands such plants are commonly called *mannentrouw*, or "marital fidelity").

In the seventeenth-century Netherlands, with its rich visual culture, the language of pictures was widely understood. At that time, especially in the seven northern provinces, more pictures were painted there than in any other country in Europe. It has rightly been observed again and again that this development coincided with the enormous economic upswing enjoyed by the young republic. But not only were there more pictures in the Netherlands at that time, there were also far more painters, an abundance which in time resulted in an oversaturated art market and falling prices for paintings. Many painters were forced either to shift to some other career altogether or to paint only on the side. Among this group were brewers and bakers, tax collectors and mariners, art and stocking dealers, schoolteachers and brickmakers. Another possibility was to specialize, to reduce the time required to produce a painting and thereby production costs. Dirck Hals, for example, the younger brother of Frans Hals, specialized in depictions of elegantly dressed ladies and gentlemen and festive gatherings. Frequently these take the form of outdoor banquets, so-called *buitenpartijen*, like the *Fête Champêtre* (plate 44) from around 1624, which is set in an idyllic garden. The house and the park landscape are idealized; they do not represent an actual location so much as the traditional garden of love—though the painting is only superficially about pleasure and

44
Dirck Hals (1591–1656)
Fête Champêtre
c. 1624
Oil on wood, 30¾ × 54 in. (78 × 137 cm)
Rijksmuseum, Amsterdam

This picture of a cheerful gathering in a garden also contains an admonition to moderation. The monkey chained to a chair leg in the foreground symbolizes the man enslaved by his own desires. The animal holds out an apple, doubtless an allusion to the temptation that resulted in the expulsion from paradise.

Detail on page 95

sensuality. At a time when simple enjoyment of art for aesthetic or even psychological reasons was still a foreign concept, pictures were not meant to be mere illustrations; they were supposed to convey a message. In conformity to Horace's dictum *ut pictura poesis*, a painting was expected to contribute to the viewer's edification and amusement—*tot leering en vermaak*. Accordingly, this picture of a banquet could also be read as an admonition, a comment on the luxurious habits of the Dutch Republic's social elite.

In the 1630s the republic's wealthier citizens began moving out of the overcrowded cities in search of a bucolic Arcadia in which to find respite from the stress of commerce. The names they gave to their country estates are telling. The poet and *Emblemata* author Jacob Cats named his country place Sorghvliet ("Flight from Care"), and in the humanist tradition, just like Lipsius before him, he extolled the hours spent in his garden as a balm to his spirit. Cats described his idyllic life in the country in great detail: his reading, his nature walks, and the farm chores he did with his own hands. There he could devote himself completely to the arts and sciences, seeing God in everything—not

45
Pieter de Hooch (1629–1683)
THREE WOMEN AND A MAN IN A
COURTYARD BEHIND A HOUSE
c. 1663/65
Oil on canvas, 23⅝ × 18 in. (60 × 45.7 cm)
Rijksmuseum, Amsterdam

This everyday scene appears to have been drawn directly from life. The house and garden seem so true to nature that one could assume that this is an immediate reflection of reality. In fact, however, the painting was based on detailed drawings that were used, in new configurations, as the patterns for other pictures as well.

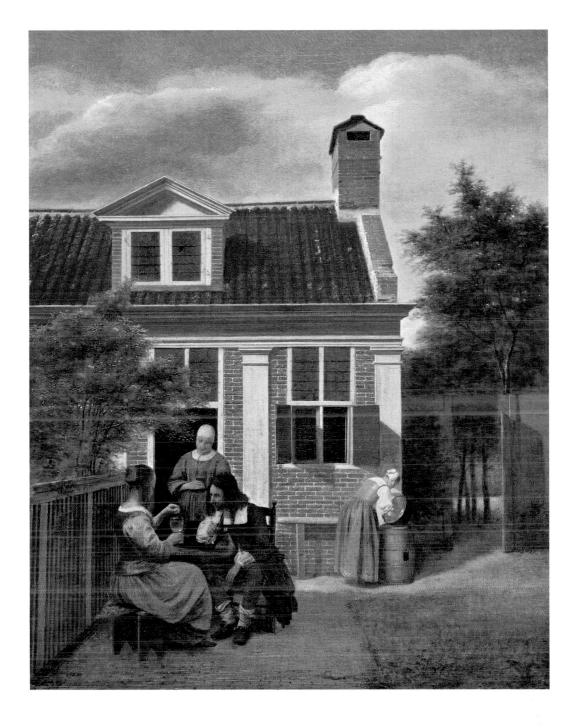

just the garden itself; even pictures of it invited meditation on God and His creation. As the Dutch profession of faith puts it: "The whole visible world is like a lovely book, one in which all creatures, large and small, are the letters, and reveal to us hidden aspects of God." Even to the eyes of Protestants who did not follow the teachings of Calvin, narrative pictures could reveal aspects of divinity just as clearly as genre paintings and portraits, landscapes and garden pictures. Their individual motifs could be variously interpreted; the engravings of Jacob Cats's *Zinne- en Minnebeelden*, in which each emblem is interpreted in three completely different ways, is a good example of this. That the individual images lacked a single, exclusive meaning was altogether intended. As Cats relates elsewhere, "Experience teaches that many things are

46
Adriaen van de Velde (1636–1672)
FARMYARD
1666
Oil on canvas, mounted on wood panel,
24¹³⁄₁₆ × 30¹¹⁄₁₆ in. (63 × 78 cm)
Staatliche Museen, Stiftung Preussischer
Kulturbesitz, Gemäldegalerie, Berlin

This atmospheric picture of a farmyard used as grazing land is an expression of the conviction, common in the Netherlands, that the beauty of Arcadia lies at one's own doorstep.

47

47 (page 99)
Diego Rodríguez de Silva y Velázquez
(1599–1660)
Garden of the Villa Medici
1630
Oil on canvas, 19⅛ × 16¹⁵⁄₁₆ in. (48.5 × 43 cm)
Museo del Prado, Madrid

If one is to believe a contemporary report, during his Italian sojourn in 1630 Velázquez obeyed the lex hortorum, *or rule of the garden, appearing on two plaques at the Medici garden's entrance. It ends with the admonition to guests: "Once you have entered, it is permitted to admire and delight in these gardens created at great expense by Ferdinando de Medici; it would be inappropriate to ask for more."*

better when they are not seen altogether clearly, but strike one as somewhat disguised and shadowy."

The paintings of the Delft painter Pieter de Hooch, for example, would appear to have no hidden meanings. De Hooch, a contemporary and colleague of Jan Vermeer, specialized in painting interiors with glimpses of rooms beyond rooms. He also painted pictures of courtyards and gardens that reflect his interest in the painterly illusion of space. In his *Three Women and a Man in a Courtyard behind a House* (plate 45), he pictures the inner courtyard of a house in Delft and a garden shaded by trees. The receding lines of the fence on the left direct the viewer's gaze to the group gathered around a table. A woman standing with a glass in her hand and a man with a pipe are watching as a younger, seated woman squeezes a lemon over a glass. This is a visual translation of the saying, "It is good when after the sour two lovers taste the sweet again," or perhaps an allusion to Jacob Cats's comment in his *Silenus Alcibiadis* that nothing is sweeter than what follows the sour—"niets soets en heeft yet soets, dan nae vorgaende suer." But aside from its implicit content, the picture was created for a public that could appreciate the realism in its rendering of nature.

The same is true of the so-called *Farmyard* (plate 46) by the Haarlem painter Adriaen van de Velde. The painting, executed in 1666, presents a view of the garden section of a farmyard set off with a high wooden fence and flanked by additional gardens and courtyards. The tree-studded grazing area, rendered in contrasting light and shadow, elevates a Dutch farmstead into an Arcadian landscape. The pride in the country's natural beauty expressed here would make patriotic symbols of Holland's cows and landscapes. In the political propaganda of the period, the "Dutch garden" that was to be defended against encroaching enemies can often be seen even in prints and on handbills.

Although paintings like van de Velde's *Farmyard* were popular among collectors even beyond the borders of the northern Netherlands, and their subjects legitimized by the classical writings of Vitruvius and Pliny, contemporary art theory tended to view them with skepticism. Seventeenth-century Italian and French theorists were largely of the opinion that narrative painting, with its depictions of the story of salvation or the heroic deeds of gods and men, was the only truly worthy genre and the only justification for representations of nature. The use of such secondary elements as landscapes and gardens for actual subject matter in painting was held to be a deviation peculiar to the art of the Netherlands. Accordingly, the *Garden of the Villa Medici* (plate 47) by the Spanish court painter Diego Rodríguez de Silva y Velázquez, known mainly for his portraits and large-format narrative paintings, constitutes a definite exception. For stylistic reasons scholars have tended to date this remarkable work to 1650–51, the artist's second sojourn in Italy, but it was surely painted in late April 1630, during his first visit. At that time Velázquez wished to escape

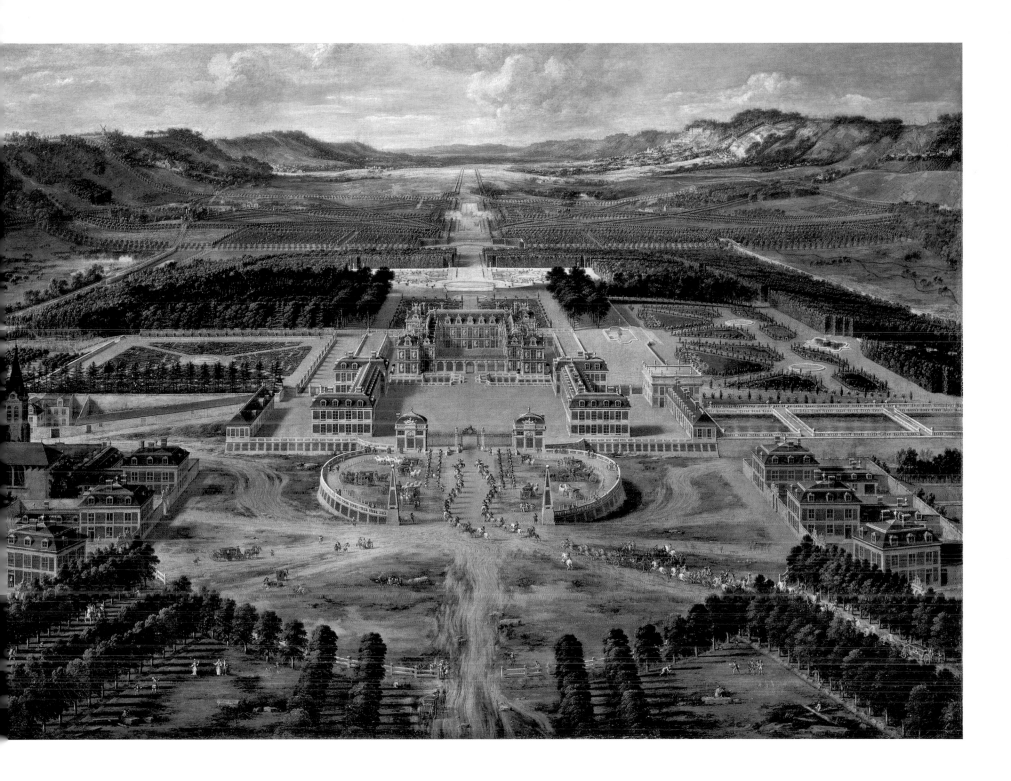

48
Pierre Patel (c. 1605–1676)
VIEW OF VERSAILLES
1668
Oil on canvas, 45¼ × 63⅜ in.
(115 × 161 cm)
Château et Trianons, Versailles

The garden designed for Louis XIV was the official stage for courtly displays and allegorical self-aggrandizement. Within this formal setting the court functioned according to strict rules of ceremony and etiquette. It was perfectly capable of appreciating the king's identification with Apollo, expressed in the park's statuary, and interpreting his role-playing in allegorical court festivities as an expression of limitless self-esteem.

Detail on page 103

the heat, and saw the hilltop Villa Medici, with its extensive gardens, as an ideal place to spend the summer. Manuel de Fonseca y Zúniga, count of Monterrey and the Spanish ambassador, took the matter in hand, and on May 4 he was informed that a room in the villa would be placed at the painter's disposal. According to his fellow painter Francisco Pacheco, who presumably heard it firsthand, Velázquez made numerous studies at the Villa Medici, "where there were remarkable classical statues to be copied." It was at that time that he produced this garden picture as well. Along with three "small landscapes," the work was purchased from Velázquez by the king's secretary Jéronimo de Villanueva in 1634. The two pictures of the garden of the Villa Medici that are still in Madrid are regularly mentioned in the inventories of the Alcázar beginning in 1666; the view of the Ariadne Pavilion is consistently referred to as a "landscape," whereas the painting reproduced here is simply called "garden." Remarkably, the former was given a higher value. Although the same size, it was appraised at 20 ducats, precisely twice as much as the picture of two men in front of the grotto loggia. Velázquez had chosen the setting for a simple, everyday scene, not with the intention of picturing a specific garden, and for a long time the location was not identified. The painting could have represented any garden at all—yet it was the work of Velázquez, after all, a fact that was also mentioned in the earliest inventories. That such a picture, doubtless uncommissioned, should have found its way into a princely collection as testimony to a particular artistic style was highly unusual at the time.

A clear distinction was already being made between pictures that "merely" represented a specific place and more ambitious compositions illustrating historic events, or at least infusing nature with an idealized beauty. In this sense the *View of Versailles* (plate 48) painted in 1668 by the French landscape painter Pierre Patel was nothing but an ordinary chorograph, though at the same time it served to symbolize regal authority. The painting was one of a whole series of views of royal palaces, now lost, for which, according to surviving account books of the Bâtiments du Roi, Patel received payments between 1668 and 1676. Despite its panoramic expanse, the imaginary bird's-eye view was still incapable of capturing the entire garden, which appears to extend outward to infinity from the central palace. Patel nevertheless managed to produce a pleasing picture of Le Nôtre's design, with its visual axes imposing structure on the landscape and thereby symbolizing the immense power of the monarchy. The garden at Versailles, the quintessential ruler's park and model for countless others in Europe, was certainly perceived as a symbol of the state. Critics of absolutist courts had harsh things to say about the type of garden design these courts practiced. In *The Moralists*, in 1709, Lord Shaftesbury characterized the "tailored" appearance of the French royal garden as a symbol of despotism, contrasting it with untouched nature as a symbol of freedom. A new age was dawning.

Opposite
Detail of plate 48

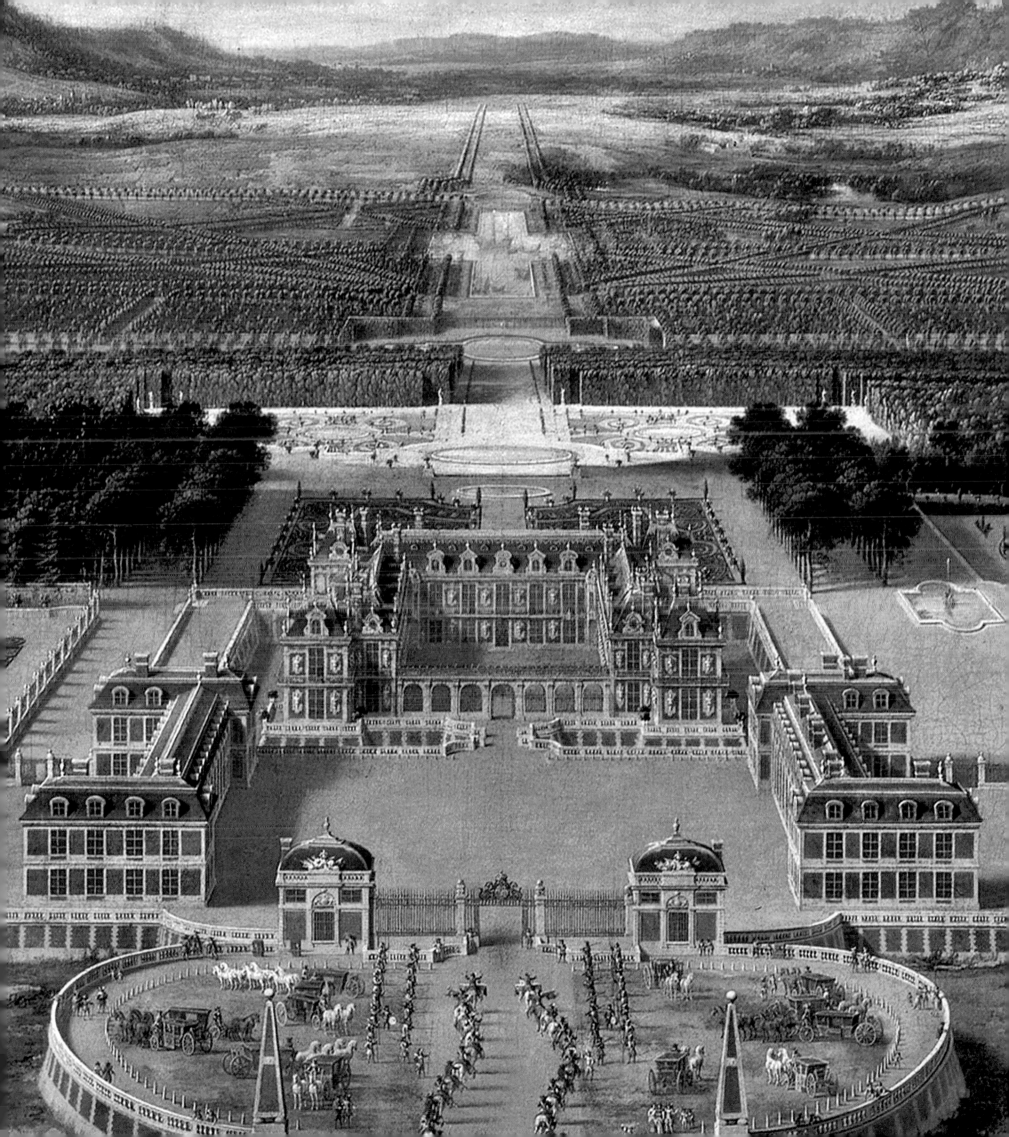

Old Subjects—New Ideals

The Régence, or early reign of Philippe II, duc d'Orléans, following the death of the Sun King in 1715, was for France a period of political and social renewal. The absolute norm of good taste, *le grand goût*, ceased to be universally recognized. In 1719, in his *Réflexions critiques sur la poésie et la peinture*, the abbé Du Bos distanced himself from the ideals represented by the Académie Royale and argued for the primacy of the senses and feelings over the intellect, or *raison*; readers welcomed his ideas. And in defiance of the hierarchy of mediums and genres upheld by the academy, which considered narrative painting to be the supreme form of artistic expression, the public began to demonstrate an enthusiasm for Netherlandish pictures from the seventeenth century, "lowly" in their subject matter but true to nature. Their influence is visible in the pictures of Jean-Antoine Watteau, which were in great demand at the time and treasured by influential connoisseurs and collectors, though upsetting to the academy. Watteau, the son of a roofer, was thought to be ill suited to the execution of "exalted" subjects owing to his low birth and modest education. On two occasions the painter took part in the Académie Royale's competitions. First prize would have brought him a scholarship in Rome, but Watteau's sole success was being listed as a candidate for full membership. The painting he finally submitted for admission, after repeated requests, confronted the academy with significant problems. It pictured several elegantly dressed couples in a parklike setting, and since it was neither a narrative painting, a genre painting, nor an ordinary landscape, it could not be assigned to any of the traditional categories. After considerable discussion it was decided to leave the classical hierarchy of genres untouched, but to grant Watteau the title *peintre* and accord him full membership, crediting him with the invention of a new genre, the *fête galante*. It is just such a scene that is pictured in his *Plaisirs d'amour* (plate 49), from around 1717, in which several stylish couples are relaxing in what must be the edge of a park or garden, which is adorned with a statue of Venus. The comte de Caylus relates that at the beginning of the painter's career, while he was still employed in the workshop of Claude Audran, Watteau made endless sketches of trees in the Jardin du Luxembourg, which, being "wilder and less well groomed than those of the other royal palaces, provided him with an infinite number of vantage points." This is precisely the sort of virtually natural landscape setting, as opposed to the contemporary French garden with its geometric, symmetrical layout and topiaries, that Watteau pictures in his paintings to suggest to an aristocratic public a utopian society, free from the constraints of etiquette and governed by love. These works were direct references to the tradition of the garden of love (plate 9).

49 (below and opposite)
Jean-Antoine Watteau (1684–1721)
Plaisirs d'amour
c. 1717
Oil on canvas, 24 × 29½ in. (61 × 75 cm)
Staatliche Museen, Stiftung Preussischer
Kulturbesitz, Gemäldegalerie, Berlin

In the tradition of the garden of love, Watteau creates a utopian world characterized by love, but at the same time, with the image of Venus snatching the quiver of love arrows away from her son Amor, warns against carnal desire. In the French edition of Cesare Ripa's popular Iconologia, *a compilation of allegorical symbols, the disarming of Amor, under the motto "Amour dompté," stands for the dangers of physical lust.*

50 (above and opposite)
Giovanni Battista Tiepolo (1696–1770 Madrid)
Rinaldo and Armida in Her Garden
c. 1742/45
Oil on canvas, 6 ft. 1½ in. × 8 ft. 6½ in.
(186.8 × 259.9 cm)
Art Institute, Chicago; Gift of James Deering

Following the literary source, the erotic encounter between the Christian knight Rinaldo and the heathen sorceress Armida takes place in her garden in Antioch. Tiepolo plays with the classical iconography of the garden of love and underscores the conflict between duty and desire by showing the messengers from Gottfried of Bouillon, who have come to free the hero, fallen into idleness and voluptuousness outside the walls of the enchanted garden, the realm of Venus.

Watteau must have been familiar with the Flemish version in Rubens's *Garden of Love* (plate 41), for the picture was readily available in the form of prints, and at least one version of it hung in Paris at the time. It includes telling details also found in Watteau's *Plaisirs d'amour*, like the head of Pan on the base of the Venus statue. The Latin *pan* also has the meaning *omnia*, which, when connected to the depiction of Venus and Amor, hints at the well-known *omnia vincit amor* ("love conquers all") from Virgil's *Eclogues*, a phrase widely quoted in Watteau's time.

Among the commonplace literary motifs that served courtly society as examples of the power of love and were accordingly repeatedly illustrated was the love affair of Rinaldo and Armida. Giovanni Battista Tiepolo's version of it (plate 50) is from a series of twelve pictures of varied format that he painted between 1742 and 1745, and that presumably once adorned an elegant reception room in the Palazzo Dolfin Manin on Venice's Grand Canal. All of them pictured scenes from Torquato Tasso's *Gerusalemme liberata*, or *Jerusalem Delivered*, published in 1581 and still widely read and admired in the eighteenth century. A central element in the plot of the poem, set in the era of the Crusades, is the love between the Christian knight Rinaldo and the heathen sorceress Armida. It reaches its culmination in the sixteenth canto, when two of Rinaldo's fellow warriors, Carlo and Ubaldo, discover the lovers in the palace garden, "he lying in her lap and she on the ground." As Tasso describes the scene, she gazes at a magic mirror while the two mercenaries stand transfixed at the gate, and Rinaldo cannot take his eyes away from her face. In Tiepolo's picture the two soldiers have not yet entered the garden, which is identified as the realm of Venus by the presence of Amor, thus underscoring the tension in the scene between eroticism and moralism—an ambiguity Tasso exploits as well.

Of course there were any number of patrons who wished their paintings of figures in garden or park landscapes—an increasingly popular genre—to be somewhat more explicit. In 1767 Baron Baillet de Saint-Julien, the treasurer of the French church, commissioned Jean-Honoré Fragonard to paint a picture of his mistress being pushed on a swing by her unsuspecting husband while in the foreground, beneath a sculpture of a chiding Amor, the baron himself appears as a hidden voyeur. Fragonard's *Swing* (plate 51) became the talk of Parisian society, and was widely known even before Nicolas de Lauray published an engraving after it in 1782 with the title *Les Hazards heureux de l'escarpolette* (The fortuitous possibilities of the swing). The motif of a man pushing a woman on a swing could be taken both as a metaphor for the traditional assignment of roles in courtship and as a direct allusion to sexual intercourse. In Fragonard's painting the flourishing garden serves as the setting for an erotic obsession, without any sort of moralizing commentary. Fragonard based this garden on drawings of trees and shrubs that he combined into a

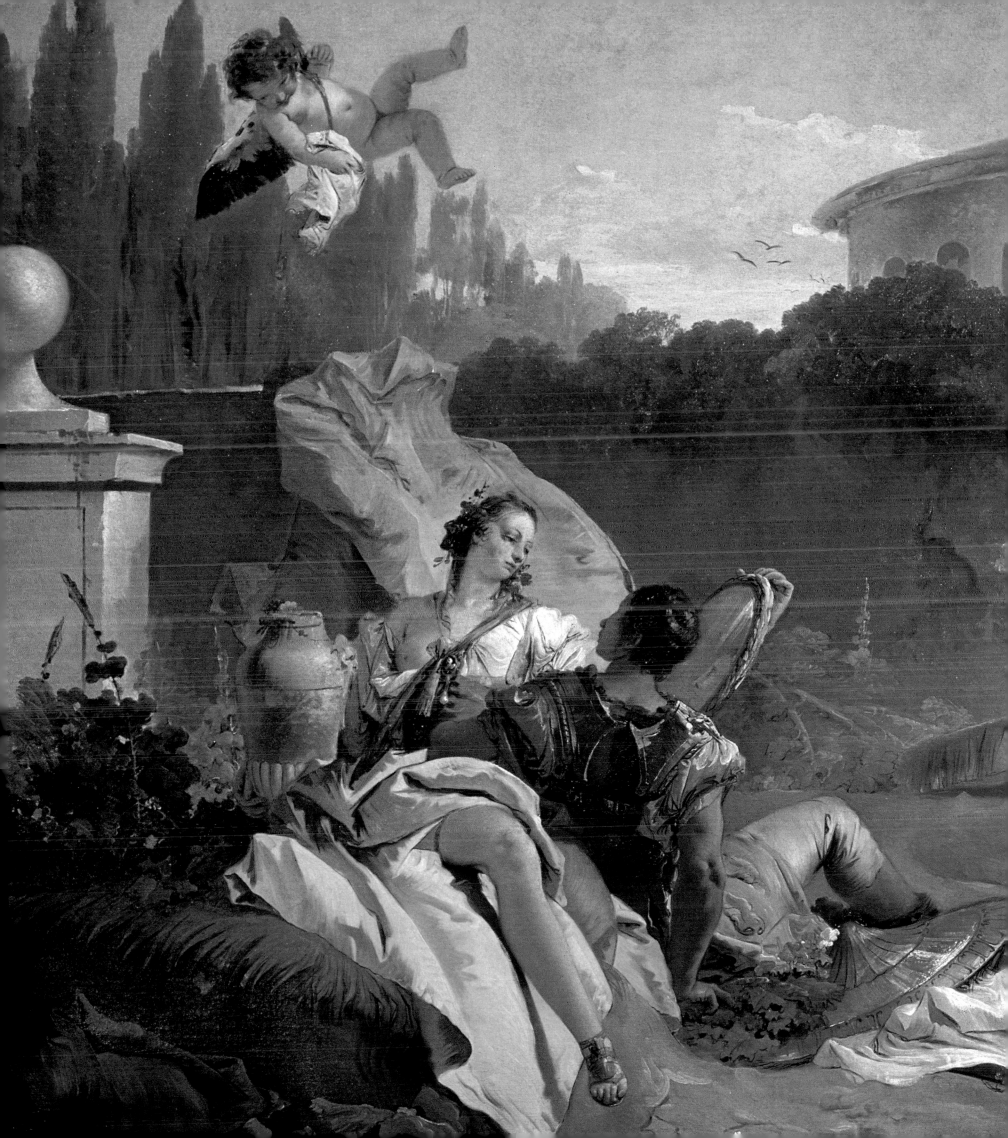

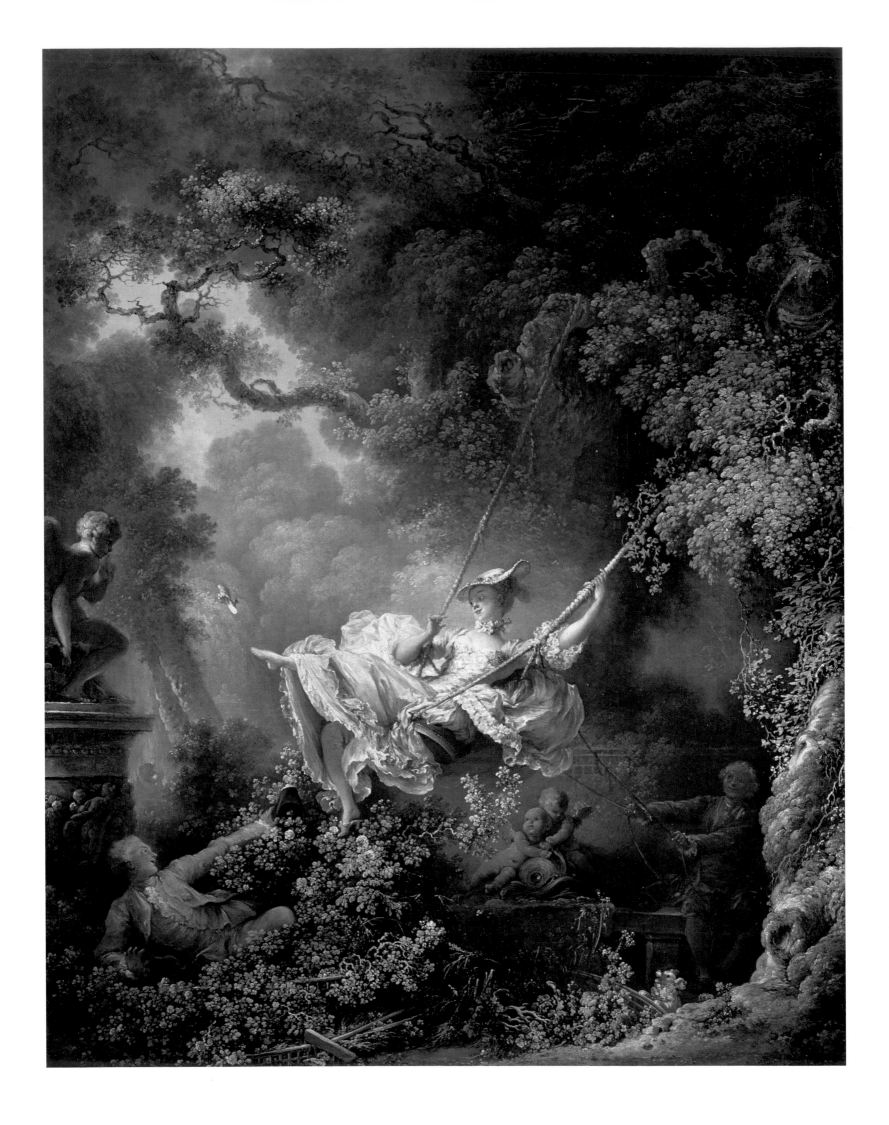

fictitious backdrop in his atelier, thereby satisfying the dictum of art theorists as early as the beginning of the century that in the rendering of natural details one should not simply reproduce what one can see.

According to such theorists, it is the artist's selection of beautiful details from nature and their subsequent artistic arrangement that gives a garden or landscape picture its aesthetic merit, elevating it to a work of art instead of a mere record of something seen in nature. But despite such theoretical reservations, faithful renderings of specific locations continued to be in demand. Antonio Canale, called Canaletto, became known all over Europe for his views of his native Venice, the majority of them bought by English tourists. He worked in England for more than eight years, painting not only the country estates of his wealthy patrons but also London views like *Whitehall and the Privy Garden from Richmond House* (plate 52). His luminous pictures were produced in part with the aid of a camera obscura and based on any number of detail sketches that he combined in his atelier into a highly convincing perspective view. He passed along his technique of translating careful drawings into paintings to his nephew and pupil Bernardo Bellotto, also called Canaletto, who after being

51 (opposite)
Jean-Honoré Fragonard (1732–1806)
THE SWING
1767
Oil on canvas, 32¹¹⁄₁₆ × 25⁹⁄₁₆ in. (83 × 65 cm)
Wallace Collection, London

Fragonard used the garden backdrop, nearly unreal in its dense exuberance, to shift the voyeuristic act from a reality dictated by strict social convention into a world of dream and illusion.

52 (right)
Giovanni Antonio Canal, called Canaletto
(1697–1768)
WHITEHALL AND THE PRIVY GARDEN
FROM RICHMOND HOUSE
1747
Oil on canvas, 42⅞ × 47 in. (109 × 119.5 cm)
Goodwood House, West Sussex, England;
Collection Duke of Richmond and Gordon

In 1746, sales of his views having slowed in Venice, Canaletto set out for England. A letter of recommendation from Joseph Smith, the British consul in Venice, introduced the painter to the Duke of Richmond, for whom he painted the view from his dining room of Whitehall and the royal Privy Garden.

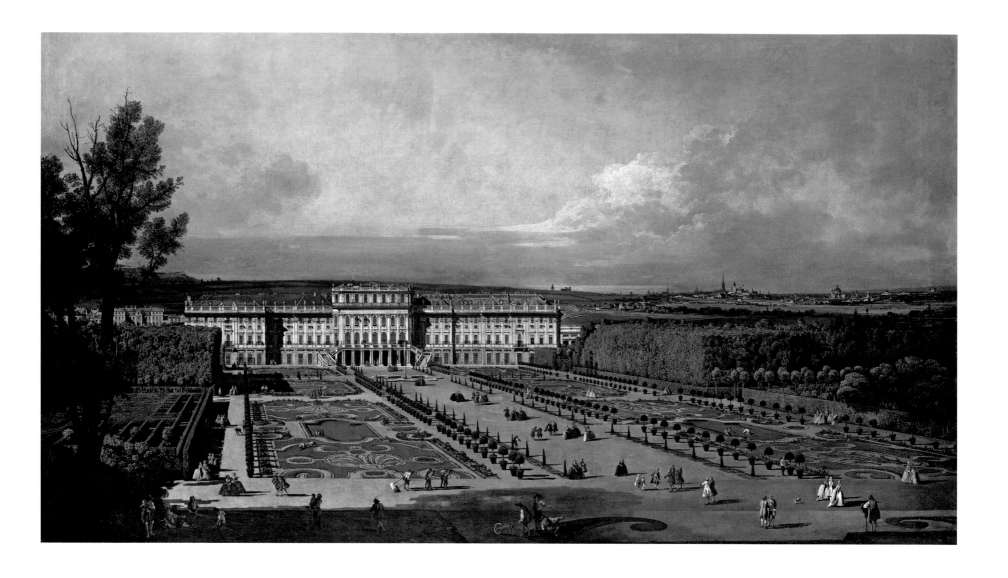

53
Bernardo Bellotto, called Canaletto (1720–1780)
Schönbrunn Palace
1759/60
Oil on canvas, 52¾ × 93¾ in. (134 × 238 cm)
Kunsthistorisches Museum, Gemäldegalerie,
Vienna

*In the 1750s the gardens at Schönbrunn were
redesigned* à l'angloise *by the French architect
Nicolas Jadot and the engineer Jean Brequin de
Demenge. The lawns of the parterre were divided
by ornamental walkways and larger expanses of
gravel. Emperor Francis I, the husband of Maria
Theresa, took a great interest in the project.*

Detail on pages 8–9

summoned to the court of Saxony in 1749 sojourned at the leading princely
courts of Europe, where precisely detailed views of palaces and gardens were
in great demand. Empress Maria Theresa commissioned from him a series of
thirteen views for the decoration of a salon, one of which shows the garden
side of Schönbrunn Palace (plate 53), the imperial summer residence. The
main focus of the picture is the garden, originally laid out by the French archi-
tect Jean Trehet. It was unusual in that its parterre was narrower than the pal-
ace facade. Canaletto's painting not only illustrates its ornamental layout but
also shows in precise detail the sorts of chores required to maintain it. All in all
it is a faithful *veduta*, even though the artist embellished the reality he could
see to create an artistic composition. For example, the line of the palace roof
accords with the silhouette of the hill lying north of Schönbrunn, and both fall
precisely on the picture's central horizontal axis.

A comparable artistic rearrangement of observed reality is evident in *Tree
Felling in the Garden of Versailles* (plate 54), a painting by Hubert Robert from
1775. One of a pair of pictures documenting this event—part of the redesign

of the Bosquet de Bains d'Apollon—the painting shows the queen with her retinue standing next to a group of tritons from the so-called Baths of Apollo and watching the workmen. It was an historic occasion, for it marked the official introduction at the French court of the English landscape garden style. An anecdote in Petit de Bachaumont's criticism of the Salon of 1777 reveals that the painter had no intention of providing a precisely detailed *veduta*, but rather a picturesque painting. It was the comte d'Argiviller who suggested that Robert record the scene and that he be sent for at once, so that he could make drawings of the unique spectacle. But Robert declined, indicating that it would make for a poor picture, "very true, very exact, but very cold." He argued that it would be of far greater interest to His Majesty "not to provide a geometric overview of the formidable scene, but to rediscover in its essence the painful sensation of this still life." Robert himself illustrates the close connection

54
Hubert Robert (1733–1808)
Tree Felling in the Garden of Versailles
1775
Oil on canvas, 48¹³⁄₁₆ × 75³⁄₁₆ (124 × 191 cm)
Château et Trianons, Versailles, France

Even with his choice of vantage point, which gives no indication of the strict geometry of the palace garden at Versailles, Robert provided the king in this painting a foretaste of the triumph of nature and time over the concept of universal sovereignty cultivated by his predecessors.

55
Thomas Gainsborough (1727–1788)
CONVERSATION DANS UN PARK
c. 1746/47
Oil on canvas, 28¾ × 26¾ in. (73 × 68 cm)
Musée du Louvre, Paris

In this portrait of an unknown couple based on French models, the parklike garden, like the young man's prominent sword, serves as a potent expression of aristocratic prestige. At the same time, in this idealized setting there is an echo of the classical notion of the garden of love.

between garden design and the garden picture, for he not only painted garden pictures on commission from Louis XV's financier but also designed the landscape garden at his Château de Méréville. There he attempted to translate the charm of painted pictures into a three-dimensional form, for example reproducing a view of Tivoli by Claude Lorrain.

In this period the new concept of garden design developed in England and realized there since roughly 1720 was being adopted all over Europe. According to it nature was supposed to appear wholly untouched, in contrast to the Baroque garden with its severely geometric layout. Paintings served as the patterns; perspectives and light, shadow, and color effects were carefully attuned to each other, so that the garden itself seemed like a picture. In his 1731 *Epistle on Taste* the English poet Alexander Pope formulated this notion of "actual landscape painting," and in a contemporary anecdote it was reduced to the simple formula—attributed to him—"All gardening is landscape painting." The idea of gardens perceived as pictures is also central to the anonymously published *Dialogue upon the Gardens . . . at Stow[e] in Buckinghamshire* (1848), written by the pastor and schoolmaster William Gilpin, who later developed extremely influential ideas about the picturesque that provided art theory the terminology with which to distinguish the new view of nature. In his *Observations Relative Chiefly to Picturesque Beauty . . . of Cumberland and Westmoreland,* from 1786, the picturesque is added to the ideally beautiful and the sublime as a third category of beauty. Gilpin gave precedence to the beauty of nature over ideal beauty, from which he chose to see the picturesque set apart as well as from the sublime. His considerations inspired much theorizing and an ever larger number of paintings of nature. Nature unadorned had become a worthy subject for pictures.

The changes in the design of gardens evident since the mid-eighteenth century paralleled this profound shift in people's feelings about nature, which also left its mark on the fine arts. Complex intertwining factors saw to it that both the individual appearance of nature and the individual view of nature came into their own. Nature became aestheticized—not only in artistic representations but in the new manner in which it was to be perceived. For example, in 1746 the German poet Barthold Heinrich Brockes had recommended in his poem "A Proven Balm for the Eyes" that one create a frame with one's figures, and by way of the view selected turn nature into landscape. He was referring to the studies of Isaac Newton, whose thoughts on optics were first published in 1704. The theory developed in Newton's *Opticks* essay was popularized in France by Voltaire's "Elémens de la philosophie de Neuton," which clarified Newton's place in the history of optics since Johannes Kepler. In his 1604 work *Ad Vitellionem Paralipomena* (Supplement to Witelo), Kepler used the formulation *Ut pictura, ita visio* (Seeing is like a picture): seeing was the production

56
Richard Wilson (1714–1782)
VIEW OF SYON HOUSE ACROSS THE THAMES
NEAR RICHMOND GARDENS
c. 1760/70
Oil on canvas, 40¹⁵⁄₁₆ × 54½ in. (104 × 138.5 cm)
Bayerische Staatsgemäldesammlungen,
Neue Pinakothek, Munich

In his picture of a late-summer landscape garden flooded with the golden light of the setting sun, Wilson transformed his pictorial vision of nature into a Mediterranean ideal. The Syon, Richmond, and Twickenham area tended to be stylized in contemporary literature as well; writers like James Thomson and Alexander Pope compared the estates there with Rome's classical villa culture.

of an image, a *pictura*, on the surface of the retina. Inverting that formula, we could say that the ideal picture should match our own visual impression. So it was that English travelers of the period chose to look at the world through what was called a Claude glass: a convex, slightly tinted pocket mirror. Turning their backs to nature, they attempted to find in it by gazing into their mirrors those pictures widely held to be aesthetically perfect.

Thomas Gainsborough, who became one of the most sought-after portrait painters of his time in England, was a declared admirer of the landscapes of Claude Lorrain. He complained to a friend that "these people with their damned visages" would not leave him alone. His patrons, with an eye to the conventions of the aristocratic portrait established in large part by Anthonis Van Dyck, refused to let him paint them in a garden setting. Yet Gainsborough, who thought of himself primarily as a painter of landscapes, categorically rejected any form of topographical description. In his portraits especially, he turned the natural setting into a motif filled with meaning, as in his *Conversation dans un park* (plate 55). Later scholars thought to see in this seemingly informal picture of an unknown couple a wedding portrait of the painter and his wife Margaret, and based on the date of that wedding proposed that the picture was painted in the summer of 1746. The imaginary garden landscape is reminiscent of Watteau, to whom Gainsborough referred in other pictures as well, and may have inspired the wedding interpretation—for the notion of the garden of love was still alive even in the eighteenth century.

In general, eighteenth-century English depictions of gardens and landscape swing between the poles of painterly abstraction and an obligation to be realistic, alternating realism, stylization, and autonomous painting in turn. It was above all English painters who helped to make chorographic views universally popular. One thinks particularly of Richard Wilson, who in his pictures sought to capture the atmosphere and mood of an observed segment of nature. His *View of Syon House* (plate 56), which survives in several versions he painted himself, clearly reflects this endeavor. It presents the view of the family seat of the Dukes of Northumberland from across the Thames near Richmond Gardens. The house, redesigned by Robert Adam, is emphasized by the trees that frame it. People are strolling about and relaxing in their Sunday best in the light of late afternoon. The landscape has been carefully groomed, as is underscored by the figure of a gardener resting on his wheelbarrow beneath the trees. Wilson uses the language of painting to capture the beauty embodied in the garden and park, where, as Gilpin explained, "every object is of a cultivated and elegant kind." This was to be expected not only of the "pleasure-ground," the garden close to the house, but also of the "park," Gilpin's name for the garden's subtle extension into the surrounding landscape. In Wilson's picture

a concept of garden design inspired by painted views of nature was translated back into a painting, one obviously indebted to the same models.

Jacques-Louis David's *View of the Jardin du Luxembourg in Paris*, from 1794 (plate 57), is a wholly different and very personal picture of a garden. As a supporter of the Revolution, David was arrested on 9 Thermidor, Year II (July 27, 1794), at the end of the Reign of Terror, the day before Robespierre was guillotined. In the months of his imprisonment in the Palais du Luxembourg he produced his only landscape or garden picture, which he mentions in his let-

57
Jacques-Louis David (1748–1825)
VIEW OF THE JARDIN DU
LUXEMBOURG IN PARIS
1794
Oil on canvas, 21⅝ × 25⁹⁄₁₆ in.
(55 × 65 cm)
Musée du Louvre, Paris

David's picture shows nothing more and nothing less than a patch of unbeautified nature as seen from the perspective of his cell window on a slightly cloudy late-summer day. The buildings on the rue de Vaugirard can be identified. Large portions of the garden of the Palais du Luxembourg, famed for its beauty before the Revolution, had been turned over to the citizens of Paris for use as garden plots and broken up into fields.

ters. The virtually monochrome painting is dominated by the seemingly bare, fenced courtyard. The arbitrary and unprettified view it presents was as new at the time, as was the directness of his painting style. David refrained from introducing any richness of variation and following any specific compositional scheme. Instead, he simply pictured the trees, fences, paths, and roofs he could see out his window. His garden is not burdened with iconographic significance, and he made no attempt to idealize the segment of nature available to his gaze. Nor are these trees and gardens presented in the manner of the imposing topographical *veduta*. It is a wholly unpretentious painting, one intended solely to create a painterly effect, and accordingly it represents a break with the theory and practice of the rendering of nature prevalent at the time.

The change in visual culture that is here so apparent proceeded hand in hand with the period's scientific advances. It is also apparent in a similarly personal painting by John Constable in which he portrays the surroundings of

his parents' home. He painted *Golding Constable's Vegetable Garden* (plate 58) from one of the upper windows of East Bergholt House shortly before his parents died. It remained in the family's possession until 1887, when it was finally put up for public sale. Together with the view of his parents' flower garden executed at roughly the same time, it strikes one as a poetic distillation of Constable's deep attachment to nature. At the beginning of the nineteenth century such an unprettified view of the artist's home, neither composed with the intention of creating a pleasing overall picture nor serving as the setting for a narrative scene, could not hope to be of interest to potential buyers—who accepted realistic depictions only of their own properties—or to find acceptance from critics. Constable's nature paintings were scorned. His brand of radical realism, argued in lectures and presented in his own art, found no direct followers in England, but it had a considerable influence on continental painting, especially in France.

58
John Constable (1776–1837)
GOLDING CONSTABLE'S
VEGETABLE GARDEN
1815
Oil on canvas, 13 × 20 in. (33 × 50.8 cm)
Ipswich Borough Council Museums and
Galleries Collection, Ipswich, England

The inspiration for Constable's painting was nature itself, for there is art, he proclaimed, "beneath every hedge and on every meadow." This view of his father's garden attests to his striving for maximum accuracy in the depiction of nature as well as his profound attachment to the geography of his childhood.

59 (below and opposite)
Joseph Anton Koch (1768–1839)
VIEW OF SANTA MARIA MAGGIORE IN ROME
FROM THE GARDEN OF THE VILLA NEGRONI
c. 830/32
Oil on canvas, 30 × 40½ in. (76.3 × 103 cm)
Museum Folkwang, Essen, Germany

Koch was especially drawn to Santa Maria Maggiore, one of Rome's most splendid churches and one of its four patriarchal basilicas. It looms up behind a paradisial garden idyll that has nothing to do with reality—the garden of the Villa Negroni had been turned over to plantings of cabbages and beets—like a vision of the heavenly Jerusalem.

Most painters continued to follow the traditional practice of selecting the noblest features from nature, captured in careful studies, then shaping them into a perfected composition. Johann Christian Reinhart is an ideal example. His sharply outlined precision in the rendering of details, appropriately termed "physiognomic classicism," resulted in a wholly intentional renunciation of the atmospheric cohesion of the picture space, as one sees in his view of the *Park of the Villa Doria Pamphili* (plate 60). Together with another view commissioned by Crown Prince Maximilian of Bavaria, he began the work in June 1832 and completed it the following November. The painting was based on an earlier drawing, which his patron approved if he would make certain changes to it. For example, the orange trees "could be left out in case they obscure too much of the background, but His Royal Majesty would like it if you were to

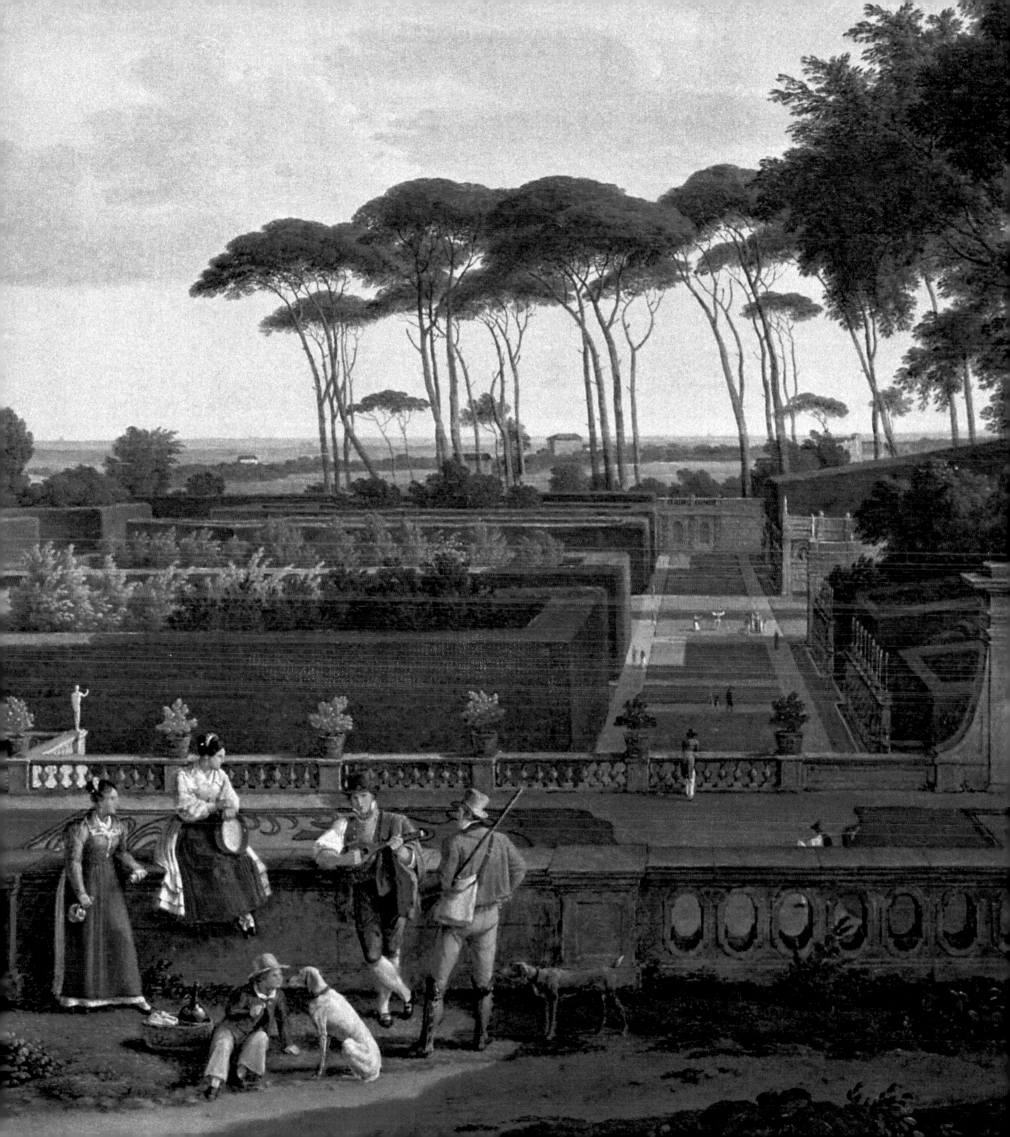

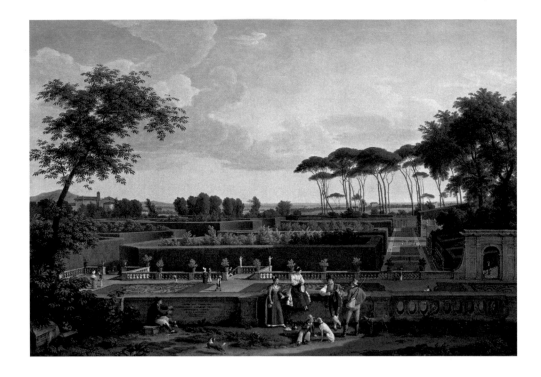

60
Johann Christian Reinhart (1761–1847)
PARK OF THE VILLA DORIA PAMPHILI
1832
Oil on canvas, 28 × 39¾ in. (71 × 101 cm)
Museum Folkwang, Essen, Germany

*With his clearly structured composition, Reinhart
tried to do justice to aesthetic requirements as well
as to topographical reality, which is presented with
utmost clarity. Some of the picture's details were pre-
scribed by his royal patron, to whom the dedication
on the foreground balustrade refers.*

Detail on pages 120–121

61 (opposite)
Karl Blechen (1798–1840)
PARK OF THE VILLA D'ESTE IN TIVOLI
c. 1832
Oil on canvas, 50³⁄₁₆ × 37 in. (127.5 × 94 cm)
Staatliche Museen, Stiftung Preussischer
Kulturbesitz, Nationalgalerie, Berlin

*Thanks to the sixteenth-century garments of the
staffage figures, the view of the Rotonda di Cipressi
in the park of the Villa d'Este becomes more than
a mere representation of reality. Together with the
small scale of the figures, the dramatic perspective
construction and pronounced manipulation of light
contribute to the historic garden's monumental effect.*

Detail on p. 124

perhaps include as foreground staffage, wherever it seems appropriate, a few young women in native costume that does not conflict with the medieval dress of the strollers in the garden or seem inappropriate." Reinhart did his best to satisfy the wishes of his princely patron and still produce a painting that was satisfying artistically, and in his own opinion he succeeded. On November 8 he wrote to his friend Adolf Heydeck: "Koch said that if he had more money he would have me make him a picture just like this." His housemate and fellow painter Joseph Anton Koch also suffered under the strictures imposed on painters of views by the contemporary public. His categorical refusal to produce illusionistic topographical *vedute* is evident in his *View of Santa Maria Maggiore in Rome from the Garden of the Villa Negroni* (plate 59). In a letter dated December 7, 1830, Koch confessed that all he knew about the site was "that it was formerly one of the wealthiest in Rome . . . now this villa has been divided up among various owners and they plant cabbage and root vegetables in it, not a single stone attests to its former magnificence." Yet instead of a vegetable garden Koch pictures carefully planted flower beds, between which people in Renaissance costume are engaged in genteel pursuits. To be sure, the obvious spiritual content and religious emphasis of his topographical picture were in conflict with the demands of contemporary art criticism, which increasingly opposed all forms of allegory.

The same criticism was leveled at the painter Karl Blechen, who during his sojourn in Rome shared a house in the Via Felice quarter with Johann

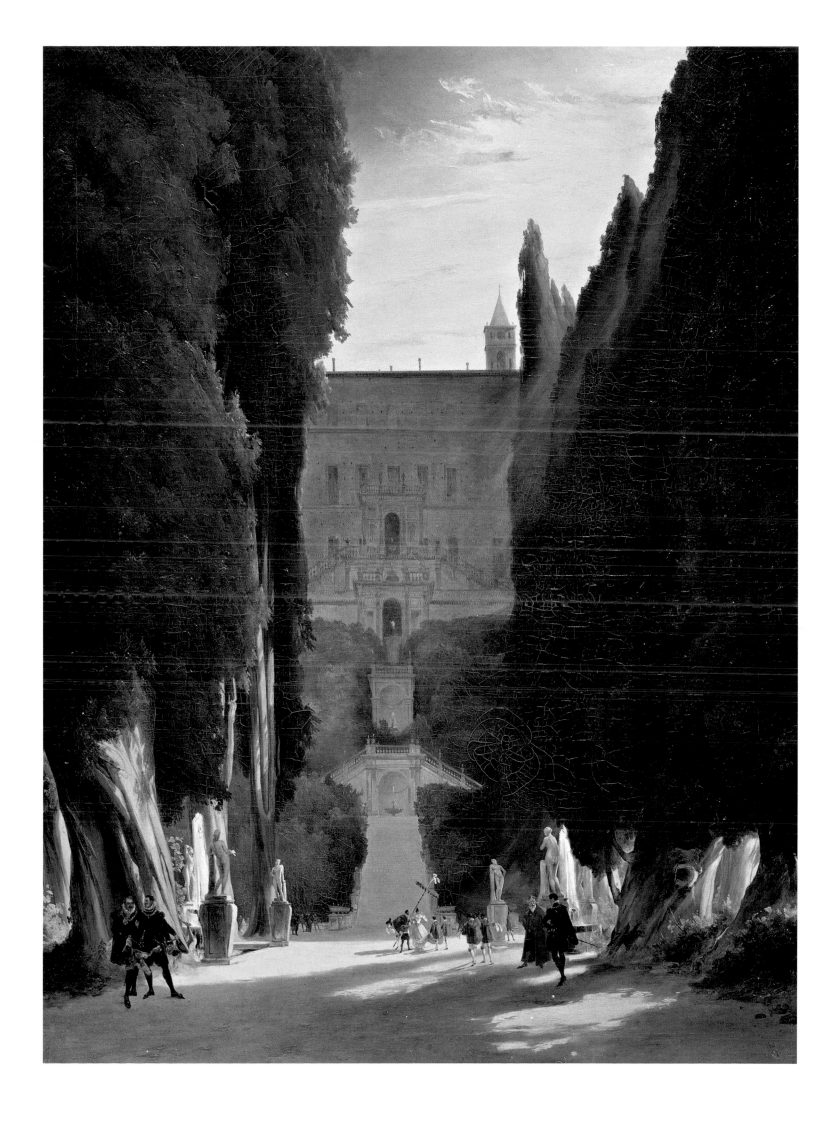

Detail from plate 61

Christian Reinhart and Joseph Anton Koch. In Blechen's *Park of the Villa d'Este in Tivoli*, for example, painted around 1832 (plate 61), one can see his attempt to render the topographical situation such that it can be identified, but also convey a symbolic meaning. His critics accused him of going beyond the limits of naturalist depiction in his use of color and light. It was expected of "prospect paintings," as such pictures illustrating recognizable settings were then called in Germany, that they should stir the soul, but without freighting the pictured objects with religious or symbolic meaning. All of this was in accord with the theories of the abbé Du Bos. Goethe, for example, clearly opposed the "neo-Catholic sentimentality . . . the monkish, mystical cant that is more threatening to art than all the Calibans calling for reality," i.e., the philistine realists who so aroused the German writer's distaste that—according to Sulpiz Boisserée—he would "smash pictures against the corner of the table—shoot books full of holes, etc." The religious pictorial world of Joseph Anton Koch was especially vilified by Weimar's Friends of Art; they saw in his precise realistic renderings of nature "a wild and disorderly talent."

Toward the end of the eighteenth century the early modern concept of pictures, which held them to be as effective a medium as verbal communication—in line with Horace's motto *Ut pictura poesis* (As is painting, so is poetry)—came to be replaced by one in which form and content seemed irreconcilable opposites. From contemporary art discourse it becomes clear that this change in what was to be expected from a picture was deliberately effected by Enlightenment thinkers who saw the concept of the picture as a means of communication too closely tied to the institutions of the court and the church. With the establishment of aesthetics as an independent branch of philosophy by Alexander Gottlieb Baumgarten, the notion that a work of art does not necessarily have any external purpose gained increasing acceptance. The theoretical discourse he initiated reached an early culmination in Immanuel Kant's definition of the aesthetic judgment as an expression of "disinterested pleasure." A growing number of prominent thinkers developed, in one form or another, an aesthetics of autonomy that sought in the work of art an inner perfection with no external function. At the same time the focus shifted to the aesthetic effect of the work of art conceived as a whole. The decades dominated by such thinking were spoken of by contemporaries as the *Geniezeit*, "genius era"; we now think of it as the Sturm und Drang period. Artistic expression was no longer considered a means to an end, but a revelation. The creative artist, the "genius," determined the form of the work of art: art was now judged from his perspective, no longer that of the viewer.

Between Sense and Sensuality

Detail from plate 62

Such total rejection of any sort of allegorical meaning by this classical aesthetics of autonomy was bound to call forth an opposing artistic movement. Its proponents applauded the efforts of the Romantics—Caspar David Friedrich, Philipp Otto Runge, and others—to imbue pictures with a new allegorical language. Landscapes and nature depictions were particularly well suited to their purposes. According to Daniel Runge, his brother Philipp Otto Runge claimed that "symbols might be presented experimentally, drawn from natural images and events animated by the hand of God." Philipp Otto Runge clarified what this meant himself when he wrote that there was as yet no landscape painter "who has intrinsic meaning in his landscapes, who has introduced allegories and distinctly charming ideas into his landscapes." The Romantics were determined to express allegorical notions through depictions of nature, but it was an ambition difficult to achieve. They faced the problem that in their own time the pictorial language employed by painters in the Middle Ages and in early modern times was no longer certain of being understood. What they created was a subjectively motivated pictorial idiom that lent new meaning to the motif of the garden, as for example in Runge's *Hülsenbeck Children* (plate 62). Friedrich August Hülsenbeck was a business associate of the artist's older brother Johann Daniel until their wholesale and shipping firm closed in 1807 as a result of the continental blockade imposed on England by Napoleon. The picture shows five-year-old Maria and four-year-old August pulling their little brother, two-year-old Friedrich, in a handcart. The garden behind the white-painted fence belonged to Hülsenbeck's country house in the village of Eimsbüttel, now incorporated into the city of Hamburg. It was not an ideal area, as the painter wrote in a letter to his fiancée in the spring of 1804, but the half-hour walk out beyond the city gates was pleasant. In another letter from October 16, 1805, he mentions the picture "of Hülsenbeck's three children, in which the two largest are wheeling the small one in the garden, the garden and Hamburg all a portrait, and will be very effective." Runge also wrote about the "very large painting" in another letter, informing his father in December that he had "really taken too much trouble" with the landscape sections. Runge tried to achieve a painterly balance between portrait and nature depiction, which he used to convey a specific message. This is apparent from the impressive sunflowers, whose main stem has broken and whose three buds and three flowers correspond to the trio of children. The cramped, stagelike play space with its trimmed grass borders is seen from a child's perspective

62 Philipp Otto Runge (1777–1810)
THE HÜLSENBECK CHILDREN
1805–6
Oil on canvas, 51¾ × 56½ in. (131.5 × 143.5 cm)
Kunsthalle, Hamburg, Germany

The composition of this idealized picture of childhood was calculated down to the last detail. The painter was just as interested in conveying a message as in balancing portraits with his rendering of nature. The garden and its motifs serve as symbols of a sheltered childhood.

Detail on p. 125

rather than that of a grown-up looking down from above. Also, the children are placed precisely as far back from the front edge of the picture space as from the fence behind them, which serves as a symbolic boundary between the tranquillity of the sheltered garden of childhood and the wide world outside.

In a garden scene that was one of a pair of contrasting pictures, the painter Caspar David Friedrich stylized childish play as a symbol of a prosperous world at peace. This picture has now disappeared; however, its pendant, called *The Garden Terrace* (plate 63), survives, and it was also meant to be symbolic. Some scholars have identified the painting as the view from the terrace of the castle at Erdmannsdorf, and others have chosen to see the Riesengebirge in

the background. But it is certain that in the two related pictures Friedrich had no intention of providing topographical portraits of specific gardens. To Friedrich and the Romantics, painting was no longer simply a matter of artistry; it reflected the artist's inner moral and religious convictions. Friedrich is famous for having insisted that the painter should not only paint "what he sees before him, but also what he sees inside himself. If he sees nothing inside, he should refrain from painting what he sees before him." For the Romantic painters feelings were fundamental to artistic creation, and in a new form of representing nature they tried to express their feelings as best they could using their own personal symbols. Friedrich's *Garden Terrace* is anything but a peaceful idyll;

63
Caspar David Friedrich (1774–1840)
THE GARDEN TERRACE
c. 1811/12
Oil on canvas, 21¹⁄₁₆ × 27⁹⁄₁₆ in. (53.5 × 70 cm)
Stiftung Pruessisch Schlösser und Gärten,
Berlin-Brandenburg

Friedrich's rigid, almost geometric composition contributes materially to the message of his picture, serving as a kind of visual argument. Here the garden represents a way of life he deplored.

64

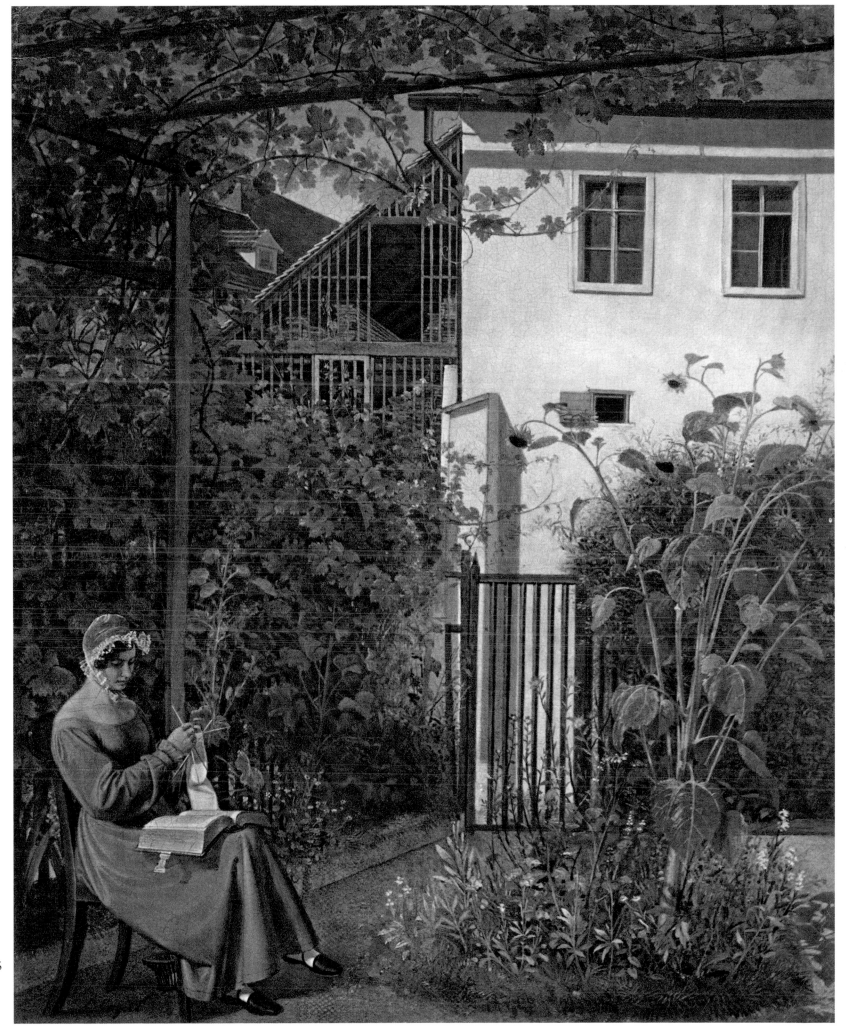

65

64 (page 128)
Caspar David Friedrich
GARDEN BOWER
1818
Oil on canvas, 11¹³⁄₁₆ × 8¹¹⁄₁₆ in. (30 × 22 cm)
Bayerische Staatsgemäldesammlungen,
Neue Pinakothek, Munich

*It is tempting to interpret the view of the church as
a transcendental glimpse of the beyond, and the
motif of the garden as a premonition of paradise. At
the same time, the picture employs the traditional
iconography of portraits of married couples, with
grapevines serving as symbols of fidelity.*

65 (page 129)
Erasmus Ritter von Engert (1796–1871)
BACKYARD IN VIENNA
1828
Oil on canvas, 12³⁄₁₆ × 10¼ in. (31 × 26 cm)
Staatliche Museen, Stiftung Preussischer
Kulturbesitz, Nationalgalerie, Berlin

*Free of allegorical meanings, this Biedermeier idyll
in the homey seclusion of a garden, featuring a
woman knitting while reading her Bible, reflects the
standards and ambitions of a petit-bourgeois public.*

Detail on page 131

the cross set into the garden gate flanked by lions invites a religious interpreta-tion. The stretch of park divided into geometrical patterns symbolizes the here and now, a kind of order based on reason. In it stand chestnut trees, which are here negative symbols in that their wood is inferior and they tend to inhibit the growth of other plants. In this context the statue of the goddess Flora stands not for abundance but rather sterility. Seen in the light of the original pair of paintings, the young woman reading also has negative connotations, for she pays no attention to nature, and represents the torpor of an intellectually oriented culture. Hope is provided by the sun-drenched distance, which is to be thought of as both an otherworldly vision and a better world to be realized under the sign of the cross. This religious content, within the framework of which the tomtits visible in the trees could be meant as birds of the soul, prob-ably had a patriotic component as well, one that was also tied to the picture of the garden and its design. In 1812 the painting was referred to in the *Journal des Luxus und der Moden* as a "Garthenparthie in französischem Style" (gar-den section in the French style). Given the political situation and the painter's patriotic feelings, this could only imply a negative interpretation. Perceived as the symbol of rationalism, the French garden is here contrasted with religious faith, a specifically German virtue. Friedrich expressed this in another garden picture as well. In his *Garden Bower* (plate 64) a couple is pictured in front of a Gothic church looming up in the background. In this context the twining gravevines, which Friedrich used in other contexts as a manifest allusion to the Eucharist, symbolize the hope for salvation. They may also have been included as a symbol of friendship and undying devotion, just as they had been in ear-lier painting (plate 43). It has been suspected with good reason that the work is a portrait of the artist himself and his wife. On January 21, 1818, Friedrich married Caroline Bommer, a woman from a bourgeois Dresden family. In the late summer of that same year the two visited Greifswald, where they had sat together in the garden bower belonging to the scholar Johann Christian Fine-lius. That visit, which is documented in letters and in a drawing related to the painting, was presumably what prompted this very personal picture of friend-ship that was dedicated to Finelius.

In both *The Garden Terrace* (plate 63) and *Garden Bower* (plate 64), the arrangement of the picturesque scenery strongly suggests that something beyond the superficial subject matter is being conveyed. This clearly distin-guishes Friedrich's pictures from paintings like *Backyard in Vienna* (plate 65), painted by Erasmus Ritter von Engert in 1828. This simple garden idyll contains no hidden allegorical meaning. Even the painter's personal style seems of less importance than his attempt, by rendering objects with the greatest precision, to produce a stylized image of petit-bourgeois tranquillity. The picture thus

66
Jean Baptiste Camille Corot (1796–1875)
VIEW OF FLORENCE FROM THE
BOBOLI GARDENS
after 1834
Oil on canvas, 20 1/16 × 28 3/4 in. (51 × 73 cm)
Musée du Louvre, Paris

*Based on spontaneous plein-air oil sketches, Corot
created carefully composed paintings in which—as
in this view of Florence—the animated style of the
originals is reflected. The brushwork and palette
underscore the atmospheric immediacy of the picture,
as does the staffage. The painting thereby becomes
more than a standard topographical view of a favor-
ite tourist site.*

becomes an expression of the smug, apolitical culture of the years following
the Congress of Vienna, now referred to as the Biedermeier era (*Biedermeier* is
a conflation of the names of two fictitious, narrow-minded philistines appear-
ing in satiric poems by Joseph Victor von Scheffel, published in the *Fliegende
Blätter* in the revolutionary year 1848). In France, ruled between 1830 and 1848
by the Citizen King, Louis-Philippe, the political climate was far more lib-
eral. French artists were beginning to abandon their striving toward maximum
fidelity and to be interested in the problems associated with the artistic repre-
sentation of reality. The oil sketch, previously considered only a preliminary
step toward a final painting, was now for the first time accorded an aesthetic
value of its own. One expression of this shift in interest was the fact that the
Paris Académie began to offer a special prize for landscape painters, which
could be won by submitting a tree study and a draft of a landscape painting.

67
Adolf Menzel (1815–1905)
PRINCE ALBRECHT'S PALACE GARDEN
1846/76
Oil on canvas, 26¾ × 33⅞ in. (68 × 86 cm)
Staatliche Museen, Stiftung Preussischer
Kulturbesitz, Nationalgalerie, Berlin

Menzel himself described this representation of reality as a "study," a term already outdated at the time. What he meant was that the picture, complete in itself, was not supposed to convey any deeper meaning. Even the poplars, traditionally symbolic, seem as unremarkable as the glimpse of a whitish gray, cloudy sky.

68 (Below and opposite)
Carl Spitzweg (1808–1885)
THE GARDEN LOVER
c. 1860
Oil on canvas, 18⅞ × 12⅝ in. (48 × 32 cm)
Städtische Sammlungen, Görlitz, Germany

*A shrewd and satirical observer, Spitzweg developed
pictorial narratives in his numerous paintings of
gardens and gardeners based on studies from nature
and detailed preliminary drawings.*

Detail on page 226

The new concern for immediacy in painting and the increasingly popular practice of plein-air painting were fostered by the invention of tubes of pigment that could be recapped, opening up completely new possibilities for working from nature. The new, more painterly view of nature that characterized this period is evident in Jean Baptiste Camille Corot's *View of Florence from the Boboli Gardens* (plate 66). On various trips to Italy Corot made numerous such oil sketches directly from nature, at times capturing the same subject under changing light and weather conditions.

Back in Germany, another painter who aimed for maximum precision in his rendering was Adolf Menzel, who nevertheless generally worked in his atelier on the basis of nature studies and only rarely painted from nature. His method is illustrated by drawings he made for his view of *Prince Albrecht's Palace Garden* (plate 67), begun in 1846 and reworked in 1876. "I painted the oil study 'Prince Albrecht's Garden' from nature in 1846 from the balcony of my apartment—with the exception of the foreground, which, along with the workers enjoying their siesta, is a fiction." The resting workers were not wholly invented, however, but inserted as a way of making a proper picture out of a landscape view after a drawing produced at another time and in another place. It is only the composition, the calculated balancing of elements, that makes the work a picture.

Carl Spitzweg's *Garden Lover* (plate 68) is another painting calculated for its satiric effect on the viewer. The point of the picture, painted around 1860, is clear from the central motif, the way the plant and the gardener bow to each other. In this, despite its comic aspect, Spitzweg's picture documents a historical development: an increasing interest in gardening is apparent during the course of the nineteenth century, along with an increasing number of gardens. At the very beginning of the century, Goethe used a garden as the dominant setting for his novel *Elective Affinities*. Part of the estate of the wealthy Baron Eduard, it also functions as a subtle reflection of the plot. The Enlightenment produced a demand for "peoples' gardens," a concept formulated by Christian Cay Lorenz Hirschfeld in 1779. It was thought that they would subtly draw city dwellers away "from the ignoble and costly sorts of urban pastimes." The yearning for a meaningful and healthy life in nature that was a result of urbanization and industrialization, the distinct division between work and leisure, and a developing consciousness of hygiene and wholesome activity gave rise, especially in the second half of the nineteenth century, to cottage colonies with small garden parcels. Around 1860 the doctor Daniel Gottlob Schreber had called for playgrounds for city children for the sake of their health, and after his death a green space laid out by a club in Leipzig came to be named after him, which became the eponymous model for Germany's later "Schreber gardens."

69
Anselm Feuerbach (1829–1880)
PAOLO MALATESTA AND FRANCESCA
DA RIMINI
1864
Oil on canvas, 29¹⁵⁄₁₆ × 22¹³⁄₁₆ in. (76 × 58 cm)
Städtische Kunsthalle, Mannheim, Germany

*The subject of the picture is the story of Paolo
Malatesta and Francesca da Rimini as told
in canto 5 (lines 127–38) of Dante's* Inferno.
*While reading together about Lancelot, the pair
become aware of their love for each other. The
atmospheric garden setting was based on studies
Feuerbach had made in the park of the Villa
d'Este in Tivoli in 1857.*

Even after gardens had become an expected element of bourgeois culture, it
was by no means customary to choose them as subjects for paintings without
some particular message. To be sure, since the beginning of the century even
simple renderings from nature and oil sketches had become worthy of inclu-
sion in exhibitions, but the public was still convinced that truly great art dealt
with exalted subjects. One such subject was the tragic love story painted by
Anselm Feuerbach in 1864, *Paolo Malatesta and Francesca da Rimini* (plate 69).
Feuerbach had been thinking about such a picture since 1857, but only after he

70
Edward Burne-Jones (1833–1898)
THE BALEFUL HEAD
1884/87
Oil on canvas, 61 × 51³⁄₁₆ in.
(155 × 130 cm)
Staatsgalerie, Stuttgart, Germany

By showing the couple's clasped right hands, traditionally a symbol of marriage, the painter underscores the relationship between Perseus and Andromeda as described in Ovid's Metamorphoses *(4.669–752). Here Andromeda becomes convinced of Perseus's divine ancestry by the display of the head of the Medusa. The figures were the most obvious images with which to convey spiritual and emotional content, yet Burne-Jones also transformed the garden backdrop into a mirror of the psyche.*

found a patron in Adolf Friedrich, Baron von Schack, did he undertake to paint it. In a study produced in connection with the commission that is preserved in Mannheim, his subjective interpretation of the scene is particularly evident. Since the rediscovery of Dante in the eighteenth century, the adulterous couple, moved to a kiss by their reading and surprised by Francesca's husband Gianciotto Malatesta, had been pictured again and again. But Feuerbach chose to illustrate their quiet absorption in their reading, not the moment in which

71
Charles Allston Collins (1828–1873)
CONVENT THOUGHTS
1850/51
Oil on canvas, 33 1/16 × 23 1/4 in. (84 × 59 cm)
Ashmolean Museum, Oxford, England

Absorbed in contemplation of a passionflower, a nun stands motionless in a garden surrounded by a high wall. The portentousness of the scene is heightened by the plants' having been rendered with the same precision as the medieval depiction of the Crucifixion in the nun's exquisitely illuminated prayer book, whose pages are presented to the viewer.

they are discovered kissing. The seemingly homey, shadowy garden backdrop underscores the elegiac, lyrical mood and the ultimate tragedy of the scene.

Another painting that features a garden as a setting for quiet contemplation is Charles Allston Collins's *Convent Thoughts* (plate 71), in which a nun is absorbed in the study of a passionflower she holds in her hand. Collins was closely associated with the Pre-Raphaelite Brotherhood, a group of artists, established in 1848, that was strongly influenced by John Ruskin and hoped to find its way back to a more spiritual art. Turning away from the academic painting tradition, and scorning the public's expectation that pictures be painted in pretty colors and convey an obvious message, the Pre-Raphaelites wished to get back to nature and render it with the greatest possible artistic truth. Above all, this meant absolute accuracy in the rendering of individual forms. Precise details and an attempt to convey a more profound meaning through symbols would become the general hallmarks of their work. Along with Collins, they were often violently criticized by the English press for their paintings' religious content, largely inspired by Catholicism. But, mainly through the writings of John Ruskin, the movement exercised a major influence on younger English artists, among them Edward Burne-Jones. In 1875 Burne-Jones was asked by the British prime minister Arthur James Balfour to decorate the reception room in his London house. The choice of subject matter was left up to the artist, and Burne-Jones decided to create a picture cycle on the Perseus legend. The textual basis for his pictorial narrative was a collection of classical legends published in 1868 by William Morris under the title *Earthly Paradise*. Between 1875 and 1887 Burne-Jones produced three cartoons and five finished paintings, among them *The Baleful Head* (figure 70), first exhibited in 1887. The paintings, carefully worked out in preliminary watercolor and tempera sketches, all make use of the same color harmonies. The reduced number of their forms, their figures placed parallel to the picture surface, and their ornamentalized garden settings gave them considerable expressive power. From this kind of stylization and the ornamental surfaces of Art Nouveau it is possible to trace a direct line of development to painterly abstraction—or so claimed Richard Muther, who in 1903 wrote of Burne-Jones that "after a long period of styleless fragmentation he once again insisted on the correlation of the arts. A picture is supposed to be a picture. It is supposed to be decorative. The whole room should be a work of art. Only the coordinated interplay of the arts produces beauty. The fact that he argued this and demonstrated it in his works links him with both the present-day decorative view of colors and the arts and crafts movement."

Gustave Courbet took a completely different path. He emphasized that "painting is in essence a literal art, and can only consist of the representation

73

73 (page 141)
Hans Thoma (1839–1924)
GOLDEN AGE
1876
Oil on canvas, 49⅝ × 35⁵⁄₁₆ in. (126 × 89.7 cm)
Städelsches Kunstinstitut, Frankfurt

A ring of towering cypresses twined with grapevines surrounds a circle of joyous dancers, which together with the seemingly ordered natural setting evokes a longing for Arcadia. Thoma's contemporary and biographer Henry Thode wrote of this picture, painted in Munich in 1876: "Radiating out of this charming depiction of paradise is the enchanted nature of fairy tales." According to the artist himself, the work was sold in the Frankfurt Kunstverein for 700 marks; at the time the average professional took home some 80 to 100 marks a month.

Detail on page 7

74 (opposite)
Fritz von Uhde (1848–1911)
AT THE SUMMER PLACE
1883
Oil on canvas, 30 × 23⅝ in. (75 × 60 cm)
Bayerische Staatsgemäldesammlungen,
Neue Pinakothek, Munich

This picture, painted entirely in clear, bright colors and virtually without shadows, is the work of the chief representative of the Munich Secession, who lived in Dachau. It is a simple, painterly paean to the joy of existence and familial togetherness stylized into a quintessential image of the bourgeois idyll, not least by the homey garden setting.

of actual things one can see." The idea of nature was crucial to Courbet's thinking on society and culture, which was also tied to a new aesthetic concept. For beauty, he felt, can only be found in nature itself, and the beauty provided by nature is superior to all artistic conventions. In his *Father Courbet's Apple Orchard in Ornans* (plate 72), nature is depicted without any attempt to prettify it. His was a new painterly position, one that would come to be known as realism and associated mainly with him. The works he submitted to the jury of the Exposition Universelle of 1855 were rejected, but with the support of his patron Alfred Bruyas, the painter built a special pavilion for the exhibition of his pictures, above the door of which he placed the laconic inscription: "Realism. Gustave Courbet." Courbet wanted to see such realism manifested in social criticism—pictures illustrating the lives of common people—and also in simple renderings of nature. Through the political writings of Courbet's friend Pierre-Joseph Proudhon, the term *realism* became inseparably associated with social issues, so in the realm of painting the style introduced by Courbet would instead come to be called "naturalism," a term coined by Jules-Antoine Castagnary in 1863.

The German painter Hans Thoma also felt a commitment to the example of nature as conceived in painterly terms. He devoted considerable study to Courbet's painting on a trip to France in 1868. But he also very deliberately borrowed from Romantic traditions, as is evident in his *Golden Age* (plate 73) from 1876, an idealized image of harmonious order set in his own Black Forest landscape. Fritz von Uhde's *At the Summer Place* (plate 74) presents a very private idyll. The picture, painted in Upper Bavaria's Bad Kohlgrub in 1883, shows the painter himself at work in the garden while his daughters play in the grass and their mother reads a newspaper in the shade of a tree.

Over the course of the nineteenth century a picture's subject matter had become less important, and the traditional hierarchy of genres was no longer much of a consideration in an art market largely dominated by a bourgeois public. The increasing acceptance of depictions of nature and landscape pictures can be seen in the catalogs of the Paris Salon, for example, where after the middle of the century landscapes, previously of only marginal interest, made up well over a third of all the paintings submitted. This tendency, which was also reflected on the international art market, was seen even at the time as a direct reflection of social discontent and a resulting escape back to nature. Gardening and other wholesome outdoor activities became as much a part of bourgeois culture as pictures of gardens, and these were no longer valued only as topographical views or as settings freighted with meanings of their own but for their own sake. The bourgeois public loved seeing its everyday activities, its values and standards, mirrored in art—and not just in Europe. In *The Croquet*

75
Winslow Homer (1836–1910)
THE CROQUET GAME
1866
Oil on canvas, 19 × 30 in. (48.3 × 76.2 cm)
Yale University Art Gallery, New Haven,
Connecticut; Bequest of Stephen Carlton Clark

In 1869 Appleton's Journal *reported how felicitous it was that ladies were spending more time outdoors thanks to the introduction of croquet. Homer's choice of precisely this game as his subject, together with the absence of any narrative features in the painting, can be understood as a deliberate attempt to be modern.*

Game (plate 75), Winslow Homer illustrated an enormously popular activity of the time, providing a specifically American view of the everyday life of the nineteenth-century upper middle class. It was said of this fashionable sport in 1870 that "this new game, which is played outdoors on a closely cropped lawn, offers everything one requires for being up-to-date, for it is the most appealing and enjoyable leisure-time activity imaginable." First exhibited in Samuel P. Avery's New York gallery in 1866 under the title *A Croquet Study*, the painting was admired above all for the quality of its painterly rendering.

The same kind of public recognition was not accorded to Thomas Eakins, who in his own words felt "misunderstood, persecuted, and disregarded." It was above all his uncompromising realism, his constant effort to portray everyday America as faithfully as possible, that failed to engage the public of his native Philadelphia. In his meticulously constructed plein-air scenes

Eakins was concerned with capturing a specific time and place, and rendering it as faithfully as possible. With their adherence to the integrity of color and form, pictures like his intimate view of *Lafayette Park, Washington* (plate 76) document the independence of American painting from contemporary developments in European art. For whereas Homer and Eakins sought to translate into painting as faithfully as possible their visual impressions of nature, European painters were beginning to experiment with the intrinsic aesthetic value of lines, forms, and above all color.

76
Thomas Eakins (1844–1916)
Lafayette Park, Washington
1877
Oil on canvas, 10½ × 14½ in. (26.7 × 36.8 cm)
Philadelphia Museum of Art

Eakins was more interested in reality than the process of reproducing it in painting. He often produced his paintings after his own photographs, and again and again it is possible to discern the characteristic photographic view being created with the triumph of the new medium.

The Gardens of the Impressionists

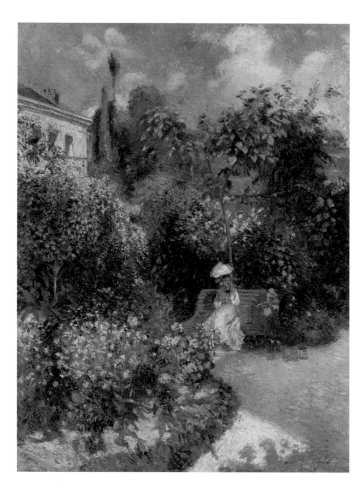

77 (above and opposite)
Camille Pissarro (1831–1903)
THE GARDEN IN PONTOISE
1877
Oil on canvas, 65 × 49³⁄₁₆ in. (165 × 125 cm)
Private collection

In his paintings of gardens from Pontoise, Pissarro pictures in warm, muted colors a nature cultivated by man, one in which buildings and vegetation are harmoniously interrelated. His loose, short, parallel brushstrokes blur the individual forms but combine to create an impression of shimmering color on the surface of the canvas.

78 (pages 148–49)
Camille Pissarro
THE HERMITAGE AT PONTOISE
1867
Oil on canvas, 49³⁄₁₆ × 59¼ in. (91 × 150.5 cm)
Wallraf-Richartz-Museum, Cologne, Germany

In 1866 Pissarro moved to the small town of Pontoise, which was still largely untouched by industrialization. There the Oise, the surrounding hills, and the local orchards provided motifs well suited to his notions of form and aesthetic subjects.

The open art market that is now taken for granted, one in which pictures can be bought by people who do not even know the artist, was only fully developed in the later nineteenth century. It provided artists with considerable creative freedom, but also imposed certain constraints. If they hoped to sell their works, they had to satisfy the public's expectations; at the same time they had to develop a distinctly personal style if they were to make a name for themselves in such a market and maintain it. In the painting of the time, the garden motif took on a new significance, as painters, now socially emancipated, began experimenting with depictions of nature as a means of solving painterly problems and exploring aesthetic effects.

An unprecedented expansion of the market for cultural goods was paralleled by the development of the press, which now largely determined which painters achieved success. This was discovered in 1874 by a group of young painters who presented an exhibition of their own two weeks before the opening of the offical Salon. Their show in the boulevard des Capucines received a certain amount of attention in the Paris papers; the more conservative ones, however, refused to provide a forum for these opponents of official art policy, or "revoltés." In the satirical paper *Le Charivari*, Louis Leroy scoffed at what he found to be the bizarre picture world of the "Impressionists," and four days later Jules-Antoine Castagnary used the new term less dismissively to characterize the intentions of Camille Pissarro, Claude Monet, and others who were no longer attempting to create faithful representations of nature, but rather to capture their impressions as they confronted it.

Camille Pissarro was among the artists who participated in this first group show, and he would be the only one represented in all eight Impressionist exhibitions between 1874 and 1886. His painterly views of the area around Pontoise (plates 77–78) form a bridge between the muted paintings of Courbet (plate 72) and the far more subjective pictures of the younger French avant-garde. In 1901 he painted his *Vegetable Garden in Eragny, Overcast Sky, Morning* (plate 79), a view that seems to have been arbitrarily selected but is nevertheless highly effective. Even its title betrays the fact that the painter was not concerned solely with the garden motif but more particularly with the weather conditions as conveyed by the light. The contemporary art public was puzzled by Pissarro's uncompromisingly personal style of painting, so different from what could be seen at the Salons that still set the standards for the market. The first collectors of his works were therefore art critics and fellow artists like Gustave Caillebotte, who had regularly participated in the shows of the Impressionists between 1876 and 1880. Caillebotte, who came from a well-to-

C. Pissarro. 186[.]

79
Camille Pissarro
VEGETABLE GARDEN IN ERAGNY, OVERCAST SKY, MORNING
1901
Oil on canvas, 25½ × 32 in. (64.8 × 81.3 cm)
Philadelphia Museum of Art; Bequest of Charlotte Dorrance Wright

After a few experiments with a luminous Pointillism after becoming acquainted with Paul Signac and Georges Seurat in 1885, Pissarro found his way at the end of his life to a less controlled kind of brushwork, more clearly influenced by Impressionism. It is evident in his view of the garden in Eragny-sur-Epte, where he had lived and worked since 1884.

80 (opposite)
Gustave Caillebotte (1848–1894)
DAHLIAS—GARDEN IN PETIT-GENNEVILLIERS
1893
Oil on canvas, 61¹³⁄₁₆ × 44⅞ in. (157 × 114 cm)
Christie's, London

Although Caillebotte produced a number of floral still lifes, only a few pictures show his garden in Petit-Gennevilliers. He worked in it with devotion, especially in the last years of his life, encouraged by the mail-order plant business then being established in France.

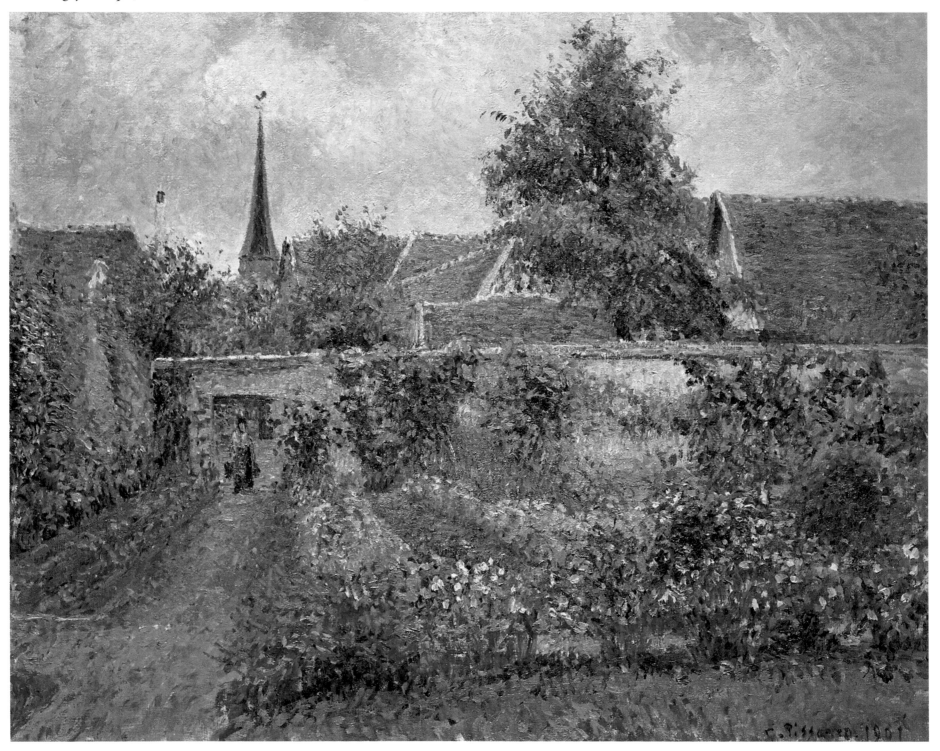

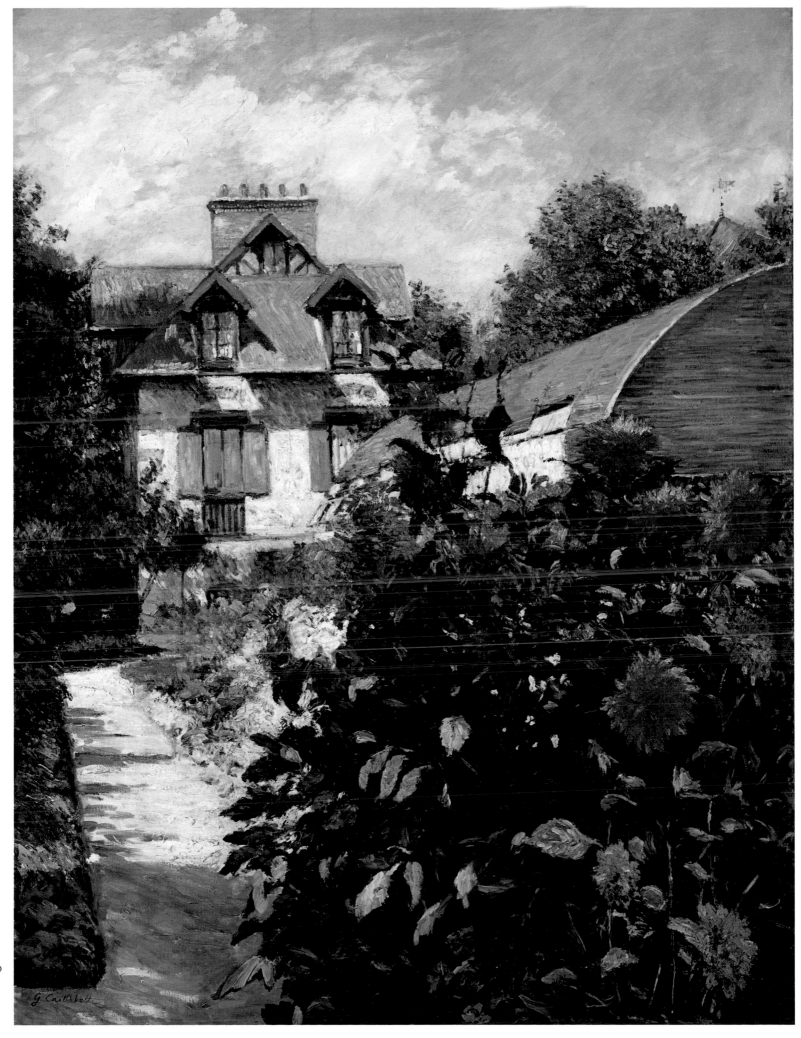

G. Caillebotte

81 Auguste Renoir (1841–1919)
MONET PAINTING IN HIS GARDEN
1873
Oil on canvas, 18⅜ × 23⅝ in. (46.7 × 60 cm)
Wadsworth Atheneum, Hartford, Connecticut

This portrait of Claude Monet was a result of the two painters' association in Argenteuil. It spontaneously depicts the mood of a moment, and in the figure of the painter standing before his easel suggests something of the Impressionists' standoffishness with respect to natural detail. Their surroundings were no longer rendered with extreme fidelity but rather subjectively interpreted, their purely sensory impressions transformed with short brushstrokes into a vibrant pattern of color.

Detail on page 2

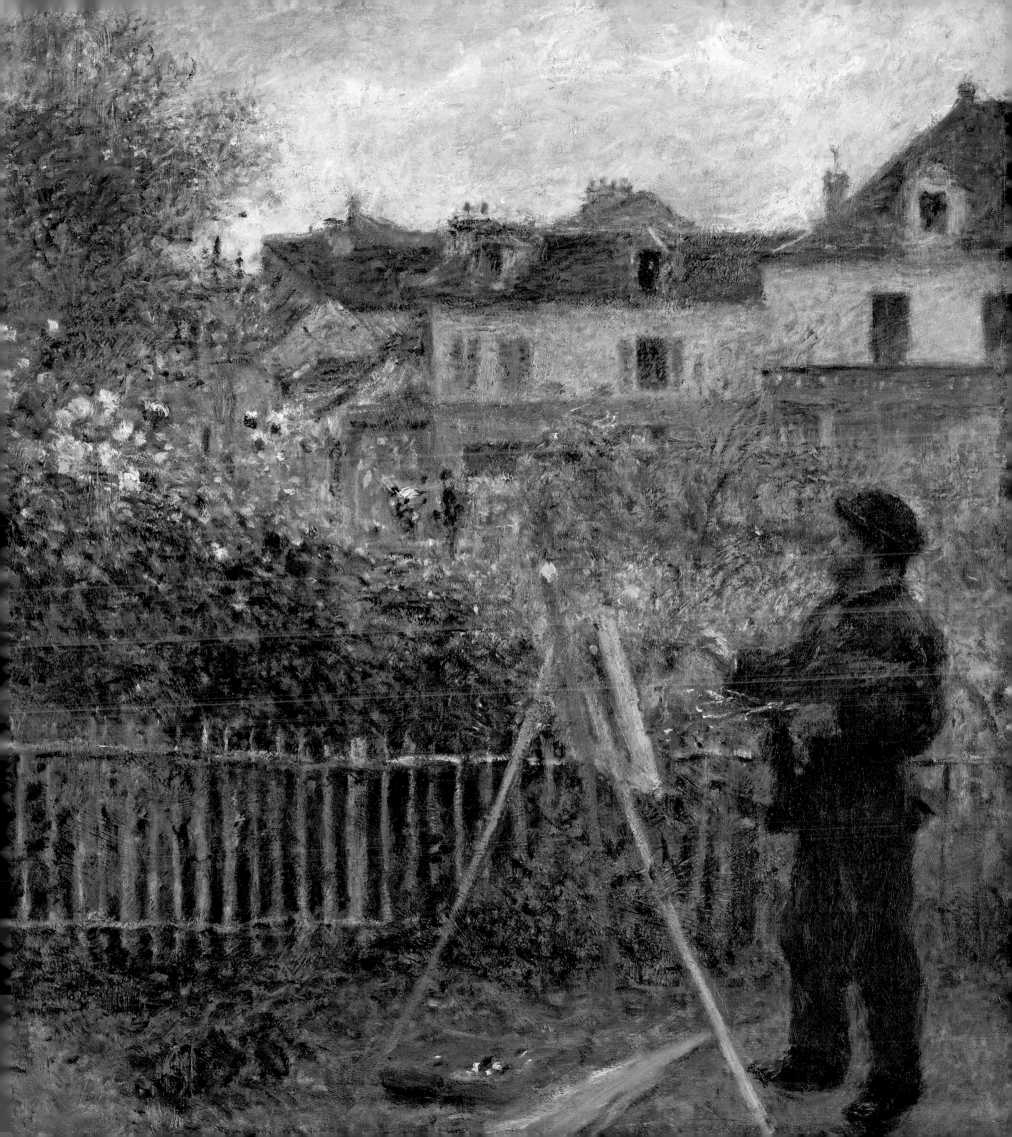

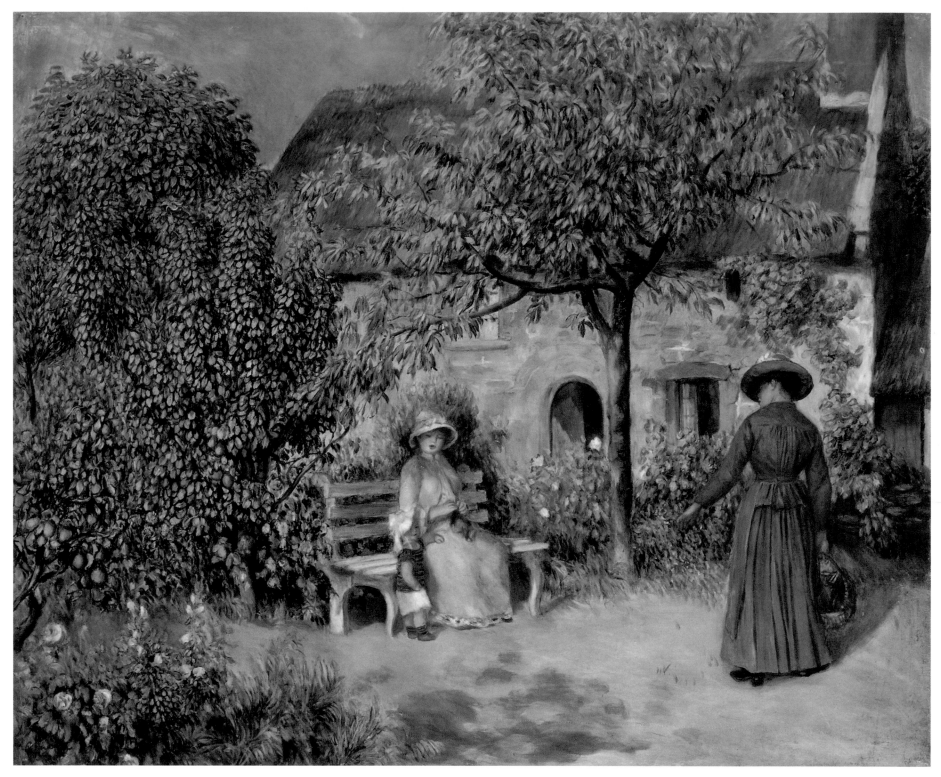

82 (above)
Auguste Renoir
THE GARDEN BENCH
c. 1886
Oil on canvas, 21¼ × 22⅛ in. (54 × 56.2 cm)
The Barnes Foundation, Merion, Pennsylvania

Beginning in the mid-1880s Renoir undertook a number of journeys in his search for new motifs. They took him into various parts of France and a number of large European cities, where he studied in museums and art collections. During a stay in Brittany he produced this intimate family portrait showing his wife Aline in the garden with their son Pierre, born in 1885.

83 (opposite)
Auguste Renoir
IN THE GARDEN
1885
Oil on canvas, 67⅛ × 44⁵⁄₁₆ in. (170.5 × 112.5 cm)
State Hermitage Museum, Saint Petersburg, Russia

In this depiction of a pair of young lovers in a garden there is an echo of the garden of love and the realm of Venus (plates 41, 49). Yet this fundamental idea is only one aspect of the picture of a light-filled garden; the painter shows us a fashionably dressed couple seated at a modern garden table in a world filled with sensual experiences.

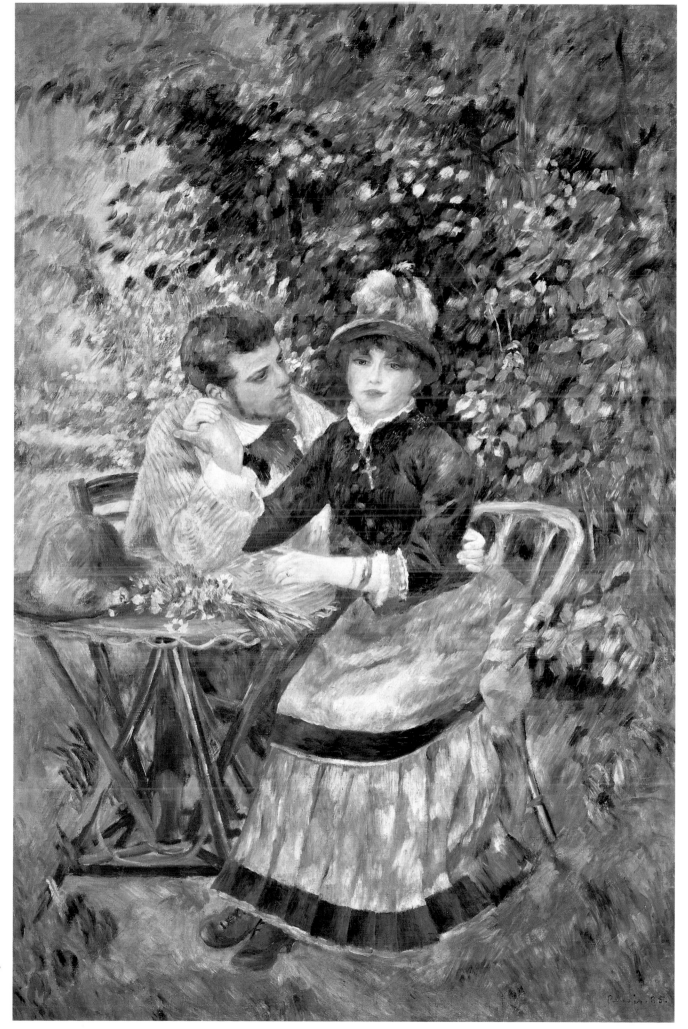

83

do Parisian family whose life and surroundings are reflected in his paintings, strove toward a new realism.

Photography was becoming more and more accepted at this time, and from images accidently captured on film, people learned to appreciate the charm of unusual perspectives or otherwise overlooked details from nature. And it is surely no coincidence that the first picture postcards had appeared in 1870. When selecting subjects for postcards and ideal vantage points, photographers attempted to realize the ideals of classical landscape painting, and this meant that paintings were no longer required primarily to be illustrations. Painters were now eager to make use of the new technique but also to explore ways of making pictures that were not available to it. Caillebotte, for example, often created his paintings with the help of optical equipment or on the basis of photographs, which he turned into drawings that he then enlarged to his picture format by means of a grid. This was the case with his *Dahlias* (plate 80), which documents both his interest in capturing light conditions in painting and his passion for gardening. The picture provides a glimpse of an uncommonly large greenhouse and the garden at Caillebotte's house in Petit-Gennevilliers. He had owned the property since 1882, and beginning in 1887 it became his primary residence. By that time he had largely withdrawn from the Paris art scene and had long since stopped showing his work in the exhibitions of the Impressionists.

The same could be said of Auguste Renoir. It was Renoir, incidentally, who had invited Caillebotte to participate in the first Impressionist show in 1874. That summer Renoir had painted in Argenteuil, next to the Seine, together with Edouard Manet and Claude Monet. There, in addition to a number of

84 (left and opposite)
Auguste Renoir
OLIVE GARDEN
c. 1907/12
Oil on canvas, 12¹¹⁄₁₆ × 18¹³⁄₁₆ in. (32.2 × 47.8 cm)
Museum Folkwang, Essen, Germany

Even in his last works, Renoir was mainly interested in the play of light and how to translate it into painting. His loose brushwork and painterly approach provide no hint of the severe illness that gradually crippled his hands. Again and again during the last years of his life he captured his impressions of trees, shrubs, and flowers on larger and smaller canvases in warm and animated colors.

85 (below)
Edouard Manet (1832–1883)
THE MONET FAMILY IN THEIR GARDEN IN ARGENTEUIL
1874
Oil on canvas, 24 × 39¼ in. (61 × 99.7 cm)
The Metropolitan Museum of Art, New York;
Bequest of Joan Whitney Payson

The picture shows Manet's fellow painter Monet in his garden in Argenteuil with his wife Camille and son Jean. Manet exploited the possibilities of pure painting, with no effort to slavishly capture the various textures. Concerned with the overall painterly effect, he refrained from troubling with details, so that one has the impression of looking at the world in a new way.

Details from plates 85, 86 on pages 160, 161

86 (opposite)
Edouard Manet
A CORNER IN THE GARDEN AT BELLEVUE
1880
Oil on canvas, 36¼ × 27⁹⁄₁₆ in. (92 × 70 cm)
E. G. Bührle Collection, Zurich

At the urging of Berthe Morisot, Manet first went out into the garden to paint in 1870. He subsequently devoted himself to the depiction of nature in summer again and again.

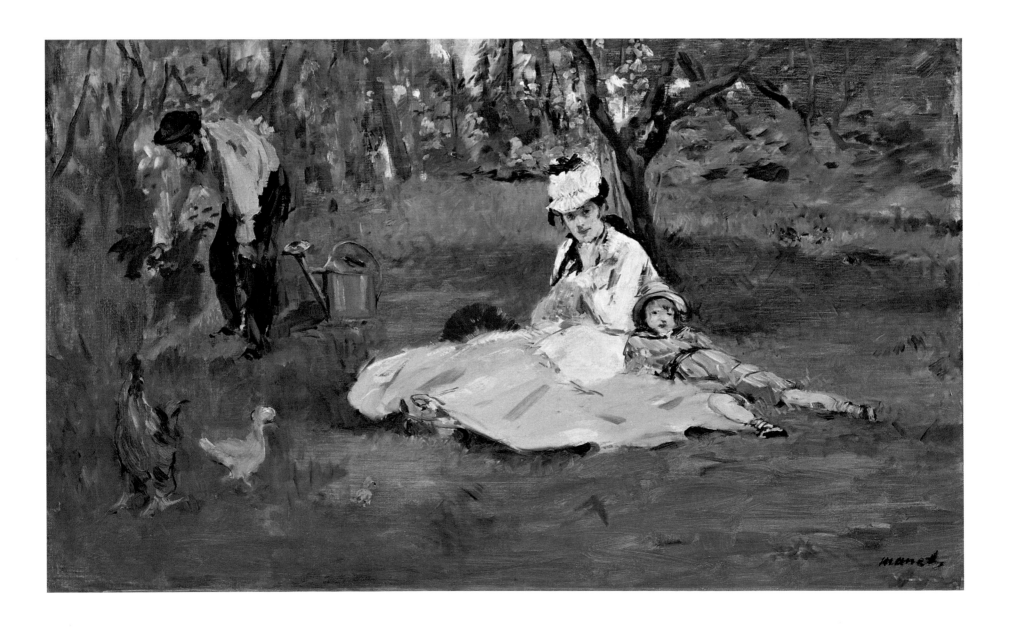

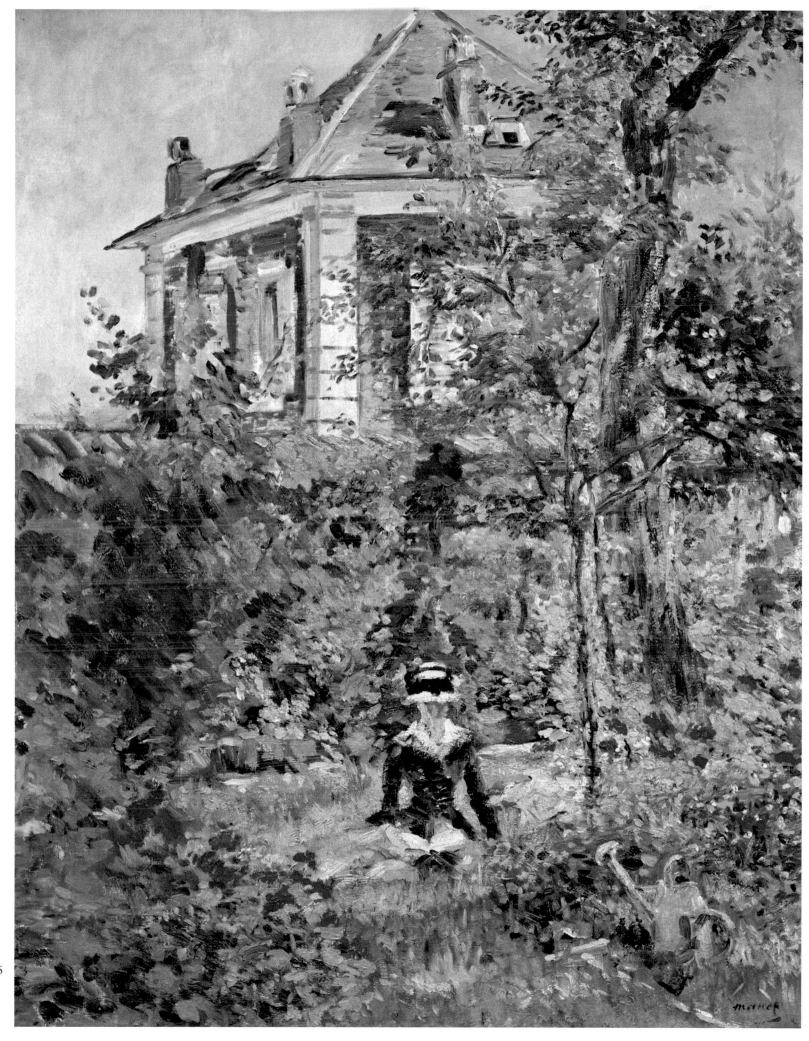

85

87
Claude Monet (1840–1926)
Blooming Garden
c. 1866
Oil on canvas, 25⁹⁄₁₆ × 21¼ in. (65 × 54 cm)
Musée d'Orsay, Paris

Monet painted this view of a garden in full bloom during a visit to his family's summer house in Sainte-Adresse. There, in the garden of the Villa Le Coteau, owned by the Lecadre family, he produced a number of pictures that document his new concept of plein-air painting.

landscapes, he had painted his portrait *Monet Painting in His Garden* (plate 81) the previous year, testament to the close association between the two painters. After this time Renoir would develop an increasingly personal style, at the same time attempting to affiliate himself with "official" art. In 1878 he exhibited in the Salon, and in 1879 he began to be successful, especially with his portraits. His main interest was the human figure (plate 83), not depictions of nature. But he produced pictures of gardens again and again, often with some biographical association, like *The Garden Bench* (plate 82) or *Olive Garden* (plate 84), the latter a glimpse of the artist's garden in Cagne-sur-Mer on the Côte d'Azur. Renoir had bought a house there in 1907, and had its garden laid out according to his own very precise specifications. By the time a retrospective of his works was included in the autumn Salon of 1904, he was highly celebrated. The public had learned to embrace these new picture worlds, accepting that if only one stepped back a bit from his paintings, their seemingly unrelated patches of color suddenly took on form and came to life.

One of Renoir's closest friends was Edouard Manet, an important mentor, especially at the beginning of his career. Along with the upper-class Edgar Degas, Manet and Renoir regularly visited the Café de la Nouvelle Athènes on place Pigalle, or the somewhat less elegant Café Guerbois, which was also frequented by Camille Pissarro and Claude Monet. In part because in that era of gaslight it was possible to paint only during the day, these painters would gather each evening with writers and critics like Charles Baudelaire, Emile Zola, and Jules Antoine Castagnary to discuss their views on art or rant against the official art establishment. By the early 1880s their conversations had begun to bear fruit, in that the art market was increasingly welcoming to the new style of painting, recognizing that it was creating extraordinary visual sensations.

Manet had spent the summer of 1874 at his family's country place in Gennevilliers, from which he went on outings with Renoir and Monet to paint near the Seine in Argenteuil. His picture *The Monet Family in Their Garden in Argenteuil* (plate 85) dates from that time and documents the beginning of a close collaboration between Manet and Monet. Nevertheless, fearing that the group exhibition in the boulevard des Capucines would be perceived as an expression of protest by the officially rejected painters, Manet chose not to take part in it. Again and again the "independents" tried to get Manet to participate in their exhibitions, while for many years he struggled to gain recognition with pictures of events and portraits. Hoping to restore his health, he spent the summer of 1880 in a rented house in Bellevue, whose garden he captured in an unpretentious but charming picture (plate 86). In the following year one of his paintings was awarded second prize at the Salon d'Automne, causing the artist to comment to a friend that such recognition came too late "to make up for twenty years of failure." And in truth success did come too late. It was only after Manet's

88 (above and opposite)
Claude Monet
Breakfast
1873
Oil on canvas, 63¾ × 79¹⁵⁄₁₆ in. (162 × 203 cm)
Musée d'Orsay, Paris

Only from a certain distance can one make out the blooming bushes in the individual dots of color in the background. The female figures shifted to the edge of the picture do not suggest any particular narrative, so that the picture's decorative quality takes on a value of its own. The balanced composition and colors in this painting, unusual in Monet's œuvre even in its format, betray the fact that it was not made directly before the subject, the garden of the artist's first house in Argenteuil, but in his atelier.

death, at which time Degas sadly remarked that "he was greater than we knew," that prices for his pictures shot up, and according to Renoir the auction of his estate early the following year was an event that "exceeded all expectations."

Claude Monet (plate 87) had to deal with incomprehension as well. He first showed his paintings to the public in 1867, when as a favor the paint dealer Louis Latouche placed a few of his pictures in the window of his shop at 34, rue de Lafayette. Legend has it that the display attracted a mob, but he failed to make any money from it. In defiance of centuries of oil-painting tradition, Monet did not begin his paintings with dark colors on a muted canvas, then progressively lighten them. Instead, he followed Manet's example, painting directly on the white of the canvas. Monet's picture world clearly differs from those of earlier naturalistic movements, if only owing to the subjective color harmonies developed in the painting process, through which objectivity becomes less important. His brushstrokes do not follow the shapes of objects; they only illustrate the light effects on their surfaces (plate 88). In the years between 1873 and 1876 Monet completed a picture every two weeks on average, frequently choosing

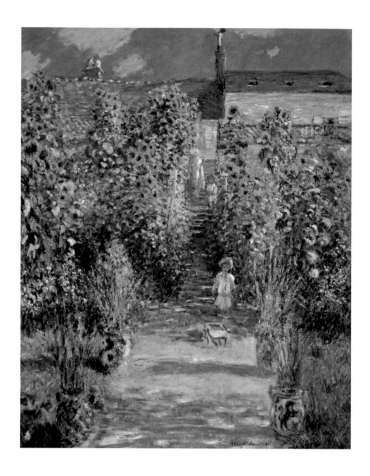

89 (above and opposite)
Claude Monet
THE ARTIST'S GARDEN IN VÉTHEUIL
1880
Oil on canvas, 59⅝ × 47⅝ in. (151.4 × 121 cm)
National Gallery, Washington, D.C.;
Ailsa Mellow Bruce Collection

In the small village of Vétheuil Monet had rented a house whose extensive garden plot sloped down to the bank of the Seine. There he found a rich store of subjects for pictures that led critics to praise him as "the painter of light."

as his subject his own garden, where he could paint in plein air without having to make major preparations. He did not depict his subjects and nature for their own sake, but merely as the bearers of different tonal values. In atmospheric pictures like *The Artist's Garden in Vétheuil* (plate 89), color clearly triumphs over the subject matter. In 1883 Monet rented a large country house in Giverny, a small village near Vernon where the Epte empties into the Seine. In the early 1890s he began to make a lot of money, as his pictures were becoming more sought after; he was able to buy the property, and in 1893 he even enlarged it, purchasing an additional piece of land. During his first years in Giverny he began laying out his garden for the express purpose of creating for himself a ready stock of painterly motifs (plate 90). Part of it was given over to a water-lily pond, across the western end of which was an arched bridge like those seen in Japanese color woodcuts (plate 91). Monet worked with various plant dealers, ordering large quantities from them at great expense. Although the shapes of the beds and the color values and contrasts of the plantings were planned with an eye to their translation into paint, Monet became less and less concerned with picturing given sections of the garden or specific weather and light conditions. In his later pictures especially, no longer created in his garden but in his atelier, his painting had largely freed itself from its indebtedness to nature (plate 92).

The disregard for objectivity that is expressed especially clearly in Monet's later serial pictures was a result of his insistence on seeing as the true subject of his painting. Once painting was liberated from form, the mere representation of recognizable objects was no longer the purpose of art; it became instead a medium through which one could experience visual pleasure. The pure artistry in Monet's pictures and those of the Impressionists developed a dynamic of its own, one that caused objectivity to retreat into the background in favor of a total focus on artistic subjectivity. From now on what really mattered was no longer primarily *what* was painted but *how* it was painted. In a well-known anecdote, Georges Moor describes a visit to the atelier of Edgar Degas. There the artist pointed out a recently-acquired drawing of the god Jupiter by the famous narrative painter Jean-Auguste-Dominique Ingres. It hung next to a painting of a pear by Manet. Moor preferred the latter work because of its utter simplicity, and said as much. Degas then admitted that he had hung it there on purpose, "because a pear painted like that puts any god to shame."

From then on still lifes and depictions of nature—the latter now perceived as an aesthetic object and largely free of meaningful content—would be employed in experimental works intended to draw the viewer's gaze to the painting itself. For a picture's subject, though still considered important in the eyes of the public, played only a subordinate role; the way a painting was made became paramount. Beginning in the 1870s, a picture's compositional rhetoric had also become secondary, as unpretentious subjects came to be placed in paintings in

90 (right)
Claude Monet
IRIS BED IN MONET'S GARDEN
1900
Oil on canvas, 31⅞ × 36³⁄₁₆ in. (81 × 92 cm)
Musée d'Orsay, Paris

In his careful plantings, calculated with an eye to the seasons and the overall color effects, Monet made good use of his experiences in Argenteuil and Vétheuil. The beds extending straight out from the house were completely filled with violet irises, in vivid contrast to the narrower flower beds in the background.

Details on pages 10–11

91 (page 170)
Claude Monet
THE WATER-LILY POND, HARMONY IN PINK
1900
Oil on canvas, 35¼ × 39⅜ in. (89.5 × 100 cm)
Musée d'Orsay, Paris

The many pictures of Monet's water-lily pond and its pont japonais are impressive testimony to the dedication with which Monet applied himself, from only slightly shifting vantage points, to the changing light and colors of various times of day and different weather conditions.

92 (page 171)
Claude Monet
THE HOUSE SEEN FROM THE ROSE GARDEN
1922/24
Oil on canvas, 35 × 36¼ in. (89 × 92 cm)
Musée Marmottan, Paris

In Monet's late paintings the colors are no longer asked to reflect forms in nature. They take on a life of their own, with a radiance that contemporary viewers found jarring. He explored the effect of colors on his canvas in endless variations; in his repeated use of a given motif he elevated the serial work from a mere painterly experiment to a valid artistic principle.

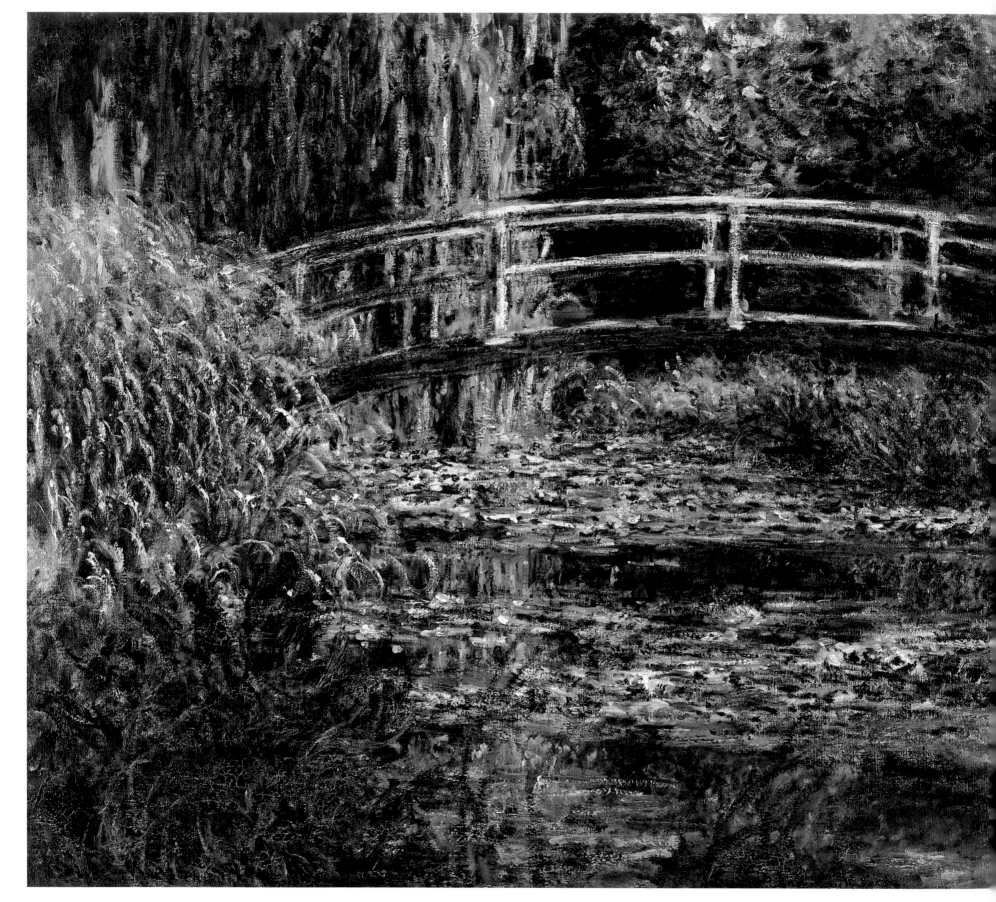

91

92

93

Paul Cézanne (1839–1906)

TREES IN A PARK, JAS DE BOUFFAN

1885–87

Oil on canvas, 28¾ × 36¼ in. (73 × 92 cm)

Pushkin Museum of Fine Arts, Moscow

Cézanne's father bought the elegant estate Jas de Bouffon, a little over a mile (2 km) west of Aix, as a country house in 1859, and for roughly four decades it served as the painter's primary residence. He worked there in seclusion directly before his subjects. For Cézanne painting from nature meant making use of the discoveries of the Impressionists but also reviving the regularity of early modern picture design in the search for a painterly language appropriate to the two-dimensionality of the picture surface.

unpretentious ways. The painterly tradition of providing religious, moral, or scientific instruction or encouraging contemplation of nature from a spiritual point of view was irrevocably at an end. The picture motif, freed from any symbolic meaning, was now of far less importance than the mood a picture conveyed, perceived as a reflection of the artist's emotions while painting it. Once the artist himself became the subject, the notion of *l'art pour l'art*, long since bandied about, took on new importance; a picture drew its meaning and cultural value from the fact that it was a picture and nothing more. To the contemporary public, however, this notion, now taken for granted, seemed altogether as revolutionary as a pictorial language that broke with all the traditional ways of seeing.

Harmony Parallel to Nature

For Paul Cézanne a work of art was a product obeying laws of its own, created in close contact with reality through observation as well as in accordance with theory and by means of craftsmanly skill. A painting was not supposed to imitate the visible world, but rather to seem like a "harmony parallel to nature" that had become a picture; a picture could only take on the desired truth if the observed subject was represented, not reproduced.

94
Paul Cézanne
THE GARDEN AT LES LAUVES
c. 1906
Oil on canvas, 25¾ × 31⅞ in. (65.5 × 80.9 cm)
Phillips Collection, Washington, D.C.

After inheritance issues forced the sale of Jas de Bouffon in 1899, Cézanne moved into an apartment in downtown Aix, and in 1901–2 he had an atelier built after his own plans on the Chemin des Lauves, where he created a garden that he painted again and again in the last years of his life. One of his last paintings, left unfinished, was purchased from his estate by the art dealer Ambroise Vollard. It clearly shows Cézanne's painterly attempt to find an ideal equilibrium in a two-dimensional composition.

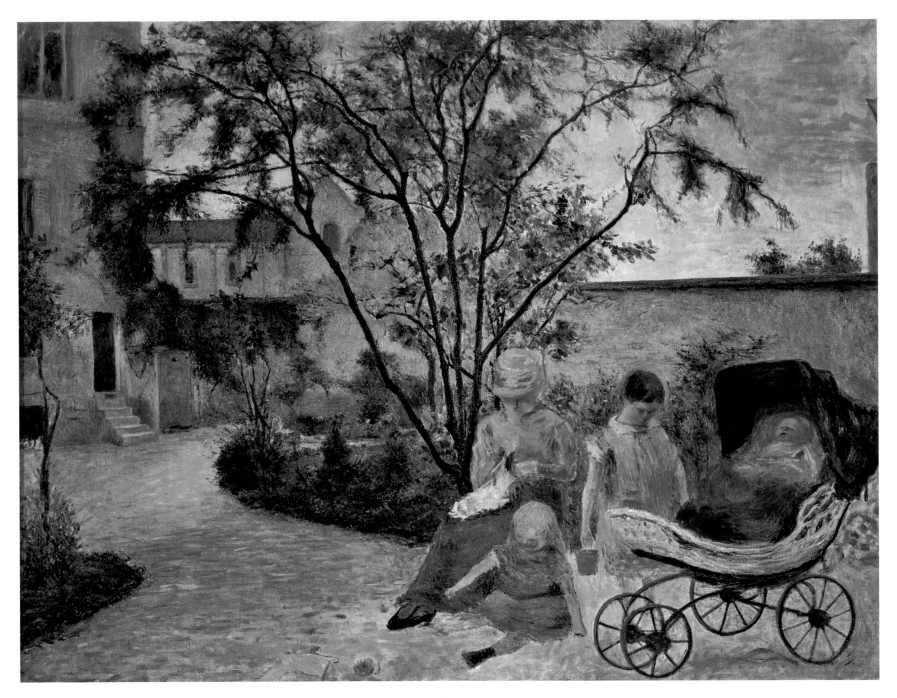

95 (above)
Paul Gauguin (1848–1903)
THE ARTIST'S FAMILY IN THE GARDEN OF
RUE CARCEL
1881
Oil on canvas, 34¼ × 44⅞ in. (87 × 114 cm)
Ny Carlsberg Glyptothek, Copenhagen

Gauguin first worked as a sailor, then later made his living as a stockbroker. With his earnings he bought a small house with a garden in Paris's rue Carcel in the summer of 1880. Two years later he wrote to Pissarro, who had taught him Impressionist landscape painting and a sense of composition, that he had decided to spend the rest of his life "under the financial conditions of an amateur painter. . . . I have determined to become an artist."

96 (opposite)
Vincent van Gogh (1853–1890)
A MEMORY OF THE GARDEN IN ETTEN
1888
Oil on canvas, 28¹⁵⁄₁₆ × 36⁷⁄₁₆ in. (73.5 × 92.5 cm)
State Hermitage Museum, Saint Petersburg, Russia

This picture, a blend of reminiscence and immediate experience, is wholly indebted to Gauguin. Van Gogh did not paint this picture from nature, but "out of his head." Its unreal character is emphasized by the fact that there is no horizon line to anchor the scene in a world the viewer could understand. Despite the suggested foreshortenings, the objects he imagined as being stacked one behind the other become adjacent graphic forms on the picture's surface. Van Gogh explained that with his intense colors and stylized brushwork he wished to reflect poetry and emotions.

Accordingly, Cézanne made no attempt to render nature realistically, but to recreate it in his pictures in terms of his visual experience. This concept and the pictures he produced were so revolutionary that it was only with the greatest difficulty that Pissarro succeeded in convincing the other members of the group to allow Cézanne to participate in the first Impressionist show. In his pictures Cézanne broke down the visible world into an array of color structures, attempting to capture light effects by means of *taches*, or spots of the purest possible pigments loosely placed next to each other. A definite tension in the interplay of forms and spaces is already apparent in his *Trees in a Park, Jas de Bouffan* (plate 93), painted between 1885 and 1887, and becomes even more pronounced in his later pictures. The rhythmical structure of spots of color in a painting produced around 1906 (plate 94) can only be identified as a view

97 (below)
Vincent van Gogh
THE PARISH GARDEN AT NUENEN
1884
Oil on paper on wood, 9¹³⁄₁₆ × 22⁷⁄₁₆ in. (25 × 57 cm)
Groninger Museum, Groningen, the Netherlands

*As this picture of his parents' garden in Nuenen
shows, at the beginning of his painting career van
Gogh stood under the influence of Anton Mauves and
the so-called Hague School, a group of naturalistic
painters not unlike the earlier group at Barbizon.
With no attempt to create a pleasing painting, he
placed the parish garden in a gloomy, almost depress-
ing composition whose symbolic intent is underscored
by the church tower looming up in the background.
The viewer is inevitably forced to reflect on the place
of man in his journey through time.*

of *The Garden at Les Lauves* by comparing it with a more finished watercolor executed with more objective references. The composition's horizontal pattern of loosely arranged, blocklike areas of color clearly suggests the complexity of Cézanne's painterly response to the visible world, his attempt to do justice to both the three-dimensional impression of nature and the two-dimensionality of the picture. The view of his own garden, like a still life, a portrait, or a self-portrait, was only a possible provocation toward the attainment of this artistic goal, one that accorded the picture's individual elements—its colors and the structures formed of them—a sensory value independent of their illustrative function. With Cézanne and the fin-de-siècle artist generation came a kind of painting that created objects rather than depicting them.

One painter who owed a great deal to Cézanne was Paul Gauguin. He was among the first to recognize the importance of the older man's artistic endeavors and owned some of his paintings. About 1881 Cézanne referred to his young colleague's emulation of him with a touch of admiration: "Il m'a chipé ma petite sensation" (He has stolen my modest sensation from me). Gauguin first took part in one of the Impressionist exhibitions in 1879. He was most closely associated with Pissarro, with whom he spent the summer of 1881 in Pontoise. In *The Artist's Family in the Garden of Rue Carcel* (plate 95), it is possible to sense his indebtedness to Pissarro. Joris-Karl Huysmans was fully aware of the connection; in a review of the Salon des Indépendants of 1881 he wrote that up to that time Gauguin had contributed "watered-down versions of the works of

98 (page 177)
Vincent van Gogh
FLOWER GARDEN
1888
Oil on canvas, 36¼ × 28¾ in. (92 × 73 cm)
Private collection

To express his emotions, van Gogh altered the colors he saw, making them increasingly more intense and placing them in strong contrasts. In this period he painted gardens again and again. Wholly in the spirit of traditional iconography, these illustrations of a paradisial nature were intended as symbols of love and friendship.

99 (right)
Vincent van Gogh
GARDEN WITH PATH
1888
Oil on canvas, 28⅜ × 35¹³⁄₁₆ in. (72 × 91 cm)
Gemeentemuseum, The Hague

In Arles, van Gogh set up a simple but functional atelier whose walls were painted white—a highly unusual choice at the time—so that the pictures hung on them seemed all the more radiant. Yet he mostly painted outdoors, always on the lookout for subjects that expressed his feelings.

100
Vincent van Gogh
THE GARDEN OF THE MAISON DE SANTÉ IN ARLES
1889
Oil on canvas, 28¾ × 36¼ in. (73 × 92 cm)
Oskar Reinhart Collection "Am Römerholz," Winterthur, Switzerland

In late 1888 the failure of his creative association with Gauguin plunged van Gogh into a profound psychological crisis. At the urging of the townspeople he was placed in the hospital, whose inner courtyard he pictured in this painting. In May 1889 he voluntarily checked into the asylum in Saint-Remy. In the confinement of the last nineteen months of his life he produced another 255 paintings.

Detail on page 14

101 (opposite)
Vincent van Gogh
DOCTOR GACHET'S GARDEN IN AUVERS-SUR-OISE
1890
Oil on canvas, 28¾ × 20¼ in. (73 × 51.5 cm)
Musée d'Orsay, Paris

In May 1890 van Gogh moved to Auvers-sur-Oise, so as to be able to work there under the supervision of the art-loving doctor Paul Gachet, of whom he had learned through friends of his brother's. At that time the garden picture became for van Gogh a highly subjective metaphor for human suffering, which he tried to express both in the motivic contrast between interior and exterior space and through spontaneous brushwork in his chosen colors.

102 (opposite)
Gustav Klimt (1862–1918)
Garden with Sunflowers
c. 1905/6
Oil on canvas, 43⅛⁶ × 43⅛⁶ in. (110 × 110 cm)
Österreichische Galerie im Belvedere, Vienna

To emphasize the atmospheric element and implicit symbolism of his garden pictures, Klimt reduced reality to an ornamental web of colors parallel to the picture surface, their intensity an homage to the picture world of van Gogh. The motif of the sunflower, traditionally a symbol of devotion because of the way it turns to the light, seems particularly charged with meaning.

Detail on pages 12–13

103 (page 184)
Gustav Klimt
Garden Path with Chickens
1916
Oil on canvas, 43⅛⁶ × 43⅛⁶ in. (110 × 110 cm)
Destroyed by fire at Immendorf Palace in 1945

The dense brushstrokes create a texture of color values that reduces space to a floating curtain of color. Shifting between the foreground and the background, the garden's burgeoning flowers captivate the eye and become an atmospheric reflection of the viewer's emotions. One is directly confronted with the two chickens and the gleaming path leading between flower beds to an arbor at the back.

Monsieur Pissarro, which are still not understood." But he soon began searching for ways of expressing himself that were not so committed to reflecting reality, and managed to develop a pictorial style all his own. Contemporary critics described that style, which he arrived at after moving to Pont-Aven in Brittany, as "synthetic symbolism." It would also influence van Gogh.

Employing his brother Theo as an intermediary, van Gogh managed to convince Gauguin to join him in Arles, where the two painters worked together for roughly two months in late 1888. A product of that artistic exchange was van Gogh's painting *A Memory of the Garden in Etten* (plate 96), in which Gauguin's painterly idiom is readily apparent, especially in its dots of strong color. Its imaginative composition, with its correspondence of planes and lines, is more important than its representation of objects and the actual motif, whose subjective impression would be transformed into a harmonious picture. Van Gogh wrote about this painting to his sister: "I don't know whether you can appreciate that one can express poetry through nothing more than a nice arrangement of colors, just as one can say comforting things through music. Also, the bizarre, exaggerated, and repeated lines snaking through the picture were not intended to reproduce an ordinary semblance of the garden, but to illustrate how it might be seen in a dream, at the same time in its true nature and more curiously than in reality." In his letters van Gogh describes the process of artistic creation as a constructive response to all he has felt and suffered. Within this extremely subjective concept of art, his painterly images of the external world became metaphors for his inner experience. Even his early pictures, like *The Parish Garden at Nuenen* (plate 97), quite obviously convey meanings beyond the subject itself and the problems associated with capturing it in painting. Such meanings are expressed both in his selection of subjects and in the colors and brushwork of his pictures (plates 98–101). At the time, van Gogh's symbolic picture language was at variance with the concepts of the Impressionists and all other representatives of modernism who rejected pictorial content in the traditional sense in favor of aesthetics. According to the statements in his letters, van Gogh's pictures were the result of personal experiences, to be sure, but "all manner of feelings that are common to all of us always outweigh them." He was convinced that even though they were profoundly subjective, they reflected universal human emotions, and would therefore be understood by people who shared his feelings and his way of thinking. Here one sees the origin of the notion, commonly held to this day, that the artist as a creative subject, working for himself without commissions, adds new images to the reality of his time that must be engaged. Thanks to this sense of himself and his uncompromising approach to his work, van Gogh would become a precursor and prototypical representative of modernism.

Pictures of gardens, in which one still has a sense of their traditional metaphorical meanings, at least indirectly, could readily be structured as abstractions appealing to both the intellect and the emotions of the viewer. One sees this in the paintings of Gustav Klimt, which reveal a symbolic content that can be described as an essential feature of the fin de siècle's aestheticizing approach to nature. Formally, Klimt's paintings, though created directly from nature, seem purely ornamental (plate 102), with no attempt at any genuine illusion of depth. This leads to a radical compression of distance, a final break with the traditional concepts of spatial illusion and the creation of atmosphere by means of a simulated distant view that are still in evidence even in the works of Cézanne. To convey a seemingly meditative sense of calm, Klimt chose a perfectly square format, on which he arranged his narrow-focus motif in complete equilibrium (plate 103). Once a painter's sole concern was for the aesthetic effect of his picture and the autonomy of drawing and color were recognized a free and subjective use of painterly methods and forms had become established.

104
Heinrich Vogeler (1872–1942)
Summer Evening
1905
Oil on canvas, 5 ft. 8⅞ in. × 10 ft. 2 in. (175 × 310 cm)
Sammlung Grosse Kunstschau, Worpswede, Germany

Vogeler began working on this monumental painting in the spring of 1905, first calling it The Concert. *It pictures on the left his painter friends Paula and Otto Modersohn, Agnes Wulf, and the sculptress Clara Westhoff, the wife of his poet friend Rainer Maria Rilke. At the gate stands the painter's wife Martha, with his greyhound, a gift from the poet Alfred Walter Heymel, lying at her feet. Among the musicians the painter's brother, playing the flute, can be identified at the back, nearly obscured by the violinist Martin Schröder.*

Yet while pictures of gardens came to be exempt from all rules, gardens themselves were becoming increasingly orderly in their design. In line with current trends in architecture, the garden layout became a part of a total residential design concept, just like the house and its furnishings. Its plantings, chosen for their shapes, were above all meant to convey a sense of serenity and calm. At this same time increasing numbers of gardens and parks were being created as recreation spaces for the inhabitants of rapidly growing cities. In response to the numerous theories calling for reform in the way people lived, around 1900 the first garden cities came into being as integral housing projects. Gardens, once thought of as retreats for the aristocracy, had become a feature of bourgeois culture everywhere taken for granted. Painters and writers of the period, such as the poet Stefan George, celebrated gardens and parks as ideal antidotes to and retreats from the problems associated with industrialization and urbanization.

All over Europe artists had begun grouping together, far from the big cities, and establishing in the countryside living and working communities like the one that had formed around Paul Gauguin in Pont-Aven in Brittany and the even earlier one in Barbizon. They all represented a turning away from academic painting as well as from modern industrial society. Similar artists' colonies could be found in Newlyn in England, in Cockburnspath in Scotland, in Skagen in Denmark, and in the small village of Worpswede, on the moors near Bremen, where beginning in 1889 a group of painters sought an ideal fusion of work and nature. They were joined in 1894 by Heinrich Vogeler, who in the following year bought an old farmhouse in the vicinity. The Barkenhoff, rebuilt according to a comprehensive design concept, became a social center that Vogeler memorialized in his romanticized picture *Summer Evening* (plate 104). This paean to a way of life, begun without commission, found its way into the collection of the Bremen merchant Ludwig Roselius, the most important patron of the Worpswede painters, whose first exhibition in 1894 had been dismissed by the Bremen public as a "fun house."

Art criticism was still mainly faulting the "new painting" for its mundane subject matter, as well as its rejection of any form of artistic intervention that ennobled the impression of nature. Max Liebermann, who exhibited his first picture in 1874, was one of the painters who had to endure such criticism. In 1887 Herman Helferich noted that his work had "no Greeks, no Romans as subject matter, but rather goose-pluckers. No need to report that the Sunday visitors to the Kunstverein were appalled, and the forest-and-meadows critics found it lamentable." Even thirty years later, German audiences expected at least a charming legend or homey narrative if they could not be presented with a splendid historical painting, and their response to Liebermann's pictures was cool, for he offered them nothing but good painting. Liebermann had himself proclaimed: "The notion that the well-painted turnip is better than a poorly

105
Max Liebermann (1847–1935)
MUNICH BEER GARDEN
1883/84
Oil on canvas, 37³⁄₁₆ × 27 in. (94.5 × 68.5 cm)
Bayerische Staatsgemäldesammlungen,
Neue Pinakothek, Munich

Scenes of people relaxing in tree-shaded outdoor beer gardens were a modern subject that Liebermann pictured in a correspondingly modern manner. Though his composition seems haphazard, the relationship between foreground, middle distance, and background is as carefully calculated as the distribution of planes, forms, and colors, rendered in brushwork designed to capture the light effects. The orchestra was Liebermann's invention; Munich beer gardens were not permitted to have music or serve meals at the time.

106
Max Liebermann
THE FLOWER TERRACE IN THE WANNSEE
GARDEN AND THE GREAT LAWN TO THE EAST
1920
Oil on canvas, 26⁹⁄₁₆ × 34⁷⁄₁₆ in. (67.5 × 87.5 cm)
Private collection

Again and again Liebermann chose his garden as his subject. Always working directly from nature, he captured the floral splendor of summer on his canvases with short brushstrokes and even thick blobs of pigment applied with his palette knife. He was not interested in changes visible during the day or through the seasons, only the impact of the luscious colors. His different versions of the same views were created as experiments with painting itself, not out of any particular commitment to the subject.

107
Max Liebermann
Wannsee Garden. Flowering Shrubs Next
to the Garden House Looking North
1928
Oil on canvas, 29⅛ × 20⅞ in. (74 × 53 cm)
Private collection

When Liebermann died in 1935, the Gestapo forbade attendance at his burial. Martha Liebermann, to whom he had already deeded over the Wannsee property in 1928, was forced to sell it at a ridiculously low price after the decree of December 3, 1938 commandeering Jewish assets went into effect. The money was deposited in a savings account to which she had no access. In 1940 the neighboring Villa Marlier was transferred to an SS foundation run by Reinhard Heydrich. On January 20, 1942, it served as the setting for the Wannsee Conference, at which state officials and leading representatives of the Nazi government planned the Holocaust to exterminate the Jewish people of Europe.

108 (opposite)
Max Slevogt (1868–1932)
GRAPE ARBOR AT NEUKASTEL
1917
Oil on wood, 24 × 19½ in. (61 × 49.5 cm)
Wallraf-Richartz-Museum, Cologne, Germany

In 1913 Slevogt began to furnish his summer place at Neukastel in the Palatinate and to create its garden, which he pictured in various paintings. On September 21, 1917, he painted a picture, reproduced as an art print a short time later, showing his two children with their nanny beneath a leafy grape arbor, behind which rises the base of the Neukastel tower. The actual subject of the picture is the special light of autumn, which causes the colors to glow more more intensely and the shadows to seem deeper.

Detail page 16

109 (above)
Lovis Corinth (1858–1925)
GARDEN IN BERLIN-WESTEND
1925
Oil on canvas, 31½ × 39⅜ in. (80 × 100 cm)
Von-der-Heydt-Museum, Wuppertal, Germany

Corinth produced this intimate garden picture, which appears to have been patterned after the picture world of Manet, toward the end of his life. Like other paintings of his late period, this view of the garden belonging to the Krüger family in Berlin, whose son is depicted on the bench in the foreground, is distinguished by free brushwork and the disintegration of its subject matter.

110 (opposite)
Georges Braque (1882–1963)
HOUSES IN L'ESTAQUE
1908
Oil on canvas, 28¾ × 23⅝ in. (73 × 60 cm)
Kunstmuseum, Bern; Hermann und Margrit
Rupf-Stiftung

*In his view of the houses and gardens of L'Estaque,
Braque transformed the picture surface into a care-
fully ordered chaos of seemingly three-dimensional
color planes. Instead of a uniform light source, there
is only a carefully modeled chiaroscuro that causes
the individual stereometric forms to stand out.
The gardens that appear between the cube-shaped
houses are presented as green planes without fixed
contours; the spatial situation is thereby so obscured
that all the elements of the composition seem to lie
on a single plane.*

111 (page 194)
Pierre Bonnard (1867–1947)
THE GARDEN
c. 1936
Oil on canvas, 50 × 39⅜ in. (127 × 100 cm)
Musée du Petit Palais, Paris

*In 1926 Pierre Bonnard bought the villa Le Bosquet
in Le Cannet, whose garden provided him with
numerous subjects. Although he does not render
objects with any attempt at fidelity, his pictures
nevertheless capture the uniqueness of the patch of
nature he worked from. The ocher diagonal extending
outward from the dark center of this garden picture
takes on a compositional function; it forms a break
in the abundance of vegetation and at the same time
provides a hint of an illusion of space.*

painted Madonna has already become an iron-clad rule of modern aesthetics.
But the notion is false; it should read: The well-painted turnip is just as good
as the well-painted Madonna." And he continued to choose everyday scenes,
beer and coffee gardens, as his subject matter (plate 105). The new names for
these still somewhat innovative institutions attest to the profitability they—
and other new "gardens"—enjoyed in Germany at the time. By the time the
first volume of the Brothers Grimm's *German Dictionary* appeared in 1854, the
term *beer garden* had not yet entered the German language. From its fifth vol-
ume one learns that in 1864 a *Kindergärtnerin* was for the first time sought in
Leipzig. Also very novel at the time were zoological gardens. The concept of an
animal park featuring enclosures without bars, now taken for granted, was first
developed in 1896 by Carl Hagenbeck, who promptly applied for a patent.

Like many other artists of his time, Liebermann painted beer gardens, zoos,
and other venues of modern life. He also found a virtually endless number
of themes and motifs for his pictures in the garden of his summer house in
Wannsee. He had bought a sizable property there in 1909, and asked the archi-
tect Paul O. A. Baumgarten to build him a villa on it. The workrooms of the
house were designed in accordance with his wishes, as were the extensive flower,
vegetable, and fruit gardens. At that time mainly in demand as a portraitist, Lie-
bermann lived in his "little castle on the lake" for a quarter of a century. In the
summer months he would produce more than two hundred paintings and end-
less drawings, pastels, and watercolors (plates 106–7). Their characteristic atmo-
spheric realism is also seen in the paintings of Max Slevogt (plate 108), who, like
Liebermann, had studied Impressionism intensively during a sojourn in France.
For a long time this artistic direction was scorned in nationalistic Germany sim-
ply because it came from France. But despite—or perhaps precisely because
of—the rancorous resistance to the "Frenchifying" of German art on the part of
Emperor Wilhelm II and his adviser on art matters, Akademie der Künste direc-
tor Anton von Werner, Impressionism soon found general acceptance. Initially,
it was mainly Berlin bankers and industrialists who chose to decorate their vil-
las with these unusually colorful pictures. Indeed, they seemed to clamor for
this new style of painting, free of any weighty content. By 1913 the American
journalist Frederic W. Wile could confirm that there was probably no longer
any important private German collection that did not include a picture by Lie-
bermann or some other Impressionist. Impressionist pictures continued to be
in demand even after World War I and the collapse of the empire, though other
forms of expression had begun to gain ground. Lovis Corinth, for example, held
to be the leading representative of German Impressionism after Liebermann
and Slevogt, gradually adopted an Expressionist style of painting (plate 109)
that was certain to be understood by the art public of the time.

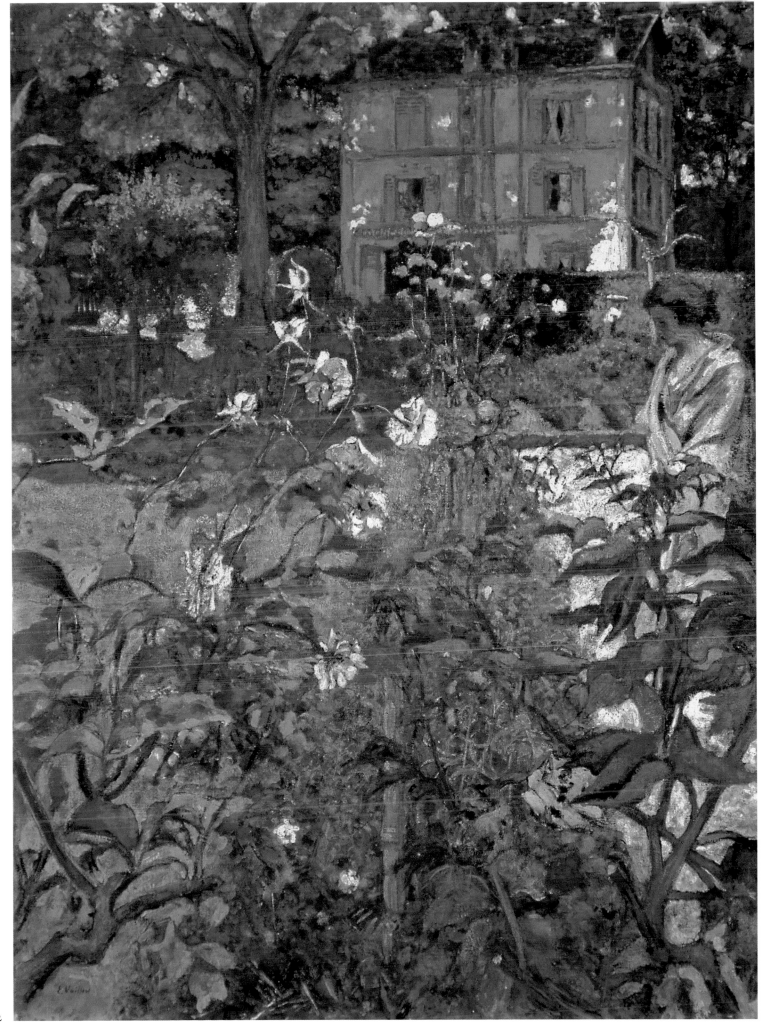

195

112 (page 195)
Edouard Vuillard (1868–1940)

Morning in the Vaucresson Garden

1923–37

Tempera on canvas, 59⁷⁄₁₆ × 43⁹⁄₁₆ in. (151 × 110.7 cm)

The Metropolitan Museum of Art, New York;
Catharine Lorillard Wolfe Collection, Wolfe Fund

*For many years Vuillard and his mother spent their
summers in the Closerie des Gênets in Vaucresson.
Nearby was the property of the art dealer Jos Hessel and his wife, friends of Vuillard for many years.
In this garden picture Lucie Hessel's figure stands
out behind the almost ornamental floral splendor
of the foreground, the design of which recalls the
Impressionist garden scenes of Claude Monet and
Pierre-Auguste Renoir.*

113 (opposite)

Henri Matisse (1869–1954)

The Evergreen,
or The Moroccan Garden

1912

Crayon and charcoal on canvas, 46 × 32½ in.
(116.8 × 82.5 cm)

Museum of Modern Art, New York;
Gift of Florene M. Schoenborn

*In one of his letters Matisse related how greatly
impressed he was by the "huge park" of the Villa
Brooks in Tangier, belonging, with its "very tall
trees," to a man with a "melancholy spirit." During the six weeks that he worked in the villa's large
garden he produced this picture that seems nearly
abstract in its interplay of shapes with seemingly no
objective meaning. "I gradually managed to discover
the secret of my art," Matisse confessed in an interview in 1925. "It is in meditation after nature, in the
expression of a dream under the constant inspiration
of reality."*

Impression and Expression

By the beginning of the twentieth century the new forms of painterly expression arrived at with the autonomy of the picture found increasing acceptance. A growing number of private patrons and art dealers, along with publishers such as Ambroise Vollard and Paul Cassirer, worked to promote the new movements in painting and create a forum for them. To show how modern, cultivated, and discriminating they were, well-to-do collectors turned to innovative, even provocative pictures. In such a climate painters were encouraged to explore new pictorial solutions to the problems presented by the autonomous painting, which were only then being identified to their full extent. Building on the painterly experiments of Cézanne, for example, who had been honored with a major retrospective at the Salon d'Automne in 1907, the painter Georges Braque sought to find a new "pictorial architecture." He spent the summer of 1908 in L'Estaque, in the south of France, where he occupied himself intensively with the painterly organization of space. The result was a series of pictures of houses and gardens with little variation in motif, whose composition and restrained colors were wholly calculated to produce an overall harmony (plate 110). Instead of creating any illusion of depth, Braque developed a new visual reality tied to the picture surface. His pictures were not accepted for Salon d'Automne, but they were exhibited by Daniel-Henry Kahnweiler in November 1908. The reviewer Louis Vauxcelles described these novel pictures as "bizarreries cubiques," and by 1911, at the latest, the term *Cubism* was being applied to a whole new movement in painting.

A group of young artists from the Paris Académie Julian that had formed around Paul Sérusier in the fall of 1888 had already sought solutions to similar painterly problems. Reflecting their avant-gardist ambitions, they called themselves Nabis—"prophets" in Hebrew. Inspired by Paul Gauguin's belief that art is a universal language expressed in symbols, they decisively rejected what they referred to as the "naturalistic lie." The painter and writer Maurice Denis wrote in the journal *Art et critique* in May 1890 that the group wished "to recall that a picture, before it is a war-horse, a naked woman, or any sort of anecdote, is essentially a flat surface covered with a specific arrangement of pigments." This assertion would become the modernist artistic credo, and it is reflected in the pictures of Pierre Bonnard, who was actively associated with the Nabis from the start and contributed greatly to the development of their aesthetic stance. Bonnard was not content with simple appearances; he wanted to capture the mystery behind them, and beginning in about 1910 he increasingly chose gardens and landscapes as his subjects. This effort, already visible in his early pictures, still marks his painting *The Garden* (plate 111), from

114
Ernst Ludwig Kirchner (1880–1938)
THE PLANTER
1911
Oil on canvas, 47¼ × 59 in. (120 × 150 cm)
Private collection

In this depiction Kirchner transformed a specific spot, a planter on Albertplatz in Dresden, into a richly colored composition of uniform flatness. To the bourgeois public of his time such a painting seemed scandalous, if only for the way the painter failed to register the individuality of the figures and the location in favor of the expressiveness of the colors.

around 1936. In it the lush vegetation of his garden in Le Cannet is woven into a dense carpet, the areas of color suggestive of plant forms interlocking in carefully constructed equilibrium.

As painters increasingly emphasized the formal and color structure of their pictures, their actual subject matter declined in importance. Even so, gardens and parks continued to be favored motifs in artists' attempts to deal with the problem of space in the construction of a flat picture. Bonnard's friend Edouard Vuillard, for example, also one of the Nabis, painted gardens and parks again and again. He employs a distinctly flat style as well, though he never fully abandoned the academic concept that a picture should create an illusion of space. He endeavored to develop new ways to create space and three-dimensionality on his picture surface. His later pictures especially, such as *Morning in the Vaucresson Garden* (plate 112), begun in 1923 and reworked in 1937 in preparation for a planned exhibition in New York, have an obvious affinity to the late work of Monet.

Henri Matisse and the Fauves took another route to painterly abstraction. They shocked their public in that they relied on the expressiveness of pure

115
Emil Nolde (1884–1956)
TROLLHOI'S GARDEN
1907
Oil on canvas, 28¹⁵⁄₁₆ × 34⅝ in. (73.5 × 88 cm)
Nolde-Stiftung, Seebüll, Germany

In 1903, the year after they married, Emil Nolde and his wife Ada moved to a small fisher-man's house on the island of Alsen in the North Sea, which would be their main residence until 1909. "My beloved sat in the little house or pottered about the modest garden between the vegetable beds and the flowers," the painter later recalled. The colors were obviously the focus of his painterly interest. Nolde freed himself from any kind of realistic representation of objects, but without completely abstracting the motifs the garden provided.

116 (above and pages 200–201)
Emil Nolde
Flower Garden (Girl and Washing)
1908
Oil on canvas, 25¾ × 32¹¹⁄₁₆ in. (65.5 × 83 cm)
Museum kunst palast, Düsseldorf

In the collection of his friend and patron Gustav Schiefler, Emil Nolde came to know an 1888 van Gogh painting of a garden that profoundly impressed him. Inspired by van Gogh's effusive colors and his picture structure, with little attempt at depth, Nolde too chose views of limited scope and with a high horizon line to structure his picture surface with a dynamic barrage of color that dissolves the forms of his subject.

colors, as intense as they could make them. At the Salon d'Automne in 1905 their pictures were hung in a room in which a Renaissance sculpture was also on display. A critic described the scene as "Donatello au milieu de fauves" (Donatello amid wild beasts), unintentionally providing the new movement with a name. The Fauves, or "wild ones," who had gathered around Henri Matisse now tried to structure not only the light in their paintings but also the picture space itself by the subtle application of color contrasts, creating a picture reality independent of the actual space represented. For Matisse, however, who was concerned that objects in his paintings be recognizable, even though his pure colors precluded values and shadows, the process of painterly abstraction was always balanced by direct impressions of nature. In 1951 he wrote to the publisher Tériade that his early trips to Morocco had helped him "get back in touch with nature, more than the application of a refreshing but often confining theory, namely Fauvism." In his picture *The Evergreen*, or *The Moroccan Garden* (plate 113), probably painted for the Russian collector Ivan Morosov

117
Emil Nolde
FLOWER GARDEN (THERSEN'S HOUSE)
1915
Oil on canvas, 27½ × 34⅝ in. (70 × 88 cm)
Staatliche Museen, Stiftung Preussischer Kulturbesitz,
Nationalgalerie, Berlin

When choosing the garden as a motif, Nolde was primarily interested in its rich colors. "It was on Alsen in the middle of the summer . . . the colors of the flowers drew me irresistibly, and almost immediately I began to paint. The colors of the blooms and the purity of these colors, I loved them."

Detail on page 19

118
Christian Rohlfs (1849–1938)
GOETHE'S GARDEN HOUSE IN WEIMAR
1902
Oil on canvas, 22⁷⁄₁₆ × 28¾ in. (57 × 73 cm)
Gallerie G. Paffrath, Düsseldorf

The influence of French Post-Impressionism is obvious in this painting, although the dots of color were clearly meant not to blend in the eye of the viewer, as the Pointillists intended, but to create a radiant mosaic.

Opposite: detail from plate 119

in early 1912, elements from nature are casually combined with ornamental arabesques into a painterly symbol of tropical vegetation.

The group of artists who called themselves Die Brücke also experimented with the formal possibilities of pictorial composition that emphasized the flat surface and employed exaggerated colors. Like the Fauves, they did not propose doing without objects in nature altogether. They opposed both academic art and the linear, floral, and Impressionistic styles of the turn of the century. On June 7, 1905, Dresden architecture students Fritz Bleyl, Erich Heckel, Ernst Ludwig Kirchner, and Karl Schmidt-Rottluff joined together with the aim—as stated in a handbill published by Kirchner the following year—of providing

youth with greater artistic freedom in the face of older, established forces. "Anyone who expresses directly and with no misrepresentation what forces him to create is one of us." In line with their revolutionary ambitions in art and politics, the painters of Die Brücke tended to choose subject matter guaranteed to be provocative: such unsavory aspects of big-city life as red-light districts on the one hand, and on the other the new emphasis on physical culture and naturism. Art had become a way of confronting social phenomena. Contemporary critics saw a group of unbridled libertines in the young Dresden artists, especially Ernst Ludwig Kirchner (see plate 114); in 1908 the journalist Ernst Köhler Haussen pronounced that he was "entirely self-centered, with no attempt to disguise it," that he painted "the rippling colors of his lurid dreams with more vividness and splotchiness than I have ever seen even in the most daring of the French Impressionists." Reviewers were quick to note that it was no longer the picture's subject matter that was the point, but rather the manner in which it was depicted.

One painter close to Die Brücke was the considerably older Emil Nolde. Born Emil Hansen, he chose to take the name of his north German birthplace. He joined the group in 1906, but left it the following year, claiming that he was put off by its members' stylistic uniformity, that their pictures were frequently so similar that one could not tell which one had painted them. By that time he was already well known for his highly unrealistic pictures of nature, particularly that of his Schleswig-Holstein homeland. After he bought a small fisherman's house on the island of Alsen, then part of Germany, his garden became his most frequent motif (plates 115–17). What drew him to it was not his interest in gardening or botany, which he would develop later, but the abundance and radiance of its colors. Another painter fascinated by the colors of gardens was Nolde's friend Christian Rohlfs (plate 118), who had studied in Weimar and who later, championed by the Hagen art patron Karl Ernst Osthaus, taught at the Folkwang School in Essen. Rohlfs maintained ties to Weimar, where in 1902 he painted Goethe's favorite retreat, the house the poet had helped to design in Ilm Park.

In an ever-growing market for new forms of painterly expression, the aspect of novelty took on unprecedented importance in the valuation of pictures. Already in the nineteenth century the term *avant-garde*—originally the military designation for an army's shock troops, or vanguard—had been applied to artists who saw themselves as innovators and whose works left all precedent behind. Use of the term was only the latest nod to the myth of the radical break with tradition, familiar enough in cultural history, according to which aesthetic innovation is always achieved by overcoming what came before. The formation of every avant-garde is necessarily based on such a notion, and it is this belief in a break with tradition that has given rise to an endless succession of new movements and -isms. Of necessity, this forward thrust of avant-gardism has brought

119
Wassily Kandinsky (1866–1944)
Murnau, Garden I
1910
Oil on canvas, 26 × 32¼ in. (66 × 82 cm)
Städtische Galerie im Lenbachhaus, Munich

In the late summer of 1919 Wassily Kandinsky and Gabriele Münter bought a picturesquely situated small house with a garden in Murnau, south of Munich. In the following years Kandinsky painted any number of pictures of his garden and the landscape around Murnau, but in them—inspired by pictures by the Fauves, then being shown in Munich—his colors developed a distinct life of their own, and forms seemed almost completely dissolved. He was less concerned about the beauty of the subject shown than about expressing a personal experience.

120
Wassily Kandinsky
IMPROVISATION 27 (GARDEN OF LOVE)
1912
Oil on canvas, 47⅜ × 55¼ in. (120.3 × 140.3 cm)
The Metropolitan Museum of Art, New York;
Alfred Stieglitz Collection

Kandinsky transposed garden motifs and imaginary shapes into pure colors and lines, distinguishing between three picture types. The ones made from direct observation of nature he called "impressions"; his largely unconscious "expressions of the internal processes of nature" he called "improvisations." The highest level, the pictures that resulted from long preparation and were to a certain extent a synthesis of the other two, he referred to as "compositions."

121
Franz Marc (1880–1916)
Doe in the Flower Garden
1913
Oil on canvas, 21⅝ × 30½ in. (55 × 77.4 cm)
Kunsthalle, Der Kunstverein in Bremen, Bremen,
Germany

Marc related that in 1913 he painted "all manner of pictures," all of them characterized by an increasing disengagement from the natural object. His goal was to renounce "external nature" in order to achieve an ideal painterly expressiveness. "I will never make a bush blue for the sake of decorative effect, but only in order to emphasize the horse standing out against it in its absolute essence. But the means employed must always be purely painterly, and enhanced to the greatest possible degree."

with it a need for historicizing, for what is out in front can only be properly apprehended in retrospect. In the statements of artists themselves, and especially in the pronouncements of art critics who thought of themselves as part of and mouthpieces for the avant-garde movement, the claim to be avant-garde is always substantiated by pointing out what is taken to be tradition.

The many journals and almanacs in which successive movements harrangued against what was considered "old"—most often itself "new" only a short time before—document the close relationship between art and art criticism at the beginning of the twentieth century. One of Wilhelmine Germany's most fervent champions of the new was Wassily Kandinsky. In 1901 he cofounded the artist group Phalanx, and as early as the following year he became its director, but Phalanx was dissolved soon afterward. In 1909, when several painters again withdrew from the Munich Secession to found the New Artists' Association, Kandinsky was once again elected director. But he broke with the association only two years later when one of his pictures was rejected by a jury, taking with him Franz Marc, Gabriele Münter, and Alfred Kubin. As an alternative, the new group opened an exhibition of its own on December 18, 1911, in Munich's Galerie Thannhauser, calling it an "Exhibition by the editors of 'The Blue Rider.' " The *Blaue Reiter* (Blue Rider) was the title of an art journal Kandinsky and Marc had been working on since the previous summer. In addition to essays of their own and contributions from artist friends, it was to contain musical compositions and illustrations of ancient, modern, exotic, and folk art, reproductions of children's drawings, and original graphics. The almanac would become a programmatic text, clearly defining the sort of renewal its editors and writers proclaimed to be so necessary. They argued that "the artist continuously internalizes experiences based on impressions he receives from the external world, from nature; and the search for artistic forms with which to express the interpenetration of all these effects—for forms necessarily freed from all that is secondary so as to strongly express only what is essential—in short, the quest for artistic synthesis, this we feel to be a watchword that at present links more and more artists in spirit."

For Blaue Reiter painters like Kandinsky (plates 119–20) and Franz Marc (plate 121), the garden was simply a possible basis for a composition. "One no longer adheres to the image in nature," Franz Marc explained, "but rather destroys it in order to show the powerful laws at work behind that lovely illusion." Further: "In essence, art was and is always the most audacious remove from nature and naturalness, the bridge into the spirit realm, the necromancy of mankind." In his paintings Marc sought a rhythmic arrangement of areas of color, their prismatic facets playing with the symbolism of the crystal. Since Romanticism, and even more prominently in the art of Expressionism, the crystal stood for the notional synthesis of the material and the spiritual, of

abstraction and nature, which as a tangible presence was supposed to retreat more and more behind the painting's spiritual content. To Kandinsky especially, objectivity seemed an actual impediment to pictorial composition. Initially indebted to the ornamental surface designs of Jugendstil, he found his way to pictures in which there is no longer any hint of natural objects.

August Macke, another member of the Blaue Reiter group and one of its programmatic writers, was also experimenting with autonomous picture structures, but unlike the others he also considered the picture's subject of great importance. He was deeply convinced that it was impossible to render the beauty of nature, and in his study of current trends in painting in Paris and elsewhere he sought a pictorial language that might do justice to both

122 (pages 210–11)
August Macke (1887–1914)
LARGE ZOOLOGICAL GARDEN
1912
Oil on canvas, center panel: 51 × 39 9/16 in. (129.5 × 100.5 cm);
side wings: 51 × 25 5/8 in. (129.5 × 65 cm)
Museum am Ostwall, Dortmund, Germany

According to his notes, Macke sought painterly possibilities "expressive of a yearning for the lost paradise." The zoo struck him as a metaphor for his vision of a universal harmony. Thanks to its three-part frame, which stylizes the picture into a triptych, the picture's peaceful atmosphere and almost meditative mood are underscored.

123 (above)
August Macke
GARDEN ON LAKE THUN
1913
Oil on canvas, 19 5/16 × 25 5/8 in. (49 × 65 cm)
Städtisches Kunstmuseum, Bonn

From October 1913 to June 1914 August Macke and his family stayed in Switzerland in Haus Rosengarten, in Hilterfingen, where he painted this view of the garden and the Stockhorn mountain range looming up in the background. According to his own statements, Macke's interest as a painter was in "infusing joy into nature, the heat of the sun and the trees, the shrubs, people, animals, flowers." In his pictures they were meant to "become an analogy to nature."

the natural impression and the picture's color surface structure. He repeatedly painted gardens and parks (plates 122 23), with the idea not of capturing their natural appearance but of re-creating it—as he put it, "finding the space-creating energies of color instead of making do with a dead chiaroscuro."

Macke's search had by no means ended when the war broke out, and all but a very few of the male members of the European avant-garde took up arms. They went to the front, as it was euphemistically said at the time, where they then lay across from one another in foxholes. Only days after the outbreak of war, the twenty-seven-year-old Macke marched off with the 160th Infantry Regiment toward France, where he was killed in an assault on September 26. Franz Marc died outside Verdun, struck by two grenade splinters during a reconaissance mission on March 4, 1916.

Continuation and Forecast

By the beginning of the twentieth century the free and subjective use of painterly methods and forms had become generally established. Regardless of the artistic process employed, it was commonly agreed that what mattered was the painting's intellectual substance as a purely visual concept. Its illustrative function was being increasingly usurped by photography, and became of lesser significance. Color and drawing became more and more central, the picture's subject now being merely what inspired the artist to creative activity. In his struggle with the formal problems of a given subject, Paul Klee was representative of the new thinking. Fundamentally skeptical about the possibility of picturing the world, he busied himself intensively with the methods of artistic expression. The objects in his pictures—here again they were repeatedly gardens (plates 124–25)—are signs, not images. As products of the human mind and expressions of his hand, they are symbols of man's relationship with the earth and the cosmos. Klee described his method with a certain humor: "While the artist is still wholly committed to grouping together the formal elements so perfectly and so logically that each one is in its necessary place and none detracts from another, some layman, looking over his shoulder, utters the devastating words: my uncle doesn't look at all like that! The artist thinks to himself, if he has disciplined nerves: uncle this, uncle that, I have to keep building. . . . This new building block, he says to himself, is probably a bit heavy, and pulls everything too far to the left; I'll have to add some trivial counterweight on the right to create balance." Only at the very end, he continued, is it possible that what has taken shape under

124 (page 214)
Paul Klee (1879–1940)
CASTLE GARDEN
1919
Watercolor on crayon-grounded paper and silver paper on cardboard, 8⅜ × 6⅝ in. (21.3 × 16.8 cm)
Kunstmuseum, Basel, Switzerland

Architectonic gardens are among the central motifs in Klee's œuvre. In his paintings he plays with the perceptual habits conditioned by perspective picture spaces. If one studies the expressly two-dimensional texture of colors and lines, one can make out walls, towers, paths, and gardens. In Klee's own words, the "dimensions of the pictorial elements like line, semidarkness, and color" and the "dimension of the object" permeate each other.

125 (page 215)
Paul Klee
ROSE GARDEN
1920
Oil pigment, pen drawing on paper, stretched on cardboard, 19⁵⁄₁₆ × 16¾ in. (49 × 42.5 cm)
Städtische Galerie im Lenbachhaus, Munich

Like August Macke, Paul Klee was convinced that the artist needed to hold "conversations with nature," not about painting from it, but simply about making responses to nature's challenge by painterly means. For "what we see is a suggestion, a possibility, a makeshift," one reads in his diary; "the genuine truth itself lies invisible in the background."

124

the artist's hands recalls an actual object, and "if the artist is lucky" it can be tweaked in such a way that it even "represents" something. In Klee's pictures line attains the greatest autonomy imaginable; it not only emancipates itself from the object, but from the artist himself.

The twentieth century discovered and explored the unconscious, spontaneity, and chance as formative elements in the composition of pictures, which triggered additional methods of abstraction as well as new forms of objectivity. The Surrealist paintings of Yves Tanguy, for example (plate 126), which were understood neither by the tradition-bound adherents of a classical concept of art nor by those who held that nonrepresentational pictures were timely, occupy the borderland between enigmatic reminiscences of manifestations of nature and a disquieting autonomous pictorial reality.

Again and again, the history of painting in this period has been described as a process taking place within the artist himself, and from the point of view of traditional aesthetics a gradual dismantling of what has been achieved in painting since the Renaissance. But art can only be understood in the context of the historical dynamic, especially the one that characterized the first decades of the twentieth century. One has to recognize that the dissolution in painting of what was visible and familiar came about at the same time as the introduction in mathematics of the fourth dimension, the space-time concept impossible to illustrate. With his general theory of relativity Albert Einstein developed a concept of time and space wholly foreign to classical notions, and astonished a public wary of the achievements of technology since the sinking of the *Titanic*. Then there was Sigmund Freud, whose emphasis on subjectivity and the unconscious was avidly discussed and internalized by any number of artists. Even more far-reaching for the larger art world was World War I, now rightly seen as the primal catastrophe of the twentieth century. Everything seemed to have been set in flux and upheaval, not just art. At the same time, the drive toward innovation on the part of the avant-garde and the associated acceleration of painterly innovation was dizzying. Any number of styles and forms of artistic expression were represented side by side—in painting, everything from nonobjective positions to a new realism. The latter responded to the challenge of photography, still black-and-white at the time, with colorful pictures of extreme fidelity to nature executed in the painting techniques of the old masters. The prevailing mood after the end of the war was one of retreat. In France, for example, Picasso responded to the cry "Rappel à l'ordre," paving the way for a widespread turning toward neoclassicism.

Common to all these styles and movements is the expression of specific artistic motivations. Especially in the popular imagination, the notion, generally accepted to this day, that a creator always reveals something of himself in his work had become firmly established, for which reason any work of art is to

126 (opposite)
Yves Tanguy (1900–1955)
THE DARK GARDEN
1928
Oil on canvas, 36 × 28 in. (91.4 × 71.1 cm)
Kunstsammlung Nordrhein-Westfalen,
Düsseldorf

Tanguy, a self-taught artist, turned to painting late, and in 1925 took up with the Paris Surrealists. As a painter he worked toward a painterly "automatism" uncontrolled by the intellect, so as to depict the stuff of dreams and the abysses of the human soul. His Dark Garden, *wholly a product of his artistic imagination, depicts strange biomorphic shapes in an eerie underwater landscape.*

127 (page 218)
Raoul Dufy (1877–1953)
THE ARTIST'S HOUSE AND GARDEN IN LE HAVRE
1915
Oil on canvas, 46¹⁄₁₆ × 35¹³⁄₁₆ in. (117 × 91 cm)
Musée d'Art Moderne de la Ville, Paris

A photograph showing the artist in uniform in front of his easel documents the creation of this atmospheric picture of his house and garden in Le Havre. Dufy's aim was to paint reality without imitating it. As a subjective symbol of reality, he employed the juxtaposition of unmixed colors, which give the picture rhythm and depth without creating any illusion of space.

128 (page 219)
Edvard Munch (1863–1944)
APPLE TREE IN THE GARDEN
1932–42
Oil on canvas, 39½ × 30½ in. (100.5 × 77.5 cm)
Munch Museum, Oslo

In his search for peace and seclusion, in 1916 Edvard Munch had acquired the Ekely estate outside Oslo. There, in deliberate isolation and at a distance from the new currents and developments in art, he transformed the subjects his garden presented to him into intensely colorful, compelling pictures.

129 (opposite)
Heimrad Prem (1934–1978)
PARADISE GARDEN
1962
Oil on collaged canvas, 47¼ × 39⅜ in. (120 × 100 cm)
Private collection

*As a cofounder of the SPUR group of painters, allied with the Situation-
ist International represented mainly in France, Prem worked to develop
a collective art. In his* Paradise Garden, *echoes of precedents from art
history and an expressive originality inspired by children's drawings are
combined into a sophisticated and distinctively expressive picture.*

130 (above)
Friedensreich Hundertwasser (1928–2000)
GRASS FOR THOSE WHO ARE DYING IN THE COUNTRY
1975
Mixed media, 24⅜ × 36⅛ in. (65 × 92 cm)
Private collection

*Hundertwasser's pictures are meant to appeal to their viewers' memories,
which are to be referred through them to the principles and primal forces
of nature. In his architecture Hundertwasser also processed his notion
of "ecological survival necessity," which involved the abandonment of
straight lines and the consistent greening of people's residential spaces.*

be thought of primarily as an emanation of the artist's personality. Especially in the motif of the garden, it is possible to see a shift in meaning. Whereas the Impressionists had dealt with the painterly attraction of the motif, one that was also exploited by the Fauves and the Cubists in their exploration of new painterly approaches, what now crowded into the foreground was the artist's conceptual and emotional relationship with the motif. The garden could no longer be subsumed arbitrarily under the genre of landscape; the picture motif and its composition now came to express a specific motivation on the part of the artist/subject. This is as true of Raoul Dufy's view of *The Artist's House and Garden in Le Havre* (plate 127) as it is of a late work by the Norwegian painter Edvard Munch, his *Apple Tree in the Garden* from between 1932 and 1942 (plate 128).

Given the quantity and variety of garden pictures in the twentieth century, their individual subjective implications, and the diverse circumstances under which they were created, it is scarcely possible to make the sort of generalizations required to extend this history up to the present day, even though such pictures are still being produced. It can only be said that for pictures exclusively intended to reflect the subjectivity of the artist, the place where the motif was presented or accidentally discovered has become increasingly unimportant. Created as an autonomous work of art, the garden picture no longer appeals to a specific audience; viewers might influence its perception, to be sure, but no longer its meaning. At the same time, it can be stated unequivocally that every direction recognized by opinion makers as a painterly movement is generally followed only a short time later by a countermovement also covered by the media. Once artists and critics alike declared, for example, that abstraction was the new international artistic language and the only one appropriate to the times, their supposed aesthetic consensus provoked any number of countermovements, among them Post-Painterly Abstraction and the so-called Pop Art promoted by Andy Warhol.

With the arrival of the ecology movement in the 1960s and '70s and a growing awareness of threats to the environment, a number of artists began dealing with nature in the most varied forms imaginable. The garden motif remained as vital as painting itself, repeatedly declared to be on its deathbed. Because actual gardens represented a refuge of calm insulated from what was perceived as an increasingly hectic world, garden pictures still reflected a yearning for paradise, a place where man and nature might exist in harmony (plate 129). The garden painting fell into disrepute only when it degenerated into kitsch, abandoning the realm of art. Yet the daubs of garden-inspired amateur painters under the guidance of Bob Ross document the unbroken popularity of the garden motif just as clearly as do the pictures sold on the Internet by Thomas Kinkade, who is especially esteemed for his paintings of cottage gardens.

131
David Hockney (born 1937)
RED POTS IN THE GARDEN
2000
Oil on canvas, 60 × 76 in. (152.3 × 193 cm)
Collection of the artist

This picture, painted in the artist's garden in the Hollywood Hills, is viewed from his blue terrace. The balcony railing, accented by red flowerpots, creates a deep perspective, behind which stretches the view of the garden and pool below. The freestyle work conveys a mood of restraint that characterizes Hockney's own garden as a paradisial spot.

Just as the garden pictures created in the twentieth century and still being produced today are extremely varied, so is the thinking about the significance and survival of painting and about what makes for a good picture in the present climate. Friedensreich Hundertwasser is known for having given gardens a prominent role in his architectural designs, and they are equally important in his paintings (plate 130). He once said that every good picture emanates a certain magic. It is good if it is "filled with magic. When one derives a certain joy from it, when it provokes laughter or tears, when it sets something in motion. It should be like a flower, like a tree. It should be like nature. It should be the sort of thing you miss when it is no longer there. It is a person. I have always likened paintings to trees. A painting is only good when it bears comparison with a tree or a living creature."

Even now there are artists who strive for such comparison with nature and closeness to it, to actual gardens as well as painted ones. David Hockney, for example (plate 131), who has studied the history of picture making as closely as anyone, has concentrated painterly treatment of the garden motif in a deliberate return to the traditions of European painting and brought it into the twenty-first century. Quite aside from how such a work is judged by critics, this painterly position—one of many at the beginning of a new millennium—reveals that for the time being painting and the motif of the garden are both alive and well. His picture by no means marks an end point in this history of the painted garden.

The sequence of pictures from two millennia that is here brought to a close was meant to bring together works of art of different eras from the point of view of their subjects. For if we hope to discover why people paint gardens, we must consider not only the subject matter but also the history of the medium. The ways artworks are made and perceived are not anthropological constants, any more than the notion of what an artist is. They are subject to change in the course of history, linked to the specific conditions and needs of the time. Yet in every era people have taken pleasure from the contemplation of both actual gardens and painted ones, even though for many centuries this pleasure was by no means their sole justification. This book is intended to foster a deeper appreciation for the pictures of gardens collected in this imaginary museum, and for all those that could not be included.

Appendices

Selected Bibliography

Exhibition Catalogues

AMSTERDAM 2000
Rijksmuseum, Amsterdam. *Der Glanz des Goldenen Jahrhunderts: Holländische Kunst des 17. Jahrhunderts; Gemälde, Bildhauerkunst und Kunstgewerbe.* Zwolle, 2000.

ANTWERP 2002
Rubenshuis, Antwerp. *De wereld is een tuin: Hans Vredeman de Vries en de tuinkunst van de Renaissance.* Ghent, 2002.

BIELEFELD 2000
Museum Huelsmann, Bielefeld. H. Wiewelhove, ed. *Gartenfeste: Das Fest im Garten, Gartenmotive im Fest.* Bielefeld, 2000.

COLOGNE 1957
Wallraf-Richartz Museum, Cologne. *Park und Garten in der Malerei: Vom 16. Jahrhundert bis zur Gegenwart.* Cologne, 1957.

DÜSSELDORF 1987
Stadtmuseum, Düsseldorf. I. Markowitz, ed. *Düsseldorfer Gartenlust.* Düsseldorf, 1987.

EMDEN 2007
Kunsthalle, Emden. N. Ohlsen, ed. *Garten Eden: Der Garten in der Kunst seit 1900.* Cologne, 2007.

ERLANGEN/NUREMBERG 1989
Erlangen, Universitätsbibliothek; Nuremberg. H.-O. Keunecke, ed. *Hortus Eystettensis. Zur Geschichte eines Gartens und eines Buches.* Munich, 1989.

FRANKFURT/MUNICH 2006
Städel-Museum, Frankfurt am Main; Städtisches Museum im Lenbachhaus and Kunstbau, Munich. Sabine Schulze, ed. *Gärten: Ordnung, Inspiration, Glück.* Ostfildern, 2006.

HAMBURG 2006
Museum für Hamburgische Geschichte, Hamburg. C. Horbas, ed. *Die unaufhörliche Gartenlust: Hamburgs Gartenkultur vom Barock bis ins 20. Jahrhundert.* Hamburg, 2006.

HAMM/MAINZ 2000
Gustav-Lübke-Museum, Hamm; Landesmuseum, Mainz. U. Harting, ed. *Gärten und Höfe der Rubenszeit im Spiegel der Malerfamilie Brueghel und der Künstler um Peter Paul Rubens.* Munich, 2000.

LONDON 2004
Tate Britain, London. N. Alfrey, S. Daniels, and M. Postle, eds. *Art of the Garden: The Garden in British Art, 1800 to the Present Day.* London, 2004.

MAGDEBURG [1999]
Kunstmuseum Kloster Unser Lieben Frauen, Magdeburg. M. Puhle, ed. *Gärten der Flora.* Magdeburg, [1999].

MUNICH 1986
Neue Pinakothek, Munich, and elsewhere. F. Büttner and H. W. Rott, eds. *Kennst Du das Land. Italienbilder der Goethezeit.* Munich, 1986.

MUNICH 1997
Neue Pinakothek and Staatliche Graphische Sammlung, Munich. T. Vignau-Wilberg, ed. *Durch die Blume: Natursymbolik um 1600.* Munich, 1997.

PITTSBURGH 1986
Frick Art Museum, Pittsburgh. K. J. Hellerstedt, ed. *Gardens of Earthly Delight: Sixteenth- and Seventeenth-Century Netherlandish Gardens.* Bloomington 1986.

SCHWEINFURT 2004
Museum Georg Schäfer, Schweinfurt. *Natur als Garten. Barbizons Folgen: Frankreichs Maler des Waldes von Fontainebleau und die Münchner Landschaftsmalerei.* Schweinfurt 2004.

VIENNA 1992
Österreichische Galerie, Vienna. R. Schmidt, ed. *Grenzenlos idyllisch: Garten und Park in Bildern von 1880 bis heute.* Vienna, 1992.

VIENNA [2002]
Historisches Museum der Stadt Wien, Vienna. U. Storch, ed. *Gartenkunst: Bilder und Texte von Gärten und Parks.* Vienna, [2002].

VIENNA 2007
Belvedere, Vienna. A. Husslein-Arco, ed. *Gartenlust: Der Garten in der Kunst.* Vienna, 2007.

Theoretical Works and Comprehensive Studies

Andreae, B. *"Am Birnbaum": Gärten und Parks im antiken Rom, in den Vesuvstädten und in Ostia.* Mainz, Germany, 1996.

Apel, F. *Die Kunst als Garten: Zur Sprachlichkeit der Welt in der deutschen Romantik und im Ästhetizismus des 19. Jahrhunderts.* Heidelberg, Germany, 1983.

Asskamp, R., et al., eds. *Luxus und Dekandenz: Römisches Leben am Golf von Neapel*, 92–121, 232–42. Mainz, 2007.

Balzer, G. *Goethe als Gartenfreund.* Munich, 1966.

Barrell, J. *The Idea of Landscape and the Sense of Place, 1730–1840.* Cambridge, 1972.

Beck, T. *Gardening with Silk and Gold.* Newton Abbot, 2002.

Benes, M., and D. Harris, eds. *Villas and Gardens in Early Modern Italy and France.* Cambridge, 2001.

Bermingham, A. *Landscape and Ideology: The English Rustic Tradition, 1740–1860.* Berkeley and Los Angeles, 1986.

Borchardt, R. *Der leidenschaftliche Gärtner.* Stuttgart, 1968.

Börsch-Supan, E. *Garten-, Landschafts- und Paradiesmotive im Innenraum: Eine ikonographische Untersuchung.* Berlin, 1967.

Brosé, C. "Park und Garten in Goethes 'Wahlverwandtschaften.' Park und Garten im 18. Jahrhundert." In *Colloquium der Arbeitsstelle 18. Jahrhundert, Gesamthochschule Wuppertal, Würzburg und Veitshöchheim, 26.–29. September 1977*, 125–29. Heidelberg, Germany, 1978.

Bumpus, J. *Impressionist Gardens.* London, 1990.

Opposite
Detail from plate 68 on page 135

Busch, W., ed. *Landschaftsmalerei. Geschichte der klassischen Bildgattungen in Quellentexten und Kommentaren 3.* Berlin, 1997.

Buttlar, A. von. *Der Landschaftsgarten—Gartenkunst des Klassizismus und der Romantik.* Cologne, 1989.

Büttner, N. *Landscape Painting: A History.* New York, 2006.

Carroll-Spillecke, M. *Der Garten von der Antike bis zum Mittelalter.* Mainz, 1992.

Coffin, D. R. *Gardens and Gardening in Papal Rome.* Princeton, N.J.: 1991.

———. *The Italian Garden.* Washington, D.C.: 1972.

Curtius, E. R. *Europäische Literatur und lateinisches Mittelalter.* Tübingen and elsewhere, 1993.

Dixon Hunt, J. *Gardens: Theory, Practice, History.* London, 1992.

Dixon Hunt, J., and P. Willis, eds. *The Genius of the Place: The English Landscape Garden, 1620–1820.* London, 1975.

Dlugaiczyk, M. *Der Waffenstillstand (1609–1621) als Medienereignis: Politische Bildpropaganda in den Niederlanden.* Münster, 2005.

Dülmen, A. von. *Das irdische Paradies: Bürgerliche Gartenkunst der Goethezeit.* Cologne, 1999.

Fell, D. *The Impressionist Garden: Ideas and inspiration from the gardens and paintings of the impressionists.* London, 1994.

Forkl, H., et al. *Die Gärten des Islam.* Stuttgart, 1993.

Förtsch, R. *Archäologischer Kommentar zu den Villenbriefen des jüngeren Plinius.* Mainz, 1993.

Franzen, B. *Die vierte Natur. Gärten in der zeitgenössischen Kunst.* Cologne, 2000.

Frass, M. *Antike römische Gärten: Soziale und wirtschaftliche Funktionen der horti Romani.* Horn, 2006.

Frühe, U. *Das Paradies ein Garten—der Garten ein Paradies: Studien zur Literatur des Mittelaters unter Berücksichtigung der bildenden Kunst und Architektur.* Frankfurt am Main, 2002.

Gamper, M. *"Die Natur ist republikanisch": Zu den ästhetischen, anthropologischen und politischen Konzepten der deutschen Gartenliteratur im 18. Jahrhundert.* Würzburg, 1998.

———. "Vom kartographischen Blick zur Perzeption des Subjekts. Der Garten und seine Darstellungsmedien im 17. und 18. Jahrhundert." In *Text—Bild—Karte. Kartographien der Vormoderne.* Jürg Glauser and Christian Kiening, eds. Freiburg im Breisgau, 2007.

Gerndt, S. *Idealisierte Natur. Die literarische Kontroverse um den Landschaftsgarten des 18. und frühen 19. Jahrhunderts in Deutschland.* Stuttgart, 1981.

Gothein, M. L. *Geschichte der Gartenkunst.* 2 vols. 1913/14; reprint, Jena, 1977.

Grimal, P. *Les jardins romains.* [Paris], 1984.

Haddad, H. *Le Jardin des Peintres.* Paris, 2000.

Hajós, G. "Kunst kontra Natur? Gartenästhetik und Naturschönheit." *Kunstforum International* 93 (1988): 135–42.

Hansmann, W. *Gartenkunst der Renaissance und des Barock.* Cologne, 1983.

Härting, U., and E. Schwinzer, eds. *Gärten und Höfe der Rubenszeit: Internationales Symposium im Gustav-Lübcke-Museum der Stadt Hamm vom 12.01.2001 bis 14.01.2001.* Worms, 2002.

Häuber, R. C. *Horti Romani: Die Horti Maecenatis und die Horti Lamiani auf dem Esquilin: Geschichte, Topographie, Statuenfunde.* Cologne, 1991.

Hennebo, D., and A. Hoffmann. *Geschichte der deutschen Gartenkunst.* 3 vols. Hamburg, 1962–65.

Hirschfeld, C. L. *Theorie der Gartenkunst.* 6 vols. Leipzig, 1779–85.

Hobhouse, P. *The Story of Gardening.* London, 2002.

Hoefer, N. N., and A. Ananjeva, eds. *Der andere Garten. Erinnern und Erfinden in Gärten von Institutionen.* Göttingen, 2005.

Hussey, C. *English Garden and Landscapes, 1700–1750.* London, 1967.

Jashemski, W. M. F. *The gardens of Pompeii: Herculaneum and the villas destroyed by Vesuvius.* 2 vols. New Rochelle, 1979–93.

Jong, E. de. *Nature and Art: Dutch Garden and Landscape Architecture, 1650–1740.* Philadelphia, 2001.

Kluckert, E. *Gartenkunst in Europa: Von der Antike bis zur Gegenwart.* Cologne, 2007.

Lauterbach, C. *Gärten der Musen und Grazien: Mensch und Natur im niederländischen Humanistengarten, 1522–1655.* Munich, 2004.

Lauterbach, I. *Der französische Garten am Ende des Ancien Régime.* Worms, 1987.

Laws, B. *Artists' Gardens.* London, 1999.

Maisak, P. *Arkadien. Landschaft vergänglichen Glücks.* Frankfurt am Main, 1992.

Mayer-Tasch, B., and B. Mayer-Hofer, eds. *Hinter Mauern ein Paradies: Der mittelalterliche Garten.* Frankfurt am Main, 1998.

Mazzoleni, D., and U. Pappalardo. *Pompejanische Wandmalerei. Architektur und illusionistische Dekoration.* Munich, 2005.

Mielsch, H. *Die römische Villa.* Munich, 1987.

———. *Römische Wandmalerei.* Darmstadt, 2001.

Morford, M. "The Stoic Garden." *Journal of Garden History* 7 (1987): 151–75.

Mosser, M., and G. Teyssot, eds. *The History of Garden Design. The Western Tradition from the Renaissance to the Present Day.* London, 1991.

Mosser, M., and P. Nys, eds. *Le jardin, art et lieu de mémoire.* Besançon, 1995.

Müller, K. *Grenzmarkierungen: Argumentationsstrategien und Identitätskonstruktionen in der politischen Druckgraphik der Niederlande zwischen 1570 und 1625.* Hamburg, 2002.

Niedermeier, M. *Erotik in der Gartenkunst. Eine Kulturgeschichte der Liebesgärten.* Leipzig, 1995.

Oesterle, G., and H. Tausch, eds. *Der imaginierte Garten.* Göttingen, 2001.

Paulson, R. *Emblem und Expression: Meaning in English Art of the Eighteenth Century.* London, 1975.

Petriconi, H. "Die verlorenen Paradiese." *Romantisches Jahrbuch* 10 (1959): 167–99.

Pizzoni, F. *Kunst und Geschichte des Gartens: Vom Mittelalter bis zur Gegenwart.* Stuttgart, 1999.

Polianski, I. J. *Die Kunst, die Natur vorzustellen: Die Ästhetisierung der Pflanzenkunde um 1800 und Goethes Gründung des Botanischen Gartens zu Jena im Spannungsfeld kunsttheoretischer und botanischer Diskussionen der Zeit.* Cologne, 2004.

Praz, M. *Der Garten der Erinnerung. Essays 1922–1980*, pp. 25–34. Vol. 1. Frankfurt am Main, 1992.

Ree, P. van der, G. Smienk, and C. Steenbergen. *Italian Villas and Gardens.* Munich, 1992.

Rees, R. *Interior Landscapes: Gardens and the Domestic Environment.* Baltimore and London, 1993.

Sarkowicz, H. *Die Geschichte der Gärten und Parks.* Frankfurt am Main and Leipzig, 1998.

Schiaparelli, A. *La Casa Fiorentina e i suoi arredi nei secoli XIV e XV.* 2 vols. Florence, 1983.

Schmidt, E., et al., eds. *Garten, Kunst, Geschichte: Festschrift für Dieter Hennebo zum 70. Geburtstag.* Worms, 1994.

Schnack, F. *Traum vom Paradies. Eine Kulturgeschichte des Gartens.* Hamburg, 1993.

Shoemaker, C. A., et al., eds. *Encyclopedia of Gardens: History and Design.* 3 vols. Chicago and elsewhere, 2001.

Skasa-Weiss, E. *Gärten, die erreichbaren Paradiese.* Munich, 1968.

Steingräber, E. *Zweitausend Jahre Europäische Landschaftsmalerei.* Munich, 1985.

Streatfield, D. C. "Art and Nature in the English Landscape Garden: Design Theory and Practice, 1700–1818." In *Landscape in the Gardens and the Literature of Eighteenth-Century England: Papers Read at a Clark Library Seminar, 18 March 1978*, pp. 3–87.

D. C. Streatfield and A. M. Duckworth, eds. Los Angeles, 1981.

Strong, R. *The Artist and the Garden.* New Haven and London, 2000.

Thümmel, H.-G. "Neilos von Ankyra über die Bilder." *Byzantinische Zeitschrift* 71 (1978): 10–22.

Trivero, G. *La camera verde: il giardino nell'immaginario cinematografico.* Verona, 2004.

Valery, M.-F. *Jardins du Moyen Âge.* Tournai, 2001.

Volkmann, H. *Unterwegs nach Eden. Von Gärtnern und Gärten in der Literatur.* Göttingen, 2000.

Wagner, B. *Gärten und Utopien: Natur- und Glücksvorstellungen in der französischen Spätaufklärung.* Vienna and elsewhere, 1985.

Warncke, C.-P. *Sprechende Bilder—sichtbare Worte. Das Bildverständnis in der frühen Neuzeit.* Wiesbaden, 1987.

———. *Symbol, Emblem, Allegorie.* Cologne, 2005.

Willsdon, C. A. P. *In the gardens of impressionism.* London 2004.

Wimmer, C. A. *Geschichte der Gartentheorie.* Darmstadt, 1989.

Winter, P. J. van. "De Hollands Tuin." *Nederlands Kunsthistorisch Jaarboek* 8 (1957): pp. 29–121.

Woodbridge, K. *Princely Gardens: The Origins and Development of the French Formal Style.* New York, 1986.

Zanker, P. "Die Villa als Vorbild des späten pompejanischen Wohngeschmacks." *Jahrbuch des Deutschen Archäologischen Instituts* 94 (1979): 460–523.

———. *Pompeji: Stadtbilder und Wohngeschmack.* Mainz, 1995.

Zuylen, G. van. *The Garden: Visions of Paradise.* London, 1995.

Artists and Works

Anonymous
HOUSE OF LIVIA
circa 20 BC
Plate 1
Mielsch 2001, 193f.; S. Settis, *La Villa di Livia e la pittura di giardino* (Milan, 2002); G. Messineo, *La Villa di Livia a Prima Porta* (Rome, 2004); Mazzoleni and Pappalardo 2004, pp. 189–91.

Anonymous
CASA DEL FRUTTETO
circa AD 40–50
Plate 2
H. Sichtermann, "Gemalte Gärten in pompejanischen Zimmern," *Antike Welt* 5 (1964): 41–51; Mielsch 2001, pp. 195f.; Mazzoleni and Pappalardo 2004, pp. 298–301.

Anonymous
CASA DI MARCUS LUCRETIUS FRONTO
circa AD 35–40
Plate 3
W. J. T. Peters, *La Casa di Marcus Lucretius Fronto a Pompei e le sue pitture* (Amsterdam, 1993), p. 261; Mielsch 2001, pp. 184f.; Mazzoleni and Pappalardo 2004, pp. 274–97.

Anonymous
MAUSOLEUM DER GALLA PLACIDIA
circa AD 425–450
Plate 4
C. Rizzardi, ed., *Il mausoleo di Galla Placidia a Ravenna* (Modena, 1996); H.-K. Siebigs, *Das Grabmal der Galla Placidia: Versuch einer Erklärung* (Aachen, 2003).

Anonymous
COMMENTARY ON THE APOCALYPSE
end of the tenth century
Plate 5
P. K. Klein, *Der ältere Beatus-Kodex Vitr. 14-1 der Biblioteca Nacional zu Madrid: Studien zur Beatus-Illustration und der spanischen Buchmalerei des 10. Jahrhunderts* (Hildesheim [and elsewhere], 1976); J. Williams, *Frühe spanische Buchmalerei* (Munich, 1977), no. 25; J. Williams, *The Illustrated Beatus: A Corpus of the Illustrations of the Commentary on the Apocalypse* (London, 1994).

Anonymous
Ebstorf World Map
circa 1300
Plate 6
J. Wilke, *Die Ebstorfer Weltkarte* (Bielefeld, 2001); M. Ohm, "Ebstorfer Weltkarte, Ferne Welten—Freie Stadt," in *Dortmund im Mittelater*, ed. M. Ohm, T. Schilp, and B. Welzel (Dortmund, 2006), pp. 330–32; H. Kugler et al., eds., *Die Ebstorfer Weltkarte*, 2 vols. (Berlin, 2007).

Anonymous
Stanza di Re Ruggero
circa 1160
Plate 7
H.-R. Meier, *Die normannischen Königspaläste in Palermo* (Worms, 1994), pp. 37f. and 110f.; R. Calandra and D. Alessi, eds., *Palazzo dei Normanni* (Palermo, 1999).

Anonymous
Palazzo Davanzati
circa 1395
Plate 8
M. Königer, "Die profanen Fresken des Palazzo Davanzati in Florenz," *Mitteilungen des Florentiner Institutes für Kunstgeschichte* 34 (1990): 245–78; M. Dachs, "Zur ornamentalen Freskendekoration des Florentiner Wohnhauses im späten 14. Jahrhundert," *Mitteilungen des Florentiner Institutes für Kunstgeschichte* 37 (1993): 71–129.

Anonymous
Roman de la Rose
circa 1490–1500
Plate 9
P.-Y. Badel, *Le "Roman de la Rose" au XIVe siècle: Etude de la réception de l'œuvre* (Geneva, 1980); Valery 2001, pp. 36–40; P. Porter, *Courtly Love in Medieval Manuscripts* (London, 2003).

Anonymous
Le Livre de Prouffits champestres et rurauls
circa 1475–1500
Plate 10
W. Richter, ed., *Ruralia commoda: Das Wissen des vollkommenen Landwirts um 1300*, 4 vols. (Heidelberg, 1995–2002); A. Taurino, "I Libri commodorum Ruralium di Pietro de Crescenzi, bolognese (1233–1321), Edizioni a stampa e manoscritti," in *Manoscritti, editoria e biblioteche dal medioevo all'età contemporanea*, ed. M. Ascheri and G. Colli (Rome, 2006), pp. 1281–1309.

Anonymous
Garden of Paradise
circa 1410–20
Plate 12
B. Brinkmann and S. Kemperdick, *Deutsche Gemälde im Städel, 1300–1500* (Mainz, 2002), pp. 93–120; exh. cat. Frankfurt/Munich 2006, 24f.

Anonymous
Hypnerotomachia Poliphili
1499
Plate 22
E. H. Gombrich, "Hypnerotomachiana," *Journal of the Warburg and Courtauld Institutes* 14 (1951): 119–25; L. Lefaivre, *Leon Battista Alberti's Hypnerotomachia Poliphili: Recognizing the Architectural Body in the Early Italian Renaissance* (Cambridge, 2005).

Leon Battista Alberti (1404–1472)
Plate 18
U. Pfisterer, *Die Kunstliteratur der italienischen Renaissance: Eine Geschichte in Quellen* (Stuttgart, 2002), pp. 25–31; J. Poeschke and C. Syndikus, eds., *Leon Battista Alberti. Humanist, Kunsttheoretiker, Architekt* (Münster, 2006).

Albrecht Altdorfer (circa 1480/85–1538)
Plate 26
T. Noll, *Albrecht Altdorfer in seiner Zeit: Religiöse und profane Themen in der Kunst um 1500* (Munich, 2001); M. Bushart, *Sehen und Erkennen: Albrecht Altdorfers religiöse Bilder* (Berlin, 2004), esp. pp. 289–96.

Fra Angelico (1387–1455)
Plate 19
T. S. Centi, *Il Beato Angelico: Fra Giovanni da Fiesole, biografia critica* (Bologna, 2003); S. Beissel, *Fra Angelico* (New York, 2007), 144–65.

Bernardo Bellotto, called Canaletto (1720–1780)
Plate 53
W. Seipel, ed., *Bernardo Bellotto genannt Canaletto: Europäische Veduten* (Milan, 2005), pp. 138f.; exh. cat. Vienna 2007, pp. 76f.

Karl Blechen (1798–1840)
Plate 61
H. R. Möller, *Carl Blechen: Romantische Malerei und Ironie* (Weimar, 1995), pp. 22f.; exh. cat. Frankfurt/Munich 2006, pp. 92f.

Pierre Bonnard (1867–1947)
Plate 111
D'Ingres à Bonnard (Paris, 2003); *Pierre Bonnard: L'Oeuvre d'art*; S. Pagé, ed., *Un Arrêt du temps* (Paris, 2006); exh. cat. Frankfurt/Munich 2006, pp. 271–76.

Sandro Botticelli (circa 1445–1510)
Plates 20, 21
M. Rohlmann, "Botticellis 'Primavera': Zu Anlass, Adressat und Funktion von mythologischen Gemälden im Florentiner Quattrocento," *Artibus et Historiae* 33 (1996): 97–132; *Botticelli: From Lorenzo the Magnificent to Savonarola* (Milan, 2003), pp. 158f., no. 20; F. Zöllner, *Sandro Botticelli* (Munich and elsewhere, 2005).

Georges Braque (1882–1963)
Plate 110
N. Worms de Romilly and J. Laude, *Braque: Le Cubisme fin 1907–1914, catalogue et oeuvre* (Fribourg, 1988), pp. 17–46; Büttner 2006, pp. 357–59.

Paul Bril (circa 1553/54–1626)
Guido Reni (1575–1642)
1575–1642
Plate 33
D. S. Pepper, *Guido Reni: A Complete Catalogue of his Works* (Oxford, 1984), p. 227, no. 36; A. Negro, *Il giardino dipinto del Cardinal Borghese: Paolo Bril e Guido Reni nel Palazzo Rospigliosi Pallavicini a Roma* (Rome, 1996); R. E. Spear, *The "Divine" Guido* (New Haven and London, 1997), p. 290; C. Hendriks, *Northern Landscapes on Roman Walls: The Frescoes of Matthijs and Paul Bril* (Florence, 2003).

Pieter Brueghel the Younger (1564/65–1637/38)
Plate 35
Pieter Breughel le Jeune (1564–1637/8)—Jan Brueghel l'Ancien (1568–1625): Une Famille des peintres flamands vers 1600 (Lingen, 1998), no. 126; exh. cat. Hamm/Mainz 2000/01, pp. 250f.

Jan Brueghel the Elder (1568–1625)
Plates 36, 37
B. Welzel, *Der Hof als Kosmos sinnlicher Erfahrung* (in press); exh. cat. Hamm/Mainz 2000/01, pp. 218–20; *Das flämische Stillleben, 1550–1680* (Lingen, 2002), pp. 278–91; A. T. Woollett, ed., *Rubens & Brueghel: A Working Friendship* (Los Angeles, 2006).

Edward Burne-Jones (1833–1898)
Plate 70
K. Löcher, *Der Perseus-Zyklus von Edward Burne-Jones* (Stuttgart, 1973); S. Widman and J. Christian, *Edward Burne-Jones: Victorian Dreamer* (New York, 1998), pp. 221–34; C. Wood, *Burne-Jones: The Life and Work of Sir Edward Burne-Jones, 1833–1898* (London, 1998).

Gustave Caillebotte (1848–1894)
Plate 80
P. Wittmer, *Caillebotte and his Garden at Yerres* (New York, 1991); K. Varnedoe, *Gustave Caillebotte* (New Haven and London, 1987), p. 174, no. 58; Willsdon 2004, pp. 206f.; J. Willi-Cosandier et al., eds., *Caillebotte: au cœur de l'impressionnisme* (Lausanne, 2005); exh. cat. Frankfurt/Munich 2006, pp. 189f., 217f.

Giovanni Antonio Canal, called Canaletto (1697–1768)
Plate 52
J. G. Links, *Canaletto* (New York, 2003), no. 148; K. Baetjer, "A Drawing by Canaletto of Richmond House Terrace," *Metropolitan Museum Journal* 37 (2002): 213–22; J. Hayes, "Parliament Street and Canaletto's Views of Whitehall," *The Burlington Magazine* 100 (1958): 341–49.

Paul Cézanne (1839–1906)
Plates 93, 94
F. Bauman, ed., *Cézanne: Vollendet—Unvollendet* (Vienna, 2000), pp. 381f.; exh. cat. Frankfurt/Munich 2006, pp. 263–68.

Hendrick de Clerck (1570–1629)
Plate 40
U. Härting, "Götter in Grotten," *Weltkunst* 5 (1998): 276–79; exh. cat. Hamm/Mainz 2000/01, pp. 241f.

Hendrik van Cleve (circa 1525–1589)
Plate 32
Fiamminghi a Roma, 1508/1608: Kunstenaars uit de Nederlanden en het Prinsbisdom Luik te Rome tijdens de Renaissance (Brussels, 1995),
pp. 136f.; *Hochrenaissance im Vatikan. Kunst und Kultur der Päpste 1503–1534*, exh. cat. Bonn, Kunst- und Ausstellungshalle der Bundesrepublik Deutschland (Ostfildern, 1999); exh. cat. Hamm/Mainz 2000/01, pp. 406–10.

Charles Allston Collins (1828–1873)
Plate 71
E. Prettejohn, *The Art of the Pre-Raphaelites* (London, 2000), pp. 62f.; R. Upstone, *The Pre-Raphaelite Dream* (London and New York, 2003), pp. 64f.; G. Stewart, "The Mind's Sigh: Pictured Reading in Nineteenth-Century Painting," *Victorian Studies* 46/2 (2004): pp. 217–30.

John Constable (1776–1837)
Plate 58
G. Reynolds, *The Early Paintings and Drawings of John Constable*, 2 vols. (New Haven and London, 1996), no. 15.23; exh. cat. Frankfurt/Munich 2006, pp. 115f.

Lovis Corinth (1858–1925)
Plate 109
S. Fehlemann, ed., *Die Gemälde des 19. und 20. Jahrhunderts, Von der Heydt-Museum Wuppertal* (Cologne, 2003), p. 224; exh. cat. Frankfurt/Munich 2006, pp. 127f., 125f., 229f.; M. Zimmermann, *Lovis Corinth* (Munich, 2008).

Jean Baptiste Camille Corot (1796–1875)
Plate 66
C. Heilmann, ed., *Corot, Courbet und die Maler von Barbizon* (Munich, 1996); M. Pantazzi et al., eds., *Corot* (New York, 1997); exh. cat. Frankfurt/Munich 2006, pp. 72, 77, 93f.

Gustave Courbet (1819–1877)
Plate 72
J.-J. Fernier, *Courbet et Ornans* (Paris, 1989); exh. cat. Frankfurt/Munich 2006, pp. 203f.; *L'Apologie de la nature . . . ou l'exemple de Courbet* (Ornans, 2007).

Lucas Cranach the Elder (1472–1553)
Plate 27
E. Bierende, *Lucas Cranach d. Ä. und der deutsche Humanismus: Tafelmalerei im Kontext von Rhetorik, Chroniken und Fürstenspiegeln* (Munich, 2002), pp. 250–70; A. Tacke, ed., *Lucas Cranach, 1553/2003: Wittenberger Tagungsbeiträge anlässlich des 450. Todesjahres Lucas Cranachs des Älteren* (Leipzig, 2007); B. Brinkmann, ed., *Cranach der Ältere* (Ostfildern, 2007).

Lucas Cranach the Younger (1515–1586)
Plate 28
A. Steinwachs, *Der Weinberg des Herrn, Lucas Cranach d. J.* (Spröda, 2001); I. Schulze, *Lucas Cranach d. J. und die protestantische Bildkunst in Sachsen und Thüringen* (Bucha bei Jena, 2004).

Jacques-Louis David (1748–1825)
Plate 57
W. E. Roberts, *Jacques-Louis David: Revolutionary Artist* (Chapel Hill and elsewhere, 1989); D. Johnson, *Jacques-Louis David: Art in Metamorphosis* (Princeton, 1993); P. Bordes, ed., *Jacques-Louis David, Empire to Exile* (New Haven and elsewhere, 2005).

Raoul Dufy (1877–1953)
Plate 127
L. Barbier, ed., *Raoul Dufy* (Paris, 1999), pp. 140f.; *Raoul Dufy du motif à la couleur* (Paris, 2003).

Albrecht Dürer (1471–1528)
Plate 17
G. Unverfehrt, ed., *Dürers Dinge* (Göttingen, 1997), pp. 296f.; A. Scherbaum, R. Schoch, and M. Mende, *Albrecht Dürer, das druckgraphische Werk*, vol. 2, *Holzschnitte und Holzschnittfolgen* (Munich and elsewhere, 2002), pp. 56f.

Thomas Eakins (1844–1916)
Plate 76
K. A. Foster, *Thomas Eakins Rediscovered: Charles Bregler's Thomas Eakins Collection at the Pennsylvania Academy of Fine Arts* (New Haven, 1997), pp. 202f.; W. I. Homer, *Thomas Eakins: His Life and Art* (New York, 2002); S. Kirkpatrick, *The Revenge of Thomas Eakins* (New Haven, 2006), pp. 214f.

Erasmus Ritter von Engert (1796–1871)
Plate 65
A. Wesenberg and E. Förschl, eds., *Nationalgalerie Berlin: Das XIX. Jahrhundert. Katalog der ausgestellten Werke* (Leipzig, 2001); exh. cat. Frankfurt/Munich 2006, pp. 159f.

Jan van Eyck (circa 1390–1441)
Plate 14
T.-H. Borchert, ed., *Jan van Eyck und seine Zeit: Flämische Meister und der Süden 1430–1530* (Stuttgart, 2002), p. 234, no. 26; J. Graham, *Inventing van Eyck: The Remaking of an Artist for the Modern Age* (New York, 2007).

Anselm Feuerbach
1829–1880
Plate 69
J. Ecker, *Anselm Feuerbach: Leben und Werk* (Munich, 1991), pp. 234–36, no. 384f.; *Anselm Feuerbach* (Ostfildern, 2002), pp. 47f., 170.

Jacques Fouquières (circa 1580/90–1659)
Plate 38
R. Zimmermann, *Hortus Palatinus: Die Entwürfe zum Heidelberger Schlossgarten von Salomon de Caus 1620* (Worms, 1986); P. Wolf, ed., *Der Winterkönig: Friedrich von der Pfalz. Bayern und Europa im Zeitalter des Dreissigjährigen Krieges* (Stuttgart, 2003), pp. 83–92.

Jean-Honoré Fragonard (1732–1806)
Plate 51
H. Beck et al., eds., *Mehr Licht: Europa um 1770; Die bildende Kunst der Aufklärung* (Munich, 1999), pp. 153–58; exh. cat. Frankfurt/Munich 2006, pp. 87f.; Büttner 2006, pp. 219f.

The Frankfurt Master (circa 1460–1530)
Plate 24
P. Vandenbroeck, *Catalogus schilderijen 14e en 15e eeuw* (Antwerp, 1985), pp. 97–103; P. van den Brinck and M. Martens, eds., *ExtravagAnt! A forgotten Chapter of Antwerp Painting, 1500–1530* ([Antwerp], 2005), pp. 26f. no. 4.

Caspar David Friedrich (1774–1840)
Plates 63, 64
T. Vignau-Wilberg, *Spätklassizismus und Romantik: Bayerische Staatsgemäldesammlungen, Neue Pinakothek, München, vollständiger Katalog*, vol. 4 (Munich, 2003), pp. 130–33; exh. cat. Frankfurt/Munich 2006, pp. 145f.

Thomas Gainsborough (1727–1788)
Plate 55
M. Rosenthal, *The Art of Thomas Gainsborough* (New Haven and London, 1999), pp. 126f.; H. Belsey, *Thomas Gainsborough: A Country Life* (Munich and elsewhere, 2002), pp. 25–44; M. Rosenthal and M. Myrone, eds., *Gainsborough* (London, 2002).

Paul Gauguin (1848–1903)
Plate 95
Richard R. Brettell, ed., *Gauguin and Impressionism* (New Haven and elsewhere, 2005); K. Thomas, *"Un Paysage est un état de l'âme,"* in *Landschaft als Stimmung bei Paul Gauguin, Vermessen: Landschaft und Ungegenständlichkeit*, ed. W. Busch (Zurich, 2007), pp. 167–85.

Vincent van Gogh (1853–1890)
Plates 96–101
Exh. cat. Frankfurt/Munich 2006, pp. 127f., 253–56; exh. cat. Vienna 2007, p. 211; M. Gayford, *The Yellow House: Van Gogh, Gauguin and Nine Turbulent Weeks in Arles* (London, 2007).

Dirck Hals (1591–1656)
Plate 44
H. Wiewelhove, *Gartenfest: Das Fest im Garten—Gartenmotive im Fest* (Bielefeld, 2000), pp. 15–33; A. Kolfin, *Een gezelschap jonge luyden: Productie, functie en betekenis van Noord-Nederlandse voorstellingen van vrolijke gezelschappen 1610–1645* (Leiden, 2002); P. Biesboer and M. Sitt, *Vergnügliches Leben—Verborgene Lust: Holländische Gesellschaftsszenen von Frans Hals bis Jan Steen* (Zwolle, 2004), pp. 96f.

Frans Hals (1580–1666)
Plate 43
S. Slive, ed., *Frans Hals* (Antwerp, 1990), pp. 162–65; E. de Jongh, ed., *Portretten van echt en trouw: Huwelijk en gezin in de Nederlandse kunst van de 17e eeuw* (Zwolle, 1986), pp. 124–30.

David Hockney (born 1937)
Plate 131
Exciting Times Are Ahead: David Hockney (Leipzig, 2001), no. 82; A. Schumacher, *David Hockney: Zitate als Bildstrategie* (Berlin, 2003); D. Hockney, *Hockney's Pictures* (New York and elsewhere, 2004), pp. 214f.

Winslow Homer (1836–1910)
Plate 75
G. Hendricks, *The Life and Work of Winslow Homer* (New York, 1979), pp. 59–64; N. Cikovsky Jr. and F. Kelly, eds., *Winslow Homer* (New Haven and elsewhere, 1995), pp. 70f.; Willsdon 2004, pp. 94f.; R. C. Griffin, *Winslow Homer: An American Vision* (London, 2006).

Pieter de Hooch (1629–1683)
Plate 45
P. C. Sutton, *Pieter de Hooch, 1629–1684* (New Haven and elsewhere, 1998), pp. 154f.; exh. cat. Amsterdam 2000, pp. 201f.

Friedensreich Hundertwasser (1928–2000)
Plate 130
W. Schurian, ed., *Schöne Wege: Gedanken über Kunst und Leben* (Munich, 1983); P. Restany, *Hundertwasser: Die Macht der Kunst, der Maler-König mit den fünf Häuten* (Cologne and elsewhere, 2001); H. Rand, *Hundertwasser der Maler* (St. Gallen, 2006).

Wassily Kandinsky (1866–1944)
Plates 119, 120
H. K. Roethel and J. K. Benjamin, *Kandinsky: Werkverzeichnis der Ölgemälde,* vol. 1, *1900–1915* (Munich, 1982), nos. 339, 430; M. M. Moeller, *Der frühe Kandinsky, 1900–1910* (Munich, 1994), pp. 261–316; G. Brucher, *Kandinsky. Wege zur Abstraktion* (Munich and elsewhere, 1999), pp. 350f.; I. Brugger and F. Steininger, eds., *Monet Kandinsky Mondrian und die Folgen* (Munich, 2008).

Ernst Ludwig Kirchner (1880–1938)
Plate 114
M. M. Moeller, *Ernst Ludwig Kirchner, die Strassenszenen, 1913–1915* (Munich, 1993); L. Griesebach, *Ernst Ludwig Kirchner, 1880–1938* (Cologne, 1999), pp. 68f.; *Ernst Ludwig Kirchner: The Dresden and Berlin Years* (London, 2003), pp. 23–25.

Paul Klee (1879–1940)
Plates 124, 125
R. Verdi, *Klee and Nature* (Paris, 1984); Paul Klee, *Wachstum regt sich: Klees Zwiesprache mit der Natur* (Munich, 1992); *Paul Klee: Catalogue Raisonné*, ed. Paul Klee Stiftung, Kunstmuseum Bern, vol. 3 (Bern, 1999), nos. 2252, 2389; exh. cat. Frankfurt/Munich 2006, pp. 312–43.

Gustav Klimt (1862–1918)
Plates 102, 103
S. Koya, ed., *Gustav Klimt: Landschaften* (Munich, 2002); A. Weidinger, *Gustav Klimt* (Munich, 2007); exh. cat. Vienna 2007, pp. 196–99.

Joseph Anton Koch (1768–1839)
Plate 59
C. von Holst, *Joseph Anton Koch, 1768–1839: Ansichten der Natur* (Stuttgart, 1989), pp. 320f.; exh. cat. Munich 2005, p. 130.

Max Liebermann (1847–1935)
Plates 105–107
"Nichts trügt weniger als der Schein": Max Liebermann der deutsche Impressionist (Bremen, 1995), pp. 208f.; U. M. Schneede and J. E. Howoldt, eds., *Im Garten von Max Liebermann* (Berlin, 2004); R. Scheer, *"Wir*

sind die Liebermanns": Die Geschichte einer Familie (Berlin, 2006); exh. cat. Frankfurt/Munich 2006, pp. 127f., 236–42; exh. cat. Vienna 2007, p. 165; G. & W. Braun, Max Liebermanns Garten am Wannsee und seine wechselvolle Geschichte (Berlin, 2008).

Limburg Brothers (?)
Plate 11
P. Stirnemann, ed., Les Très Riches Heures du Duc de Berry et l'enluminure en France au début du XVe siècle (Paris and elsewhere, 2004); R. Dückers, ed., Die Brüder von Limburg: Nijmegener Meister am französischen Hof (1400–1416) (Stuttgart, 2005).

Stephan Lochner (circa 1400–1451)
Plate 13
Stefan Lochner Meister zu Köln: Herkunft, Werke, Wirkung (Cologne, 1993); R. Krischel, Stefan Lochner, Die Muttergottes in der Rosen-laube (Leipzig, 2006).

August Macke (1887–1914)
Plates 122, 123
I. Bartsch, ed., Meisterwerke des Expres-sionismus und der Klassischen Moderne (Dortmund, 1995), pp. 21f.; K. Bussmann, ed., Durchfreuen der Natur: Blumen, Gärten, Landschaften: August Macke und die Expres-sionisten in Westfalen (Münster, 1995); exh. cat. Frankfurt/Munich 2006, pp. 232–34.

Edouard Manet (1832–1883)
Plates 85, 86
D. Rouart and D. Wildenstein, Edouard Manet. Catalogue raisonné, vol. 1 (Lausanne, 1975), p. 23; Willsdon 2004, pp. 141–48; exh. cat. Frankfurt/Munich 2006, pp. 209f.

Andrea Mantegna (1431–1506)
Plate 23
S. Ferino-Pagden, ed., Isabella d'Este: "La prima donna del mondo," Fürstin und Mäzena-tin der Renaisance (Vienna, 1994); P. P. Fehl, "Mantegnas 'Mutter der Tugenden,'" Artibus et Historiae 24 (2003): 29–42; F. Trevisani, ed., Andrea Mantegna e i Gonzaga: Rinascimento nel Castello di San Giorgio (Milan, 2006).

Franz Marc (1880–1916)
Plate 121
K. Lankheit, Franz Marc: Katalog der Werke (Cologne, 1970), no. 217; Kräfte der Natur: Werke 1912–1915 (Ostfildern, 1993), pp. 70–72; J. Horsley, Der Almanach des Blauen Reiters als

Gesamtkunstwerk: Eine interdisziplinäre Untersuchung (Frankfurt am Main, 2006).

Henri Matisse (1869–1954)
Plate 113
Haddad 2000, pp. 172f.; J. Cowart, ed., Matisse in Morocco (New York, 1990), pp. 70f.; exh. cat. Frankfurt/Munich 2006, pp. 293f.

Adolf Menzel (1815–1905)
Plate 67
Adolph Menzel, 1815–1905 (Cologne, 1996), pp. 100f.; W. Busch, Adolph Menzel: Leben und Werk (Munich, 2004); exh. cat. Frankfurt/Munich 2006, pp. 123f.

Claude Monet (1840–1926)
Plates 87–92
M. Elder, A Giverny, chez Claude Monet (Paris, 1924); H. Keller, Ein Garten wird Malerei (Cologne, 1982); G. van der Kemp, Une visite à Giverny (Versailles, 1986); C. Holmes, Monet at Giverny (London, 2003); C. Becker, ed., Monets Garten (Ostfildern, 2004); Willsdon 2004; B. Ahrens, Die "Déjeuner"-Malerei von Edouard Manet, Claude Monet und Pierre-Auguste Renoir (Freiburg im Breisgau, 2006), pp. 145–70; exh. cat. Frankfurt/Munich 2006, pp. 207, 219, 277–80, 287f.; exh. cat. Vienna 2007, pp. 154f.

Edvard Munch (1863–1944)
Plate 128
R. Heller, Edvard Munch. Leben und Werk, Munich 1993; M. Arnold, Edvard Munch, Reinbek 1995; Munch Revisited: Edvard Munch und die heutige Kunst, exh. cat. Dortmund, Museum am Ostwall, edited by R. E. Pahlke, Bielefeld 2005; exh. cat Vienna 2007, p. 236.

Emil Nolde (1884–1956)
Plates 115–117
Emil Nolde (London, 1995); exh. cat. Frankfurt/Munich 2006, pp. 231f.; exh. cat. Vienna 2007, pp. 207–9.

Jakob Cornelisz van Oostsanen (circa 1472/77–1533)
Plate 25
J. L. Carroll, The Paintings of Jacob Cornelisz. van Oostsanen (1472?–1533) (Ann Arbor, 1987); B. Schnackenburg, Gemäldegalerie Alte Meister: Gesamtkatalog (Mainz, 1996), vol. 1, p. 210.

Willem de Pannemaecker (active 1535–1578)
Plate 34
B. Franke and B. Welzel, eds., Tapisserie: Die Kunst der burgundischen Niederlande (Berlin, 1997), pp. 121–39; G. Delmarcel, Flemish Tapestry (London, 1999), pp. 130f.; exh. cat. Hamm/Mainz 2000/01, pp. 143–50.

Pierre Patel (circa 1605–1676)
Plate 48
F. H. Hazlehurst, Gardens of Illusion: The Genius of André le Nostre (Nashville, 1980), pp. 59–166; N. Coural, Les Patel: Pierre Patel (1605–1676) et ses fils (Paris, 2001).

Camille Pissarro (1831–1903)
Plates 77–79
R. R. Brettell, Pissarro and Pontoise (New Haven and London, 1990), pp. 42–45; exh. cat. Frankfurt/Munich 2006, pp. 221f.; K. Rothkopf, ed., Pissarro: Creating the Impres-sionist Landscape (London, 2007).

Heimrad Prem (1934–1978)
Plate 129
P. Dornacher, Heimrad Prem, 1934–1978: Leben und Werk (Munich, 1995); Gruppe SPUR 1958–1965; V. Loers, ed., Lothar Fischer, Helmut Sturm, Heimrad Prem, HP Zimmer (Regens-burg, 1987); N. Zimmer, SPUR und andere Künstlergruppen: Gemeinschaftsarbeit in der Kunst um 1960 zwischen Moskau und New York (Berlin, 2002).

Johann Christian Reinhart (1761–1847)
Plate 60
I. Feuchtmayr, Johann Christian Reinhart, 1761–1847 (Munich, 1975), pp. 322f.; exh. cat. Munich 2005, pp. 126–29.

Auguste Renoir (1841–1919)
Plates 81–84
D. Fell, Renoir's Garden (New York, 1991); Willsdon 2004, pp. 20f.; exh. cat. Frankfurt/Munich 2006, pp. 187f, 211f.; Auguste Renoir und die Landschaft des Impressionismus (Wuppertal, 2007).

Hubert Robert (1733–1808)
Plate 54
H. Burda, Die Ruine in den Bildern Hubert Roberts (Munich, 1967), pp. 68f.; J. de Cayeux, Hubert Robert et les jardins (Paris, 1987), pp. 71–90; G. Herzog, Hubert Robert und das Bild im Garten (Worms, 1989), pp. 64–74;

P. R. Radisich, *Hubert Robert: Painted Spaces of the Enlightenment* (Cambridge, 1998).

Christian Rohlfs (1849–1938)
Plate 118
P. Vogt, *Christian Rohlfs* (Recklinghausen, 1978), p. 55; *Christian Rohlfs, 1849–1938* (Munich, 1996); *Christian Rohlfs: Die Begegnung mit der Moderne* (Munich, 2005).

Peter Paul Rubens (1577–1640)
Plates 41, 42
B. Welzel, "Liebesgärten," exh. cat. Hamm/Mainz 2000/01, pp. 49–58, 354–58; U. Heinen, "Rubens' Garten und die Gesundheit des Künstlers," *Wallraf-Richartz-Jahrbuch* 65 (2004): 71–182; N. Büttner, *Herr P. P. Rubens* (Göttingen, 2006), pp. 89–91.

Philipp Otto Runge (1777–1810)
Plate 62
J. Traeger, *Philipp Otto Runge: Die Hülsenbeckschen Kinder* (Frankfurt am Main, 1987); exh. cat. Frankfurt/Munich 2006, pp. 365–68; P. Betthausen, *Philipp Otto Runge* (Leipzig, 1908).

Martin Schongauer (circa 1430–1491)
Plates 15, 16
S. Kemperdick, *Martin Schongauer: Eine Monographie* (Petersberg, 2004), appendix I, cat. 7, and appendix II, documents from 1471, 1478; U. Heinrichs, *Martin Schongauer, Maler und Kupferstecher* (Munich, 2007).

Max Slevogt (1868–1932)
Plate 108
H.-J. Imiela, *Max Slevogt und Neukastel* (St. Ingbert, 1957); B. Roland, *Max Slevogt, Pfälzische Landschaften* (Munich, 1991); E. G. Güse et al., eds., *Max Slevogt: Gemälde, Aquarelle, Zeichnungen* (Stuttgart, 1992), pp. 458f.; exh. cat. Frankfurt/Munich 2006, pp. 127f., 229f.

Carl Spitzweg (1808–1885)
Plate 68
S. Wichmann, *Carl Spitzweg* (Frankfurt am Main, 1991), pp. 115–21; *Carl Spitzweg: Reisen und Wandern in Europa und der Glückliche Winkel* (Stuttgart, 2002).

Yves Tanguy (1900–1955)
Plate 126
K. Schmidt, ed., *Yves Tanguy: Retrospektive, 1925–1955* (Munich, 1982); K. von Maur, ed., *Yves Tanguy und der Surrealismus* (Ostfildern, 2000).

Hans Thoma (1839–1924)
Plate 73
H.-J. Ziemke, *Städelsches Kunstinstitut Frankfurt am Main: Die Gemälde des 19. Jahrhunderts*, vol. 1, *Text* (Frankfurt am Main, 1972), p. 414; M. Dirrigl, *Hans Thoma, Karl Stauffer-Bern* (Nuremberg 2001); Büttner 2006, pp. 344–46.

Giovanni Battista Tiepolo (1696–1770)
Plate 50
G. Knox, "The Tasso Cycles of Giambattista Tiepolo and Gianantonio Guardi," *Museum Studies* 9 (1978): 49–95; K. Christiansen, *Giambattista Tiepolo* (New York, 2002).

Jacopo Tintoretto (1518–1594)
Plate 30
R. Krischel, *Jacopo Robusti, genannt Tintoretto* (Cologne, 2000); M. Falomir, *Tintoretto* (Madrid, 2007), pp. 298–303.

Titian (circa 1488–1576)
Plate 29
U. Groos, *Ars musica in Venedig im 16. Jahrhundert* (Hildesheim and elsewhere, 1996), pp. 171–92; *Venus: Bilder einer Göttin* (Munich, 2000), pp. 130–33; M. Horky, *Amors Pfeil: Tizian und die Erotik in der Kunst* (Braunschweig, 2003).

Fritz von Uhde (1848–1911)
Plate 74
A. Mochon, *Fritz von Uhde and Plein-Air Painting in Munich, 1880–1900* (New Haven, 1973), pp. 125–30; D. Hansen, ed., *Fritz von Uhde: Vom Realismus zum Impressionismus* (Ostfildern, 1998).

Justus van Utens (1570–1609)
Plate 31
D. Mignani, *Le ville medicee di Giusto Utens* (Florence, 1989); C. A. Lajos, *Artistic, Poetical, Rhetorical, and Prophetic Aspects of the Medici Family Gardens in Florence, at Fiesole, and at Castello* (Ann Arbor, 2000).

Diego Rodríguez de Silva y Velázquez (1599–1660)
Plate 47
J. López-Rey, *Velázquez*, 2 vols. (Cologne, 1996), vol. 1, pp. 72f., vol. 2, pp. 108–13; J. Montoro, *Velázquez el pintor de la luz* (Madrid, 2001); M. Warnke, *Velázquez: Form & Reform* (Cologne, 2005); D. W. Carr, ed., *Velázquez* (London, 2006).

Adriaen van de Velde (1636–1672)
Plate 46
F. Grijzenhout et al., eds., *Meesterlijk vee: Nederlandse veeschilders, 1600–1900* (Zwolle, 1988), no. 32: H. Bok et al., *Gemäldegalerie Berlin: Gesamtverzeichnis* (Berlin, 1996), pp. 123f.; exh. cat. Amsterdam 2000, pp. 265f.

Heinrich Vogeler (1872–1942)
Plate 104
D. Erlay, *Vogeler: Ein Maler und seine Zeit* (Fischerhude, 1981), pp. 104f.; B. Stenzig, *Worpswede Moskau: Das Werk von Heinrich Vogeler* (Lilienthal, 1991); F. Berchtig, *Künstlerkolonie Worpswede* (Munich, 2006); exh. cat. Vienna 2007, p. 200.

Sebastian Vrancx (1573–1647)
Plate 39
T. Fusenig, "Komödianten im Lustgarten," in *Gärten und Höfe der Rubenszeit*, ed. U. Härting and E. Schwinzer (Worms, 2002), pp. 42–49; exh. cat. Hamm/Mainz 2000/01, pp. 367f.

Edouard Vuillard (1868–1940)
Plate 112
B. Thomson, *Vuillard* (Oxford, 1988), pp. 119–23; G. Groom, ed., *Beyond the Easel: Decorative Painting by Bonnard, Vuillard, Denis, and Roussel, 1890–1930*, (Chicago, 2001), no. 85.

Jean Antoine Watteau (1684–1721)
Plate 49
D. Posner, *Antoine Watteau* (Berlin, 1984), pp. 179f.; A. W. Vetter, *"…von sanften Tönen bezaubert!" Antoine Watteau—"Venezianische Feste"* (Braunschweig, 2005); exh. cat. Frankfurt/Munich 2006, pp. 81f.; Büttner 2006, pp. 215–18.

Richard Wilson (1714–1782)
Plate 56
Richard Wilson: The Landscape of Reaction, exh. cat. London, Tate Gallery, D. H. Solkin, ed. (London, 1982); Steingräber 1985, pp. 277f.

Index